The Art & Design Series

For beginners, students, and professionals in both fine and commercial arts, these books offer practical how-to introductions to a variety of areas in contemporary art and design.

Each illustrated volume is written by a working artist, a specialist in his or her field, and each concentrates on an individual area—from advertising layout or printmaking to interior design, painting, and cartooning, among others. Each contains information that artists will find useful in the studio, in the classroom, and in the marketplace.

Lois McArdle has taught for more than fifteen years at the Art Institute of Boston, the Massachusetts College of Art, Northern Virginia Community College, and the Corcoran School of Art in Washington, DC. She has exhibited her drawings and paintings in many solo and group shows, and her work is included in private, public, and corporate collections.

LOIS McARDLE

PORTRAIT DRAWING
A Practical Guide for Today's Artists

84144

A SPECTRUM BOOK

Prentice-Hall, Inc., Englewood Cliffs, New Jersey 07632

Library of Congress Cataloging inn Publication Data

McArdle, Lois.
 Portrait drawing.

 (Art & Design Series)
 "A Spectrum Book."
 Bibliography:
 Includes index.
 1. Portrait drawing—Technique. I. Title II. Series.
 NC773.M36 1984 743'.42 83-26979
 ISBN 0-13-687509-2
 ISBN 0-13-687491-6 (pbk.)

THE ART & DESIGN SERIES
PORTRAIT DRAWING:
A Practical Guide for Today's Artists
Lois McArdle

This book is available at a special discount when ordered
in bulk quantities. Contact Prentice-Hall, Inc., General
Publishing Division, Special Sales, Englewood Cliffs, N.J. 07632.

© 1984 by Prentice-Hall, Inc., Englewood Cliffs, New Jersey 07632.

A SPECTRUM BOOK

10 9 8 7 6 5 4 3 2 1

Printed in the United States of America

Editorial/production supervison by Fred Dahl
Page layout by Marie Alexander
Manufacturing buyer: Ed Ellis
Cover art by Alice Neel. Reproduced with permission.
Courtesy the Graham Gallery, New York.

ISBN 0-13-687509-2

ISBN 0-13-687491-6 {PBK.}

PRENTICE-HALL INTERNATIONAL INC.,*London*
PRENTICE-HALL OF AUSTRALIA PTY. LIMITED, *Sydney*
PRENTICE-HALL OF CANADA INC., *Toronto*
PRENTICE-HALL OF INDIA PRIVATE, LIMITED, *New Delhi*
PRENTICE-HALL OF JAPAN, INC., *Tokyo*
PRENTICE-HALL OF SOUTHEAST ASIA PTE. LTD., *Singapore*
WHITEHALL BOOKS LIMITED, *Wellington, New Zealand*
EDITORA PRENTICE-HALL DO BRASIL LTDA., *Rio de Janeiro*

To my family

With special thanks to . . .

Prentice-Hall Editor, *Mary Kennan,* for her vision and patience.

Artist/teacher/authors *Clifford Chieffo* and *Nathan Goldstein,* for procedural suggestions and welcome encouragement.

Allan Fern, Director, and *Harold Pfister,* former Assistant Director of the National Portrait Gallery for advice and access to Gallery resources. The 1980 NPG exhibition, *American Portrait Drawing,* reinforced my belief that a centuries-old art form was still vital and influenced my decision to do ·this book.

My students, who showed me how pervasive the interest in drawing portraits is.

Phoebe Frances, who took my ideas and translated them into photographs that teach; *John Lanza,* who meticulously reviewed sections involving anatomy; *Ellen Frost,* who offered intelligent suggestions on content and organization; and *Linda Doremus,* who ably did most of the final typing.

My husband, *Jim Pettee,* who made suggestions, tolerated the interruptions in our routine, and otherwise supported my efforts; *Marguerite McArdle-Pettee,* who, at 8, was so grown-up about my "absences" in the study; and *Catherine McArdle-Pettee* whose imminent arrival was a spur to completion.

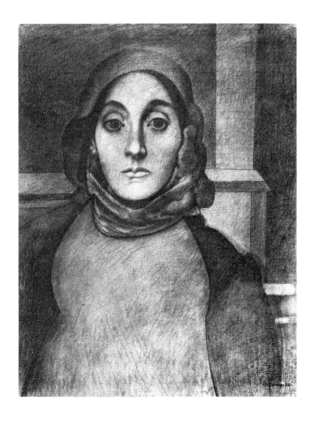

Contents

CHAPTER TWO

Basic materials 13

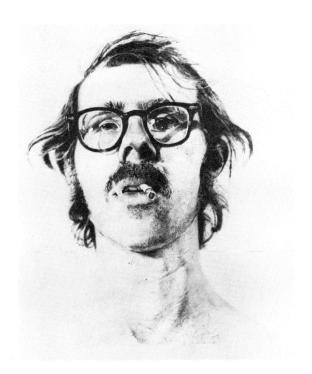

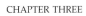

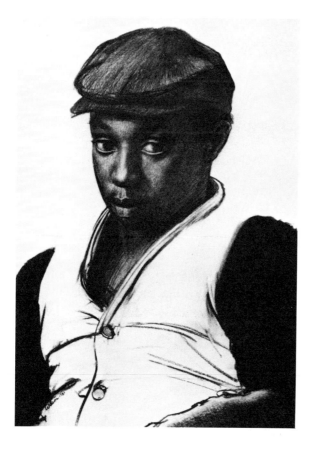

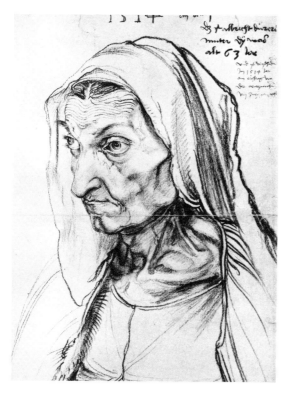

Preface

When I was a student, I felt frustrated when information I wanted on a subject was scattered or obtainable only with great difficulty. As a teacher, I find it satisfying to address a part of that frustration and bring a very broad range of information on portrait drawing together under one cover. The material is basic, yet intermediate and advanced students will find it of interest because it includes:

- a special focus on child growth and on the maturing adult face;
- an exploration of portrait caricature;

- for study (and sheer pleasure), "portfolio" sections, full-page reproductions of master drawings of children and elders and of master portrait caricatures;
- discussion of the impact of photography and its usefulness as a source of images for portrait drawings;
- a section on the costume, setting, and lighting of models.

In addition, there are fresh looks at drawing materials, techniques, and body structure. The carefully selected references following most

chapters are vital learning adjuncts that lead more deeply into many aspects of portraiture.

For teachers, this book has a well-defined, useful role as a classroom "guest" that can assist in imparting routine information and can also provide a stimulus for discussion.

Portraiture before 1830 existed largely because it was the only way to record a person's appearance. Photography deflected that purpose. Since then, portrait drawing has "ma-tured," evolving from an income producing activity to a tool for exploring artistic possibilities and for carrying those possibilities forward toward creative discovery. It is within this framework that *PORTRAIT DRAWING: A PRACTICAL GUIDE FOR TODAY'S ARTISTS* is presented.

Lois McArdle
Lincoln, Massachusetts

Acknowledgment

Grateful acknowledgment is made for permission to quote from these sources:

American Portrait Drawings by Marvin Sadik and Harold Francis Pfister. Copyright 1980 by the Smithsonian Institution. Used with permission of the Smithsonian Institution, the National Portrait Gallery. Pages 4, 5.

Art and Photography by Aaron Scharf. Copyright 1974 by Aaron Scharf. Reprinted by permission of Penguin Books Ltd. Pages 80–81.

Art and Visual Perception: A Psychology of the Creative Eye by Rudolph Arnheim. Copyright 1954, 1974 by the Regents of the University of California. Used with permission of the University of California Press. Page 39.

Artists, Authors, and Others: Drawings by David Levine. Introduction by Daniel P. Moynihan. Illustrations copyrighted 1976 by David Levine. Used with permission of the Smithsonian Institution, the Hirshhorn Museum and Sculpture Garden. Page 157.

Dynamics of Development by Dorothy V. Whipple, M.D. Copyright 1966 by McGraw-Hill Book Company. Used with permission of McGraw-Hill Book Company. Pages 111–112.

CHAPTER ONE

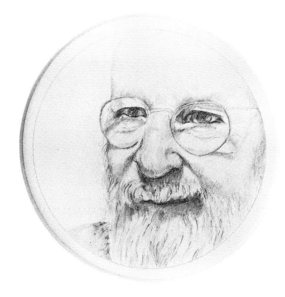

An introduction

TRADITIONAL REASONS FOR PORTRAITURE

What happened, in the dim beginnings of our history, when a person looked into a pool of water and saw a person looking back? Was the reflection recognized as a self-image, or was it seen as a spirit that inhabited the water? Was it frightening? Exhilarating? Simply puzzling? Of course, no one knows. But whatever the perception, the fascination with images of ourselves and with others of our humankind has persisted until this day. Why do we hang portraits on our walls when we can see living faces every day? Why does a powerful tradition of portraiture span the 5,000 years or so of recorded history?

Immortality

Part of the undeniable fascination of a portrait stems from the fact that—whether the image is drawn, painted, sculpted, or photographed—its presence on a wall, in a city square, or in a family album, gives the subject a presence long beyond the normal life span. In fact, ancient Egyptians came to believe that durable, three-dimensional images of people, such as the

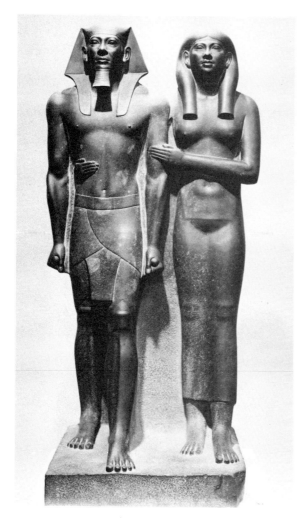

Figure 1-1.
Schist Pair Statue of Mycerinus and Queen Kha-merer-nebty II.
From Giza. 4th Dynasty. H.: .073 cm. H.: 54-½ in.
Harvard University and Museum of Fine Arts, Boston Expedition. Courtesy, Museum of Fine Arts, Boston.

double sculpture of Mycerinus and his Queen (Figure 1–1), served as homes for their spirits and insured immortality. This interaction between faith and the arts generated a magnificent portrait sculpture tradition.

Memorial and Illustration of History

Related to immortality is portraiture's potential as a memorial and as an illustration of history. A work that "remembers" a person or group in a public portrait is a memorial. Daniel Chester French's *Abraham Lincoln* in Washington, D.C. is a clear example. This Memorial also illustrates history in that it shows all viewers what that illustrious American looked like and what he typ-

ically wore. Some memorial works include a setting and thereby reveal something of the times in which they were made.

Power

Even while we live, a portrait image can multiply our presence and thus increase our sphere of influence. Before 300 B.C., coins of Greece bore the images of the gods. Then Alexander the Great put his own image on coins of the realm. By 185 B.C., *living* rulers regularly put their own profiles on these widely distributed objects, and each time a coin was used, the user was reminded of a human leader.

Through the ages, not just coins, but portraits of all kinds have been displayed and circulated to enhance power. Publicity agents in our time are well paid to exploit this function. They permeate our lives with images of the great and aspiring.

Genealogy

It is in its role as builder of visible genealogy that portraiture has yielded the greatest number of portrait *drawings*, especially those done specifically for sale or exhibition. The use of portraits as a way to present lineage, individual by individual, has roots to ancient Rome, where ancestral images were hung with lines connecting them—literally an illustrated family tree. The lines were later dropped, but the portraits assembled in rooms and hallways still told all who looked of the great and less great forbears.

Originally commissioned largely by the ruling class, portraiture slowly became more widespread and reached a popular peak in Europe from about 1675 to roughly 1850. The growth of industry distributed wealth far more broadly, and the portrait became popular with the burgeoning middle class. In fact, so great was the demand that in London in the mid-1750s one estimate was that 2,000 portraitists were at work. However, many of the newly rich still could not afford painted or sculpted likenesses, but they *could* afford finished drawings. So an even more unusual statistic emerges from Paris of 1790: that 2,000 pastellists *alone* were working there (including Maurice-Quentin de la Tour, whose self-portrait is seen in Figure 1–6).

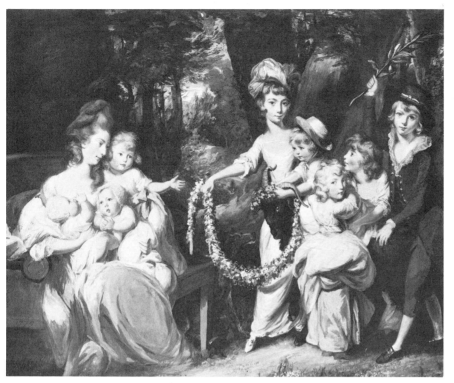

Figure 1-2.
DANIEL GARDNER (English, 1750-1805).
Mrs. Justinian Casamajor and Eight of Her Children (Bodycolor, pastel, and oil (?) on paper laud onto canvas).
Yale Center for British Art, New Haven: Paul Mellon Collection

Expressing Relationships

Also popular during the same period of 1675–1850 were group portraits. They were known as "conversation pieces" because they showed people together in everyday settings, suggesting relationships between them (Figure 1–2). Other portrait types also bespoke relationships: wedding and mother-and-child portraits as well as portraits of professionally related groups such as guilds.

The special relationship of romance led to the development of the single most popular form of presentation drawing of this period, the miniature (Figure 1–3). These tiny tokens of affection, worn in lockets or carried in small cases, were rapidly superceded after 1840 when photography more economically met the demand for tiny, greatly detailed images.

PHOTOGRAPHY— SUBSTITUTE OR STIMULUS?

Inexpensive. Realistic. Detailed. Colored, first by hand and later chemically. These words describe photographs which today make all of the

Figure 1-3.
SAMUEL COOPER (English, 1609-1672).
Charles Stuart, 3rd Duke of Richmond and 6th Duke of Lennox (Bodycolor on vellum laid onto card).
Yale Center for British Art, New Haven; Paul Mellon Collection.

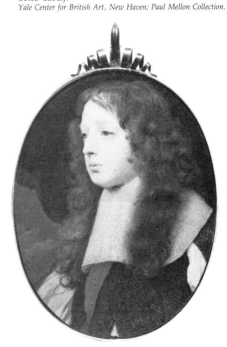

genealogy and relationship works inexpensively available to virtually everyone who would in earlier days have commissioned drawings. The single wedding portrait has become twenty or more professional shots of the wedding sequence. My father-in-law's ninetieth birthday is remembered by a professional photo of the 32 family members who were present, each of whom could have a copy.

Our family, like millions of others, also marks every birth or individual accomplishment, such as graduation, with our own lovingly taken, amateur photo portraits.

Of course, traditional portrait drawings and paintings are still made, and a number of artists support themselves today by doing them. Yet commissioning such works tends to be a conceit rather than the necessary way of recording one's image, and the artists who do primarily commissioned works are rarely those in the forefront of artistic development.

However, fascination with the human image is basic enough that it has enabled "great" portraiture to survive, though not in the traditional form of the commissioned portrait. Instead, as Harold Pfister says in *American Portrait Drawings*, it persists as "a self-renewing means of instruction and discovery." He goes on to say, "In many ways, drawing remains a superior arena for exposure and growth of the artist's imagination." The illustrations in this book testify to that continuity and growth.

Some of the illustrations also testify to the creative absorption of photography into the portrait process. Many significant artists have used photography with great benefit to their work. Ever since photos first appeared, some artists have used them to reduce the number of tedious sittings for their subjects. Then a few realized that the camera, in mechanically recording all it sees, freed art of the requirement of slavish likeness.

With this freedom, some artists began using distortion to give rein to emotional content. Skin became purple, hair green. Observed texture gave way to personal brush stroke. Shapes pushed in all directions. Picasso's self-portrait is an intersting example of how far an artist can go in personal use of expressive shape and still achieve likeness (Figure 7–7).

In contrast, in what at first might have seemed to be a return to slavish likeness, some artists moved into *photo realism*, an approach

that asserts the mechanical quality of its photographic source material. Chuck Close's self-portrait in Figure 3–7 is an example. And Jeri Metz's *Selma at 92* is even more assertively photorealistic (Figure 10–18).

Moving in yet another direction, which initially looked very radical but in retrospect seems quite logical, other artists began to incorporate actual photo images into their works, combining them with other media. Two of the most experimental artists of post-1950 America, Robert Rauschenberg and Andy Warhol, have either used photoportraits as elements in their work or based work entirely on them (Figures 1–4 and 1–5). By so doing, they achieved slavish likeness without slavish work. A younger artist, Robyn Wessner, enlarges the definition of likeness in her *photodrawings* (Figure 9–23).

Figure 1-4.
ROBERT RAUSCHENBERG (American, 1925-).
Detail of *Axle* (Silkscreen and oil).
Photo courtesy Leo Castelli Gallery, New York.

Figure 1-5.
ANDY WARHOL (American, 1928–).
Golda Meir from "Ten Portraits of Jews of the Twentieth Century" (Silkscreen).
Courtesy Ronald Feldman, New York, and Jonathan A Editions, Tel Aviv.

PORTRAIT DRAWINGS AS TOOLS FOR LEARNING

Repeating Harold Pfister's words, the portrait drawing process is "a self-renewing means of instruction and discovery." That short statement covers a lot of ground that is important to an artist—a two-fold educational process.

Portrait drawing teaches not only the solitary, personal lessons that flow from an artist's experience alone working to create an image. It also offers the interactive experience of working with live subjects and of showing work in progress to them (as well as to peers, friends, and teachers). The solitary lessons emerge from the work—fresh approaches to line, a willingness to take risks with the compositions, the dimension a certain color adds. The interactive lessons range from learning how to make the subject comfortable (see Chapter 7), to exploring what makes the subject unique, to finding out the way the person wishes to be portrayed . . . the self-image. The subject may also be a perceptive

critic who can offer useful insights into the technique, skill, and vision of the work.

In both the solitary and interactive modes, the artist takes in a great deal of information and must sort through and choose the useful bits.

Pfister also says in *American Portrait Drawings* that "portrait drawing might be considered as a slender—but sturdy—thread of continuity from generation to generation." As part of this continuity, every portrait drawing builds on the past and resembles earlier work in some way. The references listed at the end of this chapter help to acquaint you with the past. It is important to know where you come from as an artist and as a portraitist.

SPECIAL CHARACTERISTICS

You have been reading several pages about portraits, and yet they have not even been defined. Why have I gotten away with that? Only because I know you recognize a portrait when you

5

see one. When you see a drawing of a face that is not a portrait, you know it is not. You may think you cannot tell the difference, but you will see that you can.

Why? What accounts for your ability to differentiate? You know it is a drawing because the artist used drawing materials. But what makes it a portrait? *And* what—beyond technical excellence—makes it a portrait that attracts and holds your attention?

Likeness and Personal Insight

The answer is that faces in portrait drawings are likenesses of particular people, as in Figure 1–6. Features are imperfect and thus interesting. Character and life experience are captured for us to see, become involved in, and interpret.

The face in Figure 1–6, for example, reflects strengths and weaknesses that make up a person we know must have existed. Altogether, it is an entirely "human" face. When I first saw this drawing, I felt I would like to have known the person. I saw the face of a sensitive being— jaded perhaps, but still caring. Was he an actor? A musician? I felt the drawing had been done with an unusual amount of love and understanding. How compelling a portrait drawing can be! Even one of a person the viewer does not know. The work turned out to be not only a portrait, but a *self*-portrait by Maurice Quentin de la Tour, one of the greatest pastellists of the 1700s. The artist had the advantage of self-knowledge in creating the image, and that knowledge explains part of the drawing's power.

By contrast, the drawing in Figure 1–7, though equally skillful, is not a portrait. It is an emotionally one-dimensional image that is meant to represent a universal idea rather than a particular person. Michelangelo has given us a *Head of a Satyr*, a symbol for lust rather than a complex human being whose face reflects many traits, some good and some bad.

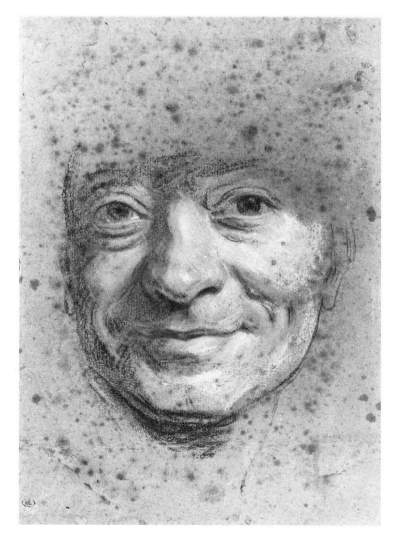

Figure 1-6.
MAURICE-QUENTIN DE LA TOUR (French, 1704-1788).
Self-Portrait (Black and red chalk heightened with white and pastel).
Cabinet des Dessins, Musseé de Louvre.

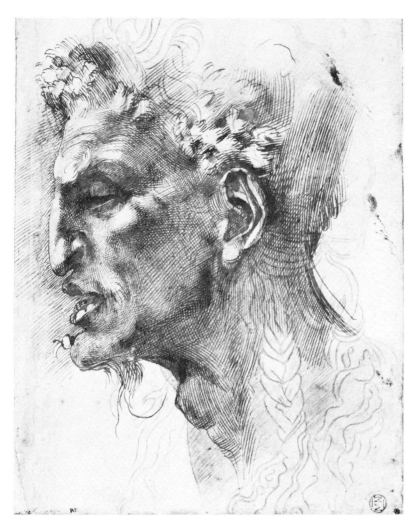

Figure 1-7.
MICHELANGELO BUONARROTI
(Italian, 1475-1564).
Head of a Satyr (Pen and ink).
Cabinet des Dessins, Musseé de Louvre.

Figure 1–8 presents several details from illustrations used later in this book. Keeping in mind what distinguishes portraits from symbols, decide which are portraits and which are not. If you have *any* doubts, they will be cleared up as you read through the book.

Universality

Portraits must be individual likenesses, but they are great only to the degree that they can reach out and involve us as human beings. Arshile Gorky understood that point, and the study of his mother, done in 1926, is deeply moving (Figure 1–9). There is such alienation in her dramatically beautiful young face. Her eyes look out at life, but they are focused somewhere else. We respond even without knowing that this poet-woman died in her 15-year-old son's arms, a victim of the Armenian genocide of the Turkish Empire. Her son speaks here for all people made into aliens by their own world. He, too,

always felt displaced. The experience is beyond understanding. Through his mother's staring eyes and immobility, he tells us not only of her experience but of his own as well.

A portrait need not be based on such devastating events to be universal. But it must present broadly understood feelings so as to elicit response from a broad range of people. De la Tour achieves this by revealing himself as a person that most people recognize—one who smiles at the world and its people, one who is just a little skeptical of everything. Of course, both Gorky's and de la Tour's portraits soar because neither artist gives us an emotionally one-dimensional face (as Michelangelo did in his *Head of a Satyr*). These are complete personalities, combining human characteristics we admire with those we don't: compassion, understanding, and love, woven together with alienation or oversophistication.

In my drawing of Jim Thorpe, I want you to see a friend the way I see him—a man who encounters the world with honesty, intelli-

Figure 1-8.
Left to right, top row: detail, Figure 11-20; detail, Figure 8-8; detail,
Figure 9-10. bottom row: Figure 4-1; Figure 7-4; detail, Figure 11-11.

gence, and loving kindness (Figure 1–10). Have I succeeded? You will decide by whether or not you are attracted to the drawing, by whether or not my message is universal enough to matter to you.

Individual Identification

Beyond the basic likeness and widely understood human qualities that are the common denominators of good portraits, the artist must address a couple of questions. Who is this person? What is his or her worldly role? The viewer wants to know.

In Figure 1–11, a woman wears clothes—rather plain, well made clothes—that tell us little except that she is of the very late 1800s or early 1900s. The figure alone with no context might be an unremarkable person of quite modest means. But the lightly drawn, densely furnished, opulent and somewhat untidy setting casually suggests wealth that the last name of the subject, Dupont, seems to confirm. And if the setting is her own and not one devised by the artist, interest is added to her stolid, awkward presence by the pile of papers on the table (did she write?), by what appears to be the back of a stretched canvas behind the screen (did she paint?), and by the contrast between the simple

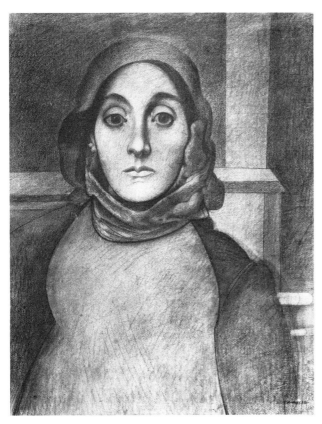

Figure 1-10.
LOIS MCARDLE (American, 1933-).
Jim Thorpe (Pencil).
Collection of the Artist.

Figure 1-9.
ARSHILE GORKY (American, 1904-1948).
The Artist's Mother (Charcoal).
Collection of The Art Institute of Chicago; Worcester Sketch Collection Fund.

Figure 1-11.
JEFFERSON DAVID CHALFANT
(American, 1856-1931).
Miss Mary Dupont (Pencil and crayon).
IBM Corporation, Armonk, New York.

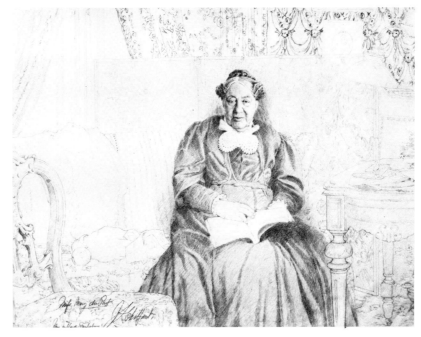

9

dress and the ornate patterning of the setting. Thus does Chalfant add setting-messages to his study of this figure.

A subject's features and posture communicate character, and they can also tell something of the subject's role. Here, an older woman sits submissively, more acted upon than acting. Her unbecoming hairstyle rests uneasily on her head like a too youthful hat. I see a woman who doesn't have a comfortable worldly role, a woman surprised by the artist as she reads, a woman who leads a private, withdrawn life.

A portraitist may tell very little or a great deal about the subject, for control of what is included lies with the person making the image. Chalfont's portrait of Mary Dupont cropped of its setting would be far more anonymous. What did Louis Berlin do each day (Figure 1–12)? Was he a businessman? How did he spend his leisure hours? The man's clothing suggests an adequate income, but there are no details about his interests or activities. In his self-portrait (Figure 1–6), de la Tour even omits a major physical detail—his hair (which, of course, allows a more intent focus on the expressiveness of the face).

Who is this person? the viewer asks. Artists must consider the question, but they are free to give as much or as little information as they wish.

Intimacy and Size

Until now, I have discussed characteristics peculiar to portraits. Intimacy, however, is a special characteristic primarily of portraits that are drawings, and it is a great part of their beguilement. It derives partly from small size. Drawings are generally done on paper, and the size of good paper is small compared to the size of most canvasses used for paintings. (Herbert Katzman's Portrait of John Bageris in Figure 8–3, at 96″ by 42″, and other giant drawings are obvious exceptions.)

We view small works of art from a distance of inches. We can hold them in our hands for close study. We feel intimately connected to a work encountered at such close range. This factor holds special import for portrait drawings. The feeling of person-to-person relationship is enhanced, and the emotional connection to the subject, whether loving or otherwise, is therefore stronger.

Intimacy and Spontaneity

An even greater contribution to the intimate quality of a great many drawings comes from their spontaneity. Though many drawings are done with meticulous care, more are done quickly, without special preparation or prior thought. They may be studies for finished drawings or for work in another medium, or they may simply be quick drawings done for no particular purpose. Their role doesn't matter, but how quickly the drawings are created does. They are akin to the notes a poet might make for personal reference. These quick drawings result from small bursts of activity, and they are unplanned, unguarded revelations of an artist's impulses.

Spontaneity in drawings is physically possible because of the materials available. Most drawing media—pencil, ink, various chalks—move easily and rapidly over the papers suited to them. And they are not bulky. Artists can take a sketch book plus pencil or ballpoint pen almost anywhere and rapidly record first impressions.

The intimate quality of drawings is evident when comparing the pencil study and the painting that Jean-August Dominiques Ingres did of Louis Berlin in 1832 (Figures 1–12 and 1–13). They are quite different.

Ingres is one of the greatest draftsmen of all time, on a par with Michelangelo and Picasso. We can therefore assume that the differences between these two works are entirely intentional.

The painting gives us a man of substance, of great mass and dignity, sitting decisively in a chair worthy of his bearing and bulk. His hands are poised in such a way that they erect a barrier between subject and viewer, keeping us all at a suitably respectful distance. The drawing, on the other hand, presents a world-weary man with barely enough energy to go on. The greater frontality of this pose (compare the routes of the vest buttons) and relaxed position of the hands make him seem more vulnerable. The drawing gives us Ingres' first impressions, his quick responses to what he saw, revealing to us an immensely human person. His painting is a contrast: it is a thoughtful and studied work, calculated to honor a client.

· · ·

In summary, portraits have immortalized,

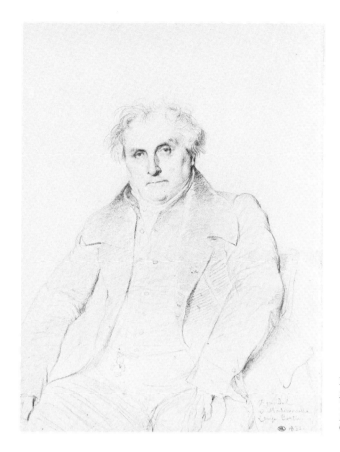

Figure 1-12.
JEAN-AUGUSTE DOMINIQUE INGRES (French,
1780-1867).
Louis Berlin (Pencil).
Cabinet des Dessins, Museé de Louvre.

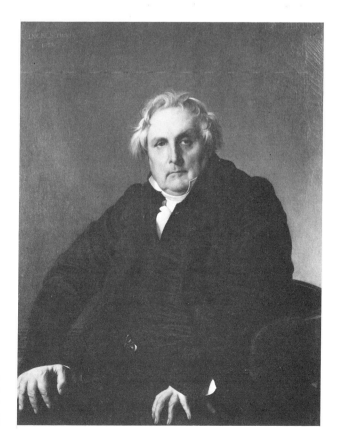

Figure 1-13.
JEAN-AUGUSTE DOMINIQUE INGRES (French,
1780-1867).
Louis Berlin (Oil).
Cabinet des Dessins, Museé de Louvre.

11

memorialized, and increased the power of individuals and have illustrated history. They have illustrated genealogy and expressed a variety of relationships. Today, portrait *drawings* provide artists with a means for refreshing and evolving their own images.

Great portraits, in addition to fulfilling a requirement for likeness, communicate universal human emotions. They may, if the artist wishes, tell about the subject's station in life and interests. The unique attribute of portraits that are drawings is usually intimacy, deriving from size, and spontaneity.

FURTHER STUDY

I do not know of a comprehensive, readily available history of portrait drawing. Each book listed for this chapter offers only a part of the portrait story. The first (see References section) includes drawing of all kinds. The second covers all Western portraiture, but only paintings. The next two deal exclusively with portrait drawings, and they give you a good understanding within limited time and geography frames. The fifth entry, though not devoted to drawings, provides a look at the work of a twentieth-century artist much concerned with portraiture that is mechanically produced. The final one is an excellent introduction to the influence of photography on art.

REFERENCES

1. MENDELOWITZ, DANIEL M. *Drawing.* Stanford: Stanford University Press, 1980.

2. WARNER, MALCOLM. *Portrait Painting.* Mayflower Books, 1979.

3. NOON, PATRICK J. *English Portrait Drawings and Miniatures.* New Haven: Yale Center for British Art, 1979.

4. SADIK, MARVIN AND HAROLD FRANCIS PFISTER. *American Portrait Drawings.* Washington, D.C.: The Smithsonian Institution Press, 1980.

5. ROSENBLUM, ROBERT. *Andy Warhol: Portraits of the '70s.* New York: Random House, Inc., in association with the Whitney Museum of American Art, 1979.

6. SCHARF, AARON. *Art and Photography.* England: Penguin Press, 1974.

CHAPTER TWO

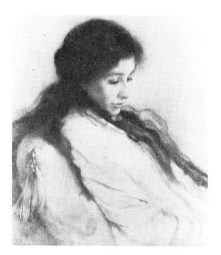

Basic materials

WHICH MATERIALS?

For a beginning or intermediate student, progress toward artistic maturity results from trying out a limited range of traditional materials—those used by artists for centuries and sold in similar forms today. There are two good reasons: (1) guidance is available in the form of books, teachers, and the works of masters: and (2) the materials can be trusted. (Today they are manufactured under quality controls, and their permanence or impermanence is a known factor.)

But which materials should be used first?

Even when the choice is limited to what is available in a well stocked artist's supply outlet, the possibilities are awesome. In addition to such familiar items such as graphite pencils (which alone are made by several different manufacturers in up to 17 hardnesses), and felt pens that dazzle the eye and the imagination with a variety of tip widths and angles and as many as 95 colors, there are old favorites (such as conté crayons) that turn up in new forms (conté pencils).

So the limitations of the marketplace still leave too many choices. Without trying materials out thoroughly, you cannot know the range

of ways in which particular items can be used, much less which ones will become your personal favorites. If you were to randomly (or even alphabetically) explore just half the choices, you would need a great deal of time. Even then, you would probably not hit upon the sequence of use best for learning purposes.

The information given here on drawing materials covers those surfaces, accessories, and media that are most widely used. The media are presented in order of difficulty. If you already have experience with some or all of them, so much the better. You will be able to concentrate more completely on such matters as structure, technique, and composition.

Specifically, the surfaces to be considered are:

1. newsprint,
2. bond paper,
3. drawing papers and boards, and
4. charcoal paper.

The markers are:

1. graphite pencils,
2. the friable (or crumbly) markers—conté, charcoal, and pastel, and
3. several pens and brushes for use with ink.

Because of their different characteristics, these materials will provide you with a broad spectrum of experience applicable in part to other markers and surfaces.

In addition, I will discuss drawing accessories and the workspace you should have. At the end of the chapter, you will find a checklist for use as you acquire necessities.

WHEN TRYING OUT NEW MATERIALS . . .

Before getting into specific materials, I would like to introduce a few guidelines for use.

One. Each material deserves a fair trial. You should explore its characteristics and limits in some depth. I have seen students initially frustrated by a given material that, after more use, become a great favorite. Give enough time to individual markers and surfaces to find out how each feels to you and how it can be used.

Two. If a particular marker and surface do not work well together for you, try other combinations.

Three. The way each drawing material looks changes greatly according to use. The potentials for expression are as varied as the individuals using the materials. Compare Figures 2–1 and 2–2. Both artists, using soft pencils and spontaneous, quick lines, achieved vastly different studies.

Four. Materials are not only the physical means for expressing an idea, they also influence the expression itself. The same subject has a different "presence" depending on the medium used. You get a sense of this if you look again at Figures 1–12 and 1–13, a pencil study and painting of the same person by the same artist.

Five. Versatility with materials can be a valuable asset, but it is by no means essential. Many artists of the past have demonstrated that one or two congenial media can be enough to develop style and to express the ideas of a lifetime.

DRAWING SURFACES

A wide variety of drawing papers is available to the artist. Most are made of wood pulp, rag, or a combination of the two. All wood pulp papers contain acid, which causes discoloration and brittleness over time. Rag paper, in contrast, is durable, and it does not discolor unless harmed by an outside agent such as moisture. Rag is therefore desirable for drawings you want to last for many years.

Newsprint

Low-grade pulp paper, usually a rather attractive off-white, makes good sense when doing a lot of rapid drawings because it is cheap, and therefore less intimidating. Newsprint, one of the most readily available low grade papers, comes in either a rough or smooth surface. The rough finish is particularly receptive to soft pencils and charcoal. While both rough and smooth newsprint take felt pen and brush and ink, ink may "bleed through" from one page to another.

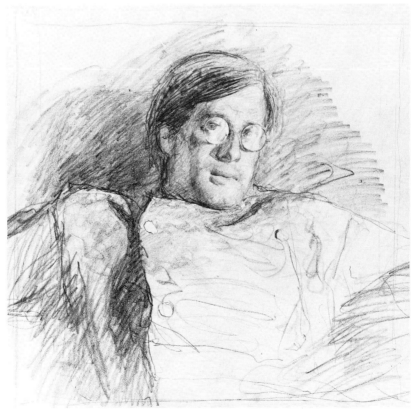

Figure 2-1.
JACK BEAL (American, 1931-).
Self-Portrait (Pencil).
Collection of The Art Institute of Chicago; Gift of
Mr. and Mrs. Douglas Kenyon.

Figure 2-2.
JAMES WYETH (American,
1946-).
Study for Portrait of Jeffrey
(Pencil).
Mr. and Mrs. James Wyeth.

15

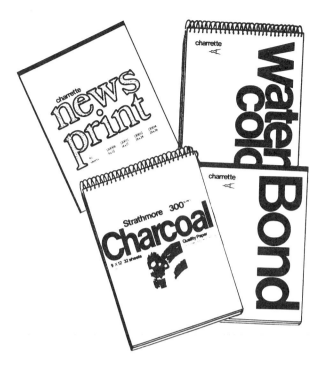

Figure 2-3.
Pads of Drawing Paper.
Courtesy Charrette Corp., Inc.

One solution to this problem is to tear sheets out of the pad and draw with them on a different, nonabsorbent surface.

Special Wet Media Papers

For felt tip markers, a special white marker paper allows heavy coverage without bleeding. It may be available in your area only from large commercial art supply outlets. For brush and ink, watercolor papers are fine, as are oriental rice papers made specifically for the purpose. But these are expensive, and, while you are getting acquainted with this medium, newsprint is the most sensible choice.

Charcoal Paper

Papers especially made for charcoal and related media are distinguished by their roughness or "tooth." Strathmore charcoal paper, a rag paper, is not only good for friable media, but it offers a choice of ten colors. It has a surface tough enough to withstand a good deal of blending and erasing. It is also relatively inexpensive.

Bond Paper

Another surface, bond paper, is also relatively inexpensive, and it is useful when white paper is desired for making a lot of pencil or ink drawings. Its smooth surface is not well-suited to charcoal.

The chart in Figure 2–4 tells you at a glance the papers and markers that are compatible.

All-Purpose Papers

The several brands of "all-purpose" drawing papers on the market are usually made with some amount of pulp content. These papers are advertised as yielding good results with a broad range of media. I frankly feel it is better to buy several papers more suited to specific media than to rely on just one that has a little tooth for charcoal, a little ruggedness for pencil, a little absorbency for wet media—but not an optimum amount of anything for any medium in particular.

Drawing Board

If, for the sake of durability, you wish to work on a stiff surface, inquire about bristol board,

Figure 2-4.
Paper-Marker compatibility.

Markers	Papers					
	Newsprint Rough ——— Smooth	Bond	Marker Paper	Toothed Papers	Boards	
Pencil	X		X		X	X
Conté/Charcoal/Pastel	X				X	some
Felt Tip Pen	OK but bleeds		X	X		X
Pen & Ink		X	X			some
Brush & Ink	X	X	X		X	X

drawing board, or illustration board. Boards offer an assortment of usually high-quality surfaces similar to the papers available.

Weights

Paper is often partially identified by weight, a number that refers to the weight of 500 sheets (a ream) of the paper. The heavier the weight, the sturdier the paper. Thus, 300-pound watercolor paper is almost like cardboard since 500 22″×30″ sheets weigh 300 pounds.

You will have to experiment with papers to find out what suits you. From time to time, browse through an art supply store to see what they have both in pads and in single sheets. Try something you have never used before. Try different media on it. See how it responds to a variety of uses.

ACCESSORIES

Erasers

You are already familiar with the erasers on the heads of most pencils, which are actually *pink pearl erasers,* though not always of the best quality. Block-shaped or cylindrical (peelable pencil-type) pink pearl erasers are best for removing pencil lines from most papers (Figure 2–5).

No eraser is satisfactory for a paper with a glazed or shiny surface, since the erased area always has a rubbed or dulled appearance. And some caution is necessary with all papers, for erasing may disturb the surface fibers and mar the work.

On any paper where you wish to avoid smudging nearby marks, use a *kneaded eraser* (Figure 2–6). It can be pressed or dabbed on a surface to "erase" by picking up loose particles of graphite, chalk, or charcoal. A kneaded eraser can also be rubbed on a surface like a pink pearl eraser. And it can be formed into many shapes, including points, for erasing pinpoint areas. When it becomes soiled from use, knead it, and a fresh surface appears for use.

When working on glazed papers, an eraser that crumbles easily—an *art gum eraser*—works best, although it may still affect the surface gloss (Figure 2–7).

If you wish to erase a small area without marring an adjacent area, an *erasing shield,* with its small openings of various shapes, can be a great help (Figure 2–8).

Whenever an eraser has been used, or if a drawing has been sitting untouched collecting dust, it should be cleaned gently with a *drafting brush* with extremely soft bristles (Figure 2–9). If the work is too fragile for even such a soft brush, blow away the erasings or dust. Any time more work is to be done on a drawing, even the smallest alien particle on its surface can cause unwanted streaks or spots. This problem can be avoided by covering drawings between work sessions with tracing paper.

Figure 2-5.
Block and pencil-type Pink Pearl Erasers.
Courtesy Charrette Corp., Inc.

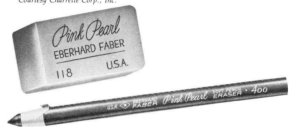

Figure 2-6.
Kneaded Eraser (below left).
Courtesy Charrette Corp., Inc.

Figure 2-7.
Art Gum Eraser (above).
Courtesy Charrette Corp., Inc.

Figure 2-8.
Erasing Shield.
Courtesy Charrette Corp., Inc.

Figure 2-9.
Drafting Brush.
Courtesy Charrette Corp., Inc. Drawing by Johanna Bohoy.

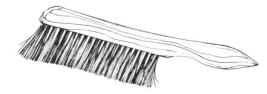

Blending Tools

Blending tools are used when separate marks made with dry media such as pencil, conté, or charcoal need to be made less distinct. Fingers, the original blending tools, are certainly useful—they are always at hand and come in different sizes. The only problem is that the trace of skin oil may leave a different-looking spot within the blended area. *Stomps*, or *tortillons*, are made of soft rolled paper with points at one or both ends, and they come in several diameters (Figure 2–10). They blend cleanly, and they can be used gently for a little blending or more vigorously for very thorough blending. A *chamois*, which is a soft piece of sheep, deer, or goat skin, functions a little like a dust cloth in that it can lift loose particles from a drawing in broad swipes (Figure 2–10). It can be used further for general blending and wrapped around fingers or other tools for blending smaller, more defined areas.

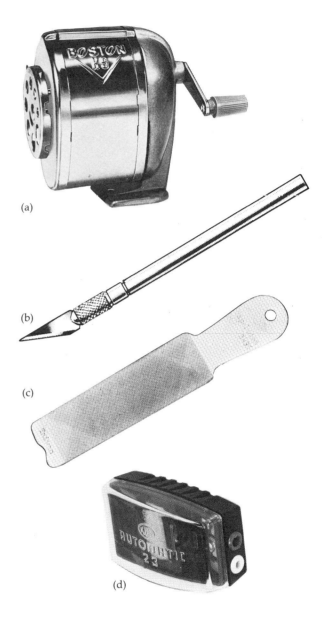
(a)

(b)

(c)

(d)

Figure 2-10.
Chamois and Stomps (or tortillons).
Courtesy Charrette Corp., Inc. Drawing by Johanna Bohoy.

Sharpeners

Everyone who draws should have a *wall- or table-mounted pencil sharpener (Figure 2–11a)*. Be aware, however, that these sharpeners are not gentle. Leads often break, and wood casings may be unevenly removed. Therefore, many artists prefer a sharp *X-Acto knife* (Figure 2–11b). It provides the greatest amount of control over the sharpening process, and the resulting blunt point can be refined with a *steel pencil pointer*, or file (Figure 2–11c). It is also useful to have a *pocket sharpener* for working outside your studio (Figure 2–11d). For charcoal pointing, a *sandpaper block* is recommended (Figure 2–11e).

(e)

Figure 2-11.
(a) Wall Pencil Sharpener. (b) X-Acto Knife. (c) Steel Pencil Pointer. (d) Pocket Sharpener. (e) Sandpaper Block.
Courtesy Charrette Corp., Inc.

Figure 2-12.
Fixative.
Courtesy Charrette Corp., Inc.

Fixative

A *fixative* is a coating sprayed on a work to protect the surface from smudging and dirt. I have always resisted its use because it alters slightly the appearance of the drawing. However, drawings done in dry media are vulnerable to smudging unless framed immediately. So, as a practical measure, any finished drawing to be stored in a portfolio or drawer should be lightly fixed with a crystal clear acrylic spray (Figure 2–12). Follow the directions carefully, and spray lightly. You can apply more fixative if the drawing is not sufficiently protected to suit you, but you cannot reverse the process. If you put too much on, the surface can become shiny, the graphite can blur, or the fixative can blot or run.

Figure 2-13.
Assortment of Pencils.
Courtesy Charrette Corp., Inc. Drawing by Johanna Bohoy.

MARK MAKERS

Graphite or "Lead" Pencils

Artists used metal styluses for centuries until, about 1790, the pencil as we know it was devised. Probably because lead was the most popular metal for the stylus, the new instrument acquired the misnomer of "lead" pencil. It was then, and still is, a thin, fragile rod of graphite mixed with clay or carbon, which is protected by wood or today sometimes by a mechanical holder.

As many as 17 variations in hardness of graphite pencil are available:

> H through 9H for hard pencils
> B through 6B for soft pencils
> F and HB, intermediate designations for pencils not as hard as H and not as soft as B

As the hard pencils go up their numerical scale from H through 9H, their mark stays silvery but gets gradually lighter and lighter. The two intermediate hardnesses, F and HB, provide a transition between the silver of the H's and the darkness of the B's, seeming to combine both and therefore usable with either. The B's get gradually softer, grainier, and darker as they go to 6B, and are a rich black. It's complicated. Perhaps the diagram on the next page will help.

Generally speaking, it is difficult to make very hard and very soft pencils work effectively in the same drawing, but a range from, say, 4H to HB, with a 2B pencil used for dark accents, is quite manageable.

As pencils get softer, they make marks on a surface more easily. This quality generates soft-pencil drawings that are complete statements, yet they seem to be, and usually are, quickly, economically, and spontaneously rendered. Compare Figures 2–1 and 2–14. Figure 2–1, done with a soft pencil, appears to be rapidly done to catch a fleeting expression. By contrast, Figure 2–14, done in hard pencil, which makes lighter marks and makes them less easily, seems carefully planned, carefully and slowly rendered, with more attention to detail.

Both are beautiful works done by experienced, sensitive artists. Do not be intimidated by them as you begin working with pencil. You will make rapid progress as you learn about the medium and about your special capabilities.

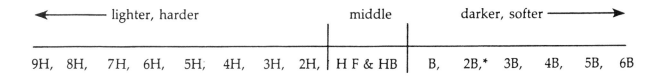

← lighter, harder								middle		darker, softer →					
9H,	8H,	7H,	6H,	5H,	4H,	3H,	2H,	H F & HB	B,	2B,*	3B,	4B,	5B,	6B	

*common school and household pencil

Some artist/teachers believe that the early use of pencils for such controlled processes as writing creates barriers to using pencils freely as drawing instruments. Yet familiarity is also an asset. Most people are already aware that some pencils are "soft" and make a darker line than others, which are "hard." In addition, people who use pencils freely to draw and doodle discover a variety of pencil effects. If a persons's work *is* too controlled, holding a pencil in a different way encourages freedom (Figure 2–15). Also, it is *desirable* to know how to use a medium in a very controlled way; few people fail to marvel at the beauty of meticulous pencil work (look again at Figure 2–14). A given artist may prefer more spontaneity, but control does not automatically squelch responsiveness or limit aesthetic quality.

Some teachers also feel the erasability of pencil can hinder development. In the beginning, going over marks is better than correcting them, because the learning process is more important than producing finished drawings. Anyone who understands this point should cooperate in using pencils that way. At the same time, pencil makes marks that can be changed quite easily, making the medium less intimidating. Like familiarity, erasability can be an asset.

The pluses of familiarity and erasability make pencil the best first drawing instrument. The following "practicals" will reintroduce you to the pencil.

Practicals for Pencil

MATERIALS. *You need at least five pencils (4H, 2H, HB, 2B, and 4B), a pink pearl eraser, and 18"×24" bond paper.*

1. Take each pencil in turn and experiment. Don't draw realistically. Simply make marks. On bond paper, try different pressures to see how light *and dark each pencil's marks can be. Do this until you feel familiar with the dark and light potential of all these pencils. Then use the pink pearl eraser. Some marks erase more completely than others. What makes the difference? Are the surface fibers of the paper disturbed when you erase? What happens when you make fresh marks in an erased area? The eraser is a drawing tool as much as any other, so you need to be fully familiar with it, and you need to assess its limits.*

Try making 4B marks over 4H marks. What happens? Continue working in this exploratory way until you feel acquainted with the variety of marks possible with each pencil. Try other papers. How do the results differ? Do you like some pencils better than others? One paper better than another? Why? Stand back from what you have done, and see how distance affects the look of the various marks.

2. With each pencil, hold it first as if you were going to write and then in the ways shown in Figure 2–15. Make marks with it. Try slow, careful marks and then quick, vigorous marks. Note in Figure 2–15 which hand position is best for which types of marks. Put a sheet of paper on a vertical drawing surface (a wall is good), and make very free marks. Hold your hand as shown in Figure 2–15, positions 2, 3, and 4, and swing your arm from your elbow and shoulder. Try sweeping marks that need the full length and breadth of the paper. Notice how these marks look different from the earlier, more controlled marks. Again, stand away to see how distance alters appearance.

Special note: I like working with leads in mechanical holders because it eliminates pencil sharpening, and the lead always has about the same point. A drawback is that the line width has less potential variation. If possible, try some HB leads in a holder to see if the holder makes any great difference to you. If it does, you should have a separate holder for each hardness of lead you use.

3. Find someone willing to pose for you for one hour. (Divide the hour into three twenty-minute poses to give your model a chance to relax.) Make the

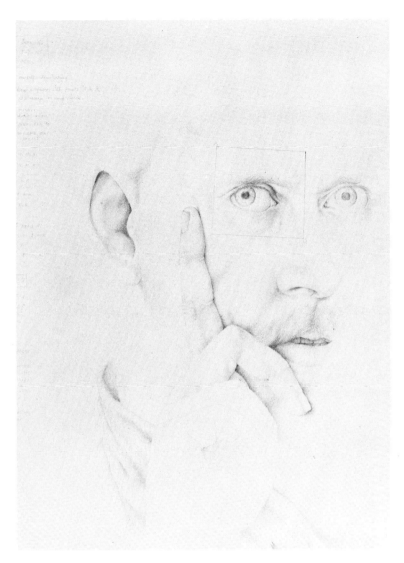

Figure 2-14.
JOHN WILDE (American, 1919-).
*Myself: Illustrating How a Square, with
Points A & H Is Always in My Vision*
(Pencil).
*Collection of Whitney Museum of American Art, New
York.*

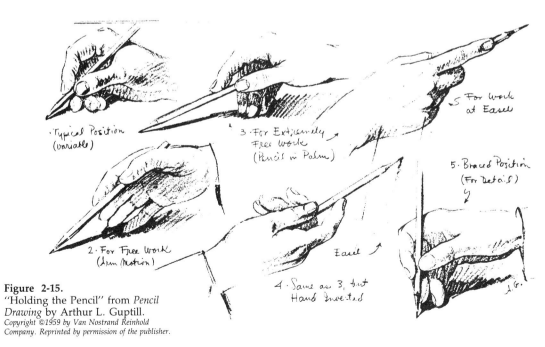

Figure 2-15.
"Holding the Pencil" from *Pencil
Drawing* by Arthur L. Guptill.
*Copyright ©1959 by Van Nostrand Reinhold
Company. Reprinted by permission of the publisher.*

person very comfortable. Have good lighting, prefera-
bly coming from one side or the other of the model. Sit
no more than six feet away. Then on 18"×24" bond
paper, do a one-hour pencil drawing of the head and
shoulders. Do the best you can. Use the entire hour.
The drawing you make serves as an excellent sample
of where you are now in terms of your portrait skills.
Be sure to keep this drawing, *because it is a basis of*
comparison. You will be pleased in the coming
months when you look at it and realize how much
your knowledge and skill have grown.

Conté Crayon and Charcoal

Conté crayon and charcoal are both not only
dry media, as pencil is, but they are *friable*
(crumbly), meaning that the particles they are
made of do not stick to each other or to surfaces
very well. As a result, their marks have a granu-
lar quality, and the best drawing surfaces for
them have tooth, or roughness, that holds
particles in place.

The friability of these media is controlled
by the amount of binder (wax, oil, or gum)
added: the more binder, the better the medium
adheres—and the less erasable it is.

Conté crayon is made in square sticks 2½"
long that are soft, medium, or hard (Figure
2–16). They come in black and white, as well as
in sanguine (brick red) and bistre (brown). The
stick contains enough oily binder to allow it to
adhere quite well, although the soft and me-
dium sticks smudge easily.

Figure 2-16.
Conté Stick.
Courtesy Charrette Corp., Inc.

Conté is suited for drawings that are
quick and fresh-looking, as well as for drawings
that are sustained and careful. Its square shape
allows sharp, crisp lines made with the corners,
very broad soft marks with the sides, and in-
between lines with the ends. Its granular but
fine texture lends itself to the creation of fin-
ished drawings with a wide value range. It has
enough binder to adhere, yet is friable enough
to allow smooth transitions from dark to light.
Its versatility in value range and types of marks
is seen clearly in Edward Hopper's self-portrait,
Figure 2–17.

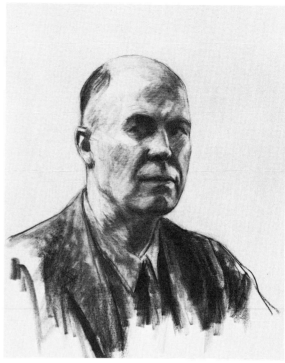

Figure 2-17.
EDWARD HOPPER (American, 1883-1967).
Self-Portrait (Conté crayon).
Collection of Whitney Museum of American Art, New York; Bequest of Josephine N. Hopper.

Conté crayon also comes in pencils,
which keep hands cleaner and are especially
maneuverable (Figure 2–18). But they lack the
mark making range of sticks because only the
points can be used to make marks.

Figure 2-18.
Conté Pencil.
Courtesy Charrette Corp., Inc.

Charcoal is available in compressed form,
in sticks, and in pencils, which have the same
advantages and drawbacks as Conté pencils.

Compressed charcoal comes in sticks 4" long
that look like enlarged versions of Conté sticks.
Made of ground charcoal, it is more friable than
Conté, even though it contains some binder. It
adheres quite well to surfaces with some tooth,
and it moves smoothly, covering large areas
quickly. Like Conté, it can produce a broad var-
iation in line quality, because it too has corners,
sides, and points for making marks. It is also ca-
pable of a great range of values, including a rich

black (Figure 2–19). All charcoal comes only in black, and compressed charcoal comes in five grades: extra soft, very soft, soft, medium soft, and medium.

The characteristics of compressed charcoal make it a more manageable medium for beginners than *stick charcoal,* which is made by burning slim sticks of beech, bass, or willow until everything but carbon oxydizes. Sticks about 6″ long remain (Figure 2–20). Sold with no binder added, they are the most friable charcoal medium.

Figure 2-20.
Vine Charcoal Stick.
Courtesy Charrette Corp., Inc.

The finest type of stick charcoal is vine charcoal made in very thin even textured sticks. It is manufactured in four hardnesses: very soft, soft, medium, and hard. Vine charcoal is not as flexible a medium as Conté or compressed charcoal, nor is it as easily controlled. It is thin and breakable, and, having no binder, it adheres to surfaces reluctantly. Creating deeply dark areas is all but impossible. It will not work well on smooth papers. It must have tooth to make satisfactory marks. However, it is good for quick, loose sketches on rough newsprint or charcoal paper, and its erasability can be an asset, though accidental smearing is frustrating and common. If you want to keep a vine charcoal drawing, it must be sprayed with fixative immediately.

Practicals for Conté Crayon and Charcoal

MATERIALS FOR CONTÉ. *Conté markets a drawing set that includes 14 assorted Conté crayons and pencils, plus kneaded erasers and a couple of tortillons (Figure 2–21). This array of materials is a more than adequate beginning at about half the per-item price. If you do not buy a set, the minimum materials needed are one each of:*

- *black, sanguine, and bistre stick Conté in assorted hardnesses*
- *sanguine pencil, medium*
- *½″ and ¼″ tortillon*
- *kneaded eraser*

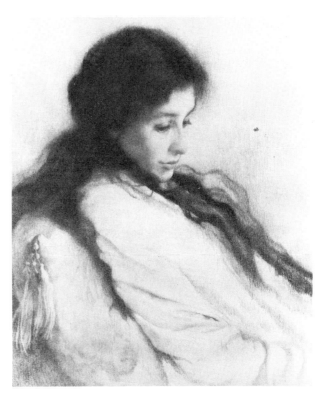

Figure 2-19.
LILIAN WESTCOTT HALE (American, 1881-1963).
Reverie: Portrait of Agnes Ruddy (Charcoal).
Private Collection.

With or without the set, you also need a sandpaper block, a chamois, and rough newsprint.

1. Using rough newsprint, work as you first did with pencil—that is, without drawing things that are recognizable. This is the time for using Conté to search out its individual characteristics. Use the corners to make thin lines. Break the stick, and use the broken edges to make even finer lines. Use the end to make various thicker lines that change as the slant of the stick changes in relation to the paper. Sharpen the end in various ways on the sandpaper block so that you can discover how to make points and different flat angles. Use the long side to make very wide strokes. Using all the hardnesses, notice how granularity dif-

Figure 2-21.
Conté Crayon Drawing Set.
Courtesy Charrette Corp., Inc. Drawinng by Johanna Bohoy.

23

fers. Make marks on top of each other to see how it affects not only the granularity but density and value as well. Try blending with your fingers, with tortillons, and with chamois. Notice how the blending differs depending on the tool used, the hardness of the Conté, and the vigor of your blending. Combine colors with black and observe the effects.

2. Now, with the same Conté crayons, try making textures. Make groups of dots, squiggles, thin and thick parallel lines. Each area of marks presents an illusion of a different surface texture. Experiment further. For example, make texture rubbings by placing your paper over a variety of surfaces such as coarse cement, tree bark, and lace, and rub conté on the paper.

3. Now try Conté pencil. See how fine and how broad the strokes can be made. Use them to make closely grouped lines that create a sense of darkness. See how you can make that darkness lighter or darker by making the lines lighter or darker and/or by putting the lines closer together or farther apart. Sharpen the pencil, and see how many fine lines you can make before you need to sharpen again.

If you prefer pencils to keep your hands cleaner, be sure that you do turn to sticks when their unique broad marks are needed.

Also, as with the sticks, be sure to try the tortillons, the chamois, and your fingers to blend, both gently and vigorously.

4. Find out to what degree the kneaded eraser can erase marks made both with sticks and with pencils. Observe how the amount removed varies with the amount applied and with the hardness of the Conté. Experiment with erasing lighter areas within dark areas.

5. At this point, you should try Conté on your other papers to see how different surfaces create visual differences.

MATERIALS FOR COMPRESSED CHARCOAL. *One stick each of the hardnesses of compressed charcoal, a chamois, a kneaded eraser, and rough newsprint. Optional: a charcoal pencil.*

1. Work with all the sticks of compressed charcoal as in practicals 1, 2, and 4 for Conté crayon. (If you chose to get a charcoal pencil, refer to Conté Practical 3.) Your objective is to become acquainted and comfortable with this medium too. As you work, notice how its marks differ from those of Conté, as well as how much more dramatic compressed charcoal can be due to the ease with which large, dark areas can be made.

2. Try out the chamois, making broad swipes with it. Also make more controlled erasures by wrapping the chamois around a finger and dragging it across the surface.

3. As with Conté, try the compressed charcoal on other papers and notice how it is affected by them.

MATERIALS FOR STICK CHARCOAL. *One or two sticks of each hardness of vine charcoal, rough newsprint, a kneaded eraser, and a chamois.*

1. Take some rough newsprint and try out each harness of vine. See how dark and light you can make marks with it, as well as how broad and how thin. What happens when you use it on its side? Use the kneaded eraser and chamois. Use the tortillons. Blend. In all these processes, how does vine compare with Conté and compressed charcoal?

Pastels

Color is the signal difference between pastel and the other friable media.

Pastels, typically of high quality, are made of dry chalk with very permanent pigments. The most beautiful are the French pastels, made with an aqueous (watery) binder that yields a very soft, or friable medium. They are round and come in some 200 colors (Figure 2–22a). They are also expensive and difficult to use because they don't adhere well. However, with practice they create very beautiful effects.

Semisoft pastels have oil added to make them adhere more readily. They are shaped like compressed charcoal, and they have the same advantages (Figure 2–22b). Hard pastels are also available. Both are less erasable than French pastels and come in a more limited but adequate range of colors.

Pastels also come in pencil form in 60 or more colors. They share the advantages and disadvantages of Conté pencils.

Pastels and pastel pencils can be bought both individually and in sets of as few as a dozen or fifteen hues. So trying them out does not require a major investment.

Drawings made with French pastels have held their color freshness over the centuries, and many are extremely beautiful. The medium has been used freely (see Figure 1–6) or meticulously (as in Figure 1–2) with equally fine results. Pastels are versatile and colorful, and

Figure 2-22.
a) French Pastels. (b) Semi-soft Pastels.
Courtesy Charrette Corp., Inc. Drawing by Johanna Bohoy.

yet they are not popular today. I encourage you to give them a very fair tryout. You may discover their special beauty.

Practicals for Pastels

MATERIALS. *A small set of pastels and Strathmore charcoal paper in several colors.*

1. The exercises for Conté and charcoal apply to pastel, and the problems described under "Color" in Chapter 3 are also designed for pastels.

2. In addition, if you have a museum nearby (or even a library with a good section of books on art), look for pastels by Degas, Chardin, Cassatt, Maurice-Quentin de la Tour, Manet, and Perronneau. Study intently what each artist did with color and how they achieved their effects. Be aware that it is possible to use fixative on a pastel and work over it, thus creating layers of color without mixing and muddying some of them. Be sure to try this technique.

Pen and Ink

Drawings done with pen and ink have a positive quality, a clarity, that stems from the clear edges of an ink line and its high contrast against light paper. Part of the positive quality of such drawings may also result from the sureness with which they are done (erasing is difficult). The chief drawback of pen used with ink is the limited range of possible tones or values. The lightness or darkness of a given area can be varied only by the distance between the marks, and it is difficult to create more than about five distinctly different values in this way.

Given those characteristics, pen and ink still yield drawings that are remarkably different from each other in terms of emotional content. Compare, for example, Figures 1–7 and the cover drawing. This variety results in part from the great range of available pens. Today, the least expensive and most widely used pens are ballpoint and felt tip. Both types are good drawing instruments, as long as the ink is permanent and does not fade with time or sunshine. They are the types of pens recommended for the Practicals, because they are familiar. However, you should be aware of other types of pens. At a later point in your development, I recommend trying them in tandem with study of the reference in ink drawing.

BAMBOO

Descendents of the ancient reed pens, bamboo pens come from the Orient. These pens, including their points, are single, continuous pieces of bamboo with no inkholding chambers, and their marks are therefore relatively short and blunt (Figure 6–18).

PENS WITH STEEL NIBS

Pens into which nibs can be inserted are more versatile and more easily controlled than bamboo pens. The points range from very fine (Figure 2–23a), through round or straight, to angular. The angular nibs of lettering pens (Figure 2–23b) come in widths of up to ½" (The angular nibs are also available in a lefthanded version.) The holders for steel pen nibs are not equipped with inkholding chambers, and the nibs must be dipped in ink frequently.

Speedball markets an inexpensive set of nine assorted Hunt and Speedball points and two holders. I recommend it when you are ready to try steel pens.

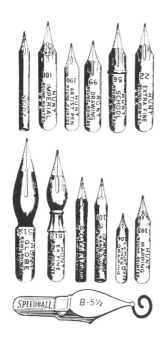

Figure 2-23.
(a) Steel Pen Points. (b) Speedball
Lettering Pen Point.
Courtesy Charrette Corp., Inc.

**AUTOMATIC STEEL
DRAWING PEN (FOUNTAIN
PEN)**

These pens have a cartridge that holds
enough ink to allow for extended dip-free draw-
ing. They come in two nib types. One is the
fountain pen with a straight nib available in
widths from fine to about ¼". The second type,
the technical pen, does not have a traditional
point but is fitted with a tube tip that releases a
steady, even flow of ink. The tube tip varies in
width from fine to ⅛" in diameter. Technical
pens are comparatively expensive and difficult
to maintain, but they are excellent for line uni-
formity and for making repeated dots of the
same size (stippling).

Figure 2-24.
Automatic Steel Drawing Pen (fountain pen).
Courtesy Charrette Corp., Inc.

Figure 2-25.
Technical Pen.
Courtesy Charrette Corp., Inc. Drawing by Johanna Bohoy.

Practicals for Pen

General note: *Do not be intimidated by ink. Every-
one who has ever used it has had to contend with its
indelibility. It helps to work slowly and thoughtfully.
Economy of line may also help—it is easier to add
than to subtract.*

MATERIALS. *You need a black ballpoint pen, felt pens
(black or brown), one in a fine tip and one in a me-
dium tip, and bond paper (18"×24"). If you find
bleed-through a problem, remove sheets from the pad
and work on another, nonabsorbent surface.*

*1. Experiment with each pen on a sheet of bond.
Get acquainted with the kinds of free-wheeling marks
each instrument can make. Try curves, circles, and
the like. As you work, let your arm move from the el-
bow and the shoulder to achieve full scope and free-
dom of movement.*

*2. On another sheet of bond, outline in pencil
several 2" squares. Using each pen in turn, fill the
squares with parallel lines, carefully drawn and
evenly spaced about 1/16" to ⅛" apart. Make one
square of vertical lines, one of horizontal, one of diag-
onal upper left to lower right, and one upper right to
lower left.*

*For this very controlled work, the heel of your
hand should rest on the table. Consequently, your
hand moves from the wrist only.*

*3. With one of the pens, make five 2" squares.
Choose one of the line directions you tried in Practical
2, and use it in all five squares. In the first box, place
the lines as close together as you can without letting
them touch, so that you create a very dark tone. Your
objective is to make each of the remaining four squares
look progressively lighter, so in each square the lines
are a little farther apart than in the last one. Try to
make the different values in five even steps.*

*Note that the lines in the boxes not only create
areas of value, they describe the flatness of the surface.
As lines creating value, they are traditionally called
hatching. When they describe a surface, they are
called structural lines. They are usually both, as in
this Practical and Figure 2–15 where the hatching not
only denotes shadow but also follows the surface
planes and helps to communicate the structure of the
hands.*

*4. If you take the lines you made in Practical 3,
and go over them in another direction, you have
cross-hatching. In Figure 1–7, Michelangelo used
cross-hatching extensively. You can see from the na-
ture of the lines that it is a rapidly worked piece. With
practice, you will be able to add this technique to your
own quick drawing "vocabulary." Make additional
squares of cross-hatching using curved lines. Notice*

how the structure of the surface changes from flat to curved when you do so.

5. Many pen drawings are done over a preliminary pencil drawing. Make, or trace, a little sketch and go over it in felt pen. When it is completely dry, erase the visible pencil lines with an art gum eraser. You may wish to leave a few or all of the pencil lines—they can be an attractive element in a drawing. This ink-over-pencil drawing gives you some idea of the possibilities of this process.

6. Bonus Practical. Draw in ink without doing sketches first using a sketch book, which can be any type of a book with unlined pages. The standard art store item has a black cover and comes in a variety of sizes. Choose a size you find convenient to carry with you. Whenever you have time and your visual attention is drawn to something, sketch it in ink. This is valuable practice in using ink, not to mention the always valuable practice of observing and drawing what you observe.

Brush and Ink

The combination of brush and ink produces a remarkable range of visual expression. Like pencil, it has the potential of a broad range of values because ink can be diluted to any degree to make a tonal area as light or dark as you wish. A great deal of subtlety is possible.

At the same time, a brush can be loaded with full strength ink. Like a pen, it can make dark, sharp-edged marks as fine as the finest pen nib (See Figure 10-19), as well as very broad marks. In addition, by varying pressure on the brush, you can make a single line begin delicately, swell to great width, and return again to fineness. As with charcoal, you can quickly create broad, dark, dramatic areas. The brush can even make a grainy mark if it is nearly dry.

So a brush used with ink has the visual and expressive range of all the previously discussed media put together. Inks today even come in up to 9 colors plus black.

When a brush is used with diluted ink to lay in a lighter area of value, the technique is called *wash* (Figure 10–15). Wash is not only effective, but it is also not as difficult to use as often thought.

Practicals for Brush and Ink

MATERIALS. *You need two bamboo brushes (numbers 2 and 6 should provide good size contrast). Sable or camel hair watercolor brushes are also appropriate*

and last longer if well cared for, but they are far more expensive. The bamboo brushes, used for calligraphy in the Orient for centuries, are more than adequate to start. With care, they last well. Always rinse them gently in water after use, and shake them until they reassume a pointed shape. You also need a bottle of ink, preferably black India drawing ink, which is both permanent and waterproof. Sepia (brownish) drawing ink is an optional alternative that creates a quite different feeling. Have bottles or cans for water to dilute ink and clean brushes. Tape your ink bottle to your drawing board or table so it does not accidentally tip over. And have scrap paper at hand for removing excess ink on the brush.

1. Using ink full strength, explore what your brushes will do. Make a series of very fine parallel lines. Find out how far a brush goes before it needs more ink, how long before the mark has a grainy or "dry brush" appearance. Make a series of lines that go from fine to broad and back to fine. Make curved lines that go from fine to broad. Wipe most of the ink off the brush, and try out dry brush effects.

2. Do these same exercises with the ink diluted to three very different strengths, which yield three different values. If you have sepia ink, try it, as well.

3. To develop a feeling for how these different values can describe shape, take a simple white object—a ball, box, or cylinder. Light it dramatically so that part of it is very light and part is very darkly shadowed. Make a light pencil drawing at least 4" high of the outlines of the shape. Then, with your brushes, lay in the shadowed areas—no lines. The edges will be shown by the ending of a value area. Do this exercise any number of times as freely as you like. Observe how the areas of value describe the location of the surface of the object. Notice that, as a surface turns away from the light, it gets darker.

4. Find 4"×4" or larger black-and-white photos of faces that are also dramatically lit. Make wash studies of them that present only major areas of dark and light. When dry, put in dark accents (lines, dots, small areas of full strength ink). Do so with great restraint, for these accents, though small, carry a lot of visual weight. As with pen and ink, ink marks made with a brush are nearly impossible to erase or conceal. Do at least five of these—more if your interest is captured. See Figure 9–20 for the sort of drawing that might result.

If one of the materials discussed in this chapter turns out to be especially congenial to you, work more with it. Look for information about it in other sources (see References). And,

as you develop more skill and expertise, remember that almost anything in the world makes marks on some surface. So almost anything in the world is potentially a mark maker or a drawing surface. This nearly complete freedom is important to remember *always* so that if *you* need to use an unusual surface or make a new kind of mark, you will feel free to look for whatever works.

But, initially, a variety of choices that includes almost *anything* in the world is ludicrous, even in an age that admires novelty for its own sake. Nontraditional materials serve a purpose for experienced artists who come to them out of clearly articulated aesthetic need. These artists have worked with questions of structure, technique, and composition, and they have an idea of where they are going in terms of personal expression. They are in a position to seek unusual materials suited to what they want to do.

YOUR WORKSPACE

Basically, you must have a well lighted area with a table, preferably one with a slanted top, and a comfortable chair or stool. You need a portfolio for storing the work you want to save. Also useful is a free wall space for viewing work either from a distance or over a period of time to see if it pleases you. (A piece of 4′ × 8′ sheetrock, lightly nailed to an existing permanent wall, does very nicely.)

A window is pleasant but not essential. North light, so important to artists of earlier centuries, is not so necessary now that good, consistent incandescent or fluorescent light is available. Most exhibitions are lit electrically, so it is appropriate to create works by the same light.

However large or small your workspace, it is an advantage if it is private and away from distraction so that you can focus on what you are doing. Privacy also enables you to personalize the space with visual stimuli that especially attract you. In my studio, I have works by friends, some river stones, a Thai puppet, and other items that have special meaning for me.

CHECKLIST OF MATERIALS LISTED IN THIS CHAPTER

Mark Makers

Graphite pencils	Pastel pencils
Felt pens	Bamboo pens
Ballpoint pens	Steel nibs with holders
Conté crayons and pencils	Technical pen
Compressed charcoal	Automatic steel drawing pen (Fountain pen)
Stick charcoal	Bamboo brushes
Charcoal pencils	Sable brushes
French pastels	Camel hair brushes
Semisoft pastels	India drawing ink

Surfaces

Rough newsprint	Strathmore charcoal paper
Smooth newsprint	
White bond paper	Bristol board
White marker paper	Illustration board
	Drawing board

Accessories

Pink pearl eraser	Sandpaper block
Kneaded eraser	Chamois
Art gum eraser	Tortillons (stomps)
Pencil sharpeners—wall and pocket	Fixative
	Container for water
X-Acto knife	
Steel pencil pointer	

REFERENCES

1. Guptill, Arthur L. *Pencil Drawing.* New York: Watson-Guptill Publications, 1977.

2. Pitz, Henry C. *Charcoal Drawing.* New York: Watson-Guptill Publications, 1981.

3. Pitz, Henry C. *Ink Drawing Techniques.* New York: Watson-Guptill Publications, 1957.

4. Roddon, Guy. *Pastel Painting Techniques.* New York: Larousse and Co., 1979.

CHAPTER THREE

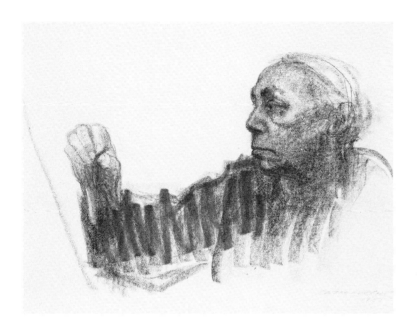

Drawing facts, illusion, and the importance of seeing

These three very different topics are brought together here because they are so necessary to each other. With drawing facts, illusion is created, but only if the artist can see accurately the way things appear.

DRAWING FACTS

A drawing is made of a couple of drawing facts, or elements. These elements—nothing more—make up all the shapes, all the illusions of texture and of volumes in space in all the drawings

you have ever seen. But this is a deceptively simple introduction. Though the *number* of drawing facts is small, each one is quite complex.

Line
Color

Value—lightness or darkness

Saturation—intensity or purity
Hue—characteristic of color referred to as red, blue, yellow, and so on; used to distinguish between surfaces with the same value and saturation.

Line

In mathematics, a line is conceived as having only one dimension—length. But, in the everyday world, such a thing does not exist. In reality, lines are as they are in art—long and with *some* width, which may vary considerably from beginning to end. When those lines join, they enclose spaces called shapes.

But artists *use* line in ways that are not realistic. If you look at a sheet of white paper on a brown table, you can identify the edge where paper ends and table starts, not because of line but because of hue, saturation, and value change (which also define shape). In a drawing, these junctures can be represented by line because, realistic or not, line is a widely accepted and understood symbol for edge.

Less easily undersood is the use of line to depict thrust or action. The most common art term for this is *gesture drawing* (a technique discussed in Chapter 4). Again, this is not a realistic use, for a drawing cannot move. However, our eyes accept certain line appearances as representing motion or thrust.

Figure 3-1.
CECILIA BEAUX (American, 1855-1942).
Henry James (Charcoal).
Collection of Mr. and Mrs. Raymond J. Horowitz. Photo courtesy the Berry Hill Galleries, Inc., New York.

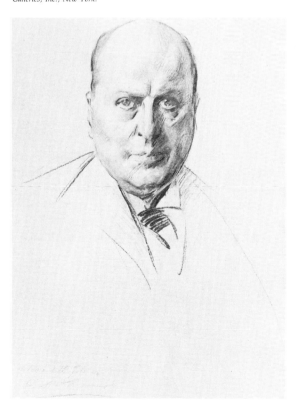

In Cecilia Beaux's study of Henry James (Figure 3–1), quick, spontaneous line was used initially to make visual notes on the gesture or the thrust of what was seen. When used this way alone, however, the marks are rarely descriptive enough for portraiture. Beaux was content to suggest posture, volume, and clothing with a single, swift, gestural line sweeping from the right shoulder to the lower right of the composition. But such economy and approximation, though full of vitality, were not sufficient as she sought to show James' piercing expression. For that job, she enlisted, in addition to gestural line, both edge lines and changes in value, discussed later in this chapter.

Yet line can be even more complex. Lines can communicate not only by tracing the edge of an object or by showing the action of a form, but also by their thickness, thinness, changes in direction, angularity, and other characteristics. These attributes add an abstract emotional quality to any drawing. As an example, look again at Figures 2–1 and 2–2. In 2–2, Wyeth's abundance of line and the always curving, often soft, sometimes playful, sometimes scribble qualities yield a sense of relaxed informality. In opposition is a sense of tension communicated partly by the sharp lines that define the spectacles, create a plane of hair across the forehead, and show closure between the lips. The *lack* of a well defined line where the jaw meets the shoulder keeps the face from being more three-dimensional and diminishes the forward thrust of the head. That, the body that leans back, and the glasses that somewhat mask the eyes all create a clear feeling of reticence.

Beal, on the other hand, in Figure 2–1, does not interfere with contact between viewer and subject. His line is generally strong and economically used. The artist clearly presents himself for all to see—a strong man whose life strength overcomes the dissolution suggested visually by rumpled shirt and hair.

Practicals for Line

MATERIALS. *Your choice. It would be worthwhile to use all the media discussed in Chapter 2.*

1. To become aware of line as an element by itself rather than as a means to make a picture of something, play with it for a while. With various drawing instruments, see how thin and thick you can make it.

How light and dark. Try curves and angles. Group lines to make areas of tone. Be free. Let your imagination take your hand wherever it wants to go. Then sit back and describe the abstract quality of your lines. Are they formal? Bold? Reticent? Mysterious? Disciplined? Dynamic? Complex? Nervous? Free? Figure 3–2 is a sample of such a worksheet done with compressed charcoal.

2. Choose one medium and an appropriate paper. Select 10 words that express an intangible quality or emotion, such as integrity, effervescence, sorrow. Define these words visually using only line. No realistic images, please.

Color

VALUE AND VALUE CHANGE

The value of a color is its lightness or darkness, and *value change* refers to the shifts as a color changes from light to dark. Much less could be seen without value change. Turn out the lights, and you see nothing. Turn them on, and hue and saturation change along with the degrees of visible lightness and darkness that help you to see forms and their textures and to see them three-dimensionally.

Manipulating these changes in value helps greatly to create the illusion of three dimensions on a two-dimensional surface. Lilian Westcott Hale's drawing in Figure 2–19 is a prime example of the gradual change from white through a range of grays to a deep black that creates, by value change alone (no lines), the sense of three-dimensional form in a drawing. Even in a good-quality reproduction, many of these subtleties are lost. Still, when you study Figure 2–19, you can clearly appreciate the gradual changes in value that reveal the curve in the planes of the cheek and lips. These also help tell us that the mass of hair is not flat but that it surrounds the volume of the head, and so on.

Practicals for Value

MATERIALS. *Conté, compressed charcoal, pencil, and appropriate papers.*

1. Make three 10"×2" rectangles, and divide them, as shown in Figure 3–3, into ten 1" vertical segments. In each leave the first segment white. In the next eight, paste on a scale of grays selected from patches you made on another sheet, one scale done in

Figure 3-2.
Line worksheet done in compressed charcoal.

Conté, one in compressed charcoal, and one in pencil. Control value by varying pressure on the medium. Don't add white. That will be done in Color Practical 3. Proceed in even steps. Use a patch of black paper for the last rectangle. When you are finished, you should have two ladders going from white to black in steps that are visually even. This is a difficult task. You may have to do many more than eight values with each medium to get even steps.

2. To appreciate the relativity of value, take one of the value scales you created in Practical 1, and, with a hole punch, make a small opening in the center of each patch (see Figure 3–3). Then take a 1"×8" strip of middle gray paper (paper that about matches step 4 or 5 on the scale), and neatly glue it behind the holes in the eight-patch strip. You will discover, as in Figure 3–3, that the gray showing through the white looks surprisingly dark and that it looks progressively lighter as it goes through the scale to black. In fact, it is hard to believe it is the same gray. Very clearly, the perceived lightness or darkness of any shade of gray is significantly affected by the value of its neighbors.

Figure 3-3.
Value and Value Relativity.

SATURATION AND HUE

Saturation (or *intensity*) refers to a hue's purity or brilliance. Black and white are unusually stable hues, for their value can be changed but not their saturation. As you can see in this book, remarkable drawings can be made with just black and white.

What is the role of other hues? An important part of the answer is that hues add a psychological or emotional dimension that conveys mood. Look for reproductions of the same portrait in black and white and in color. An excellent example would be the de la Tour in Figure 1–6. In a color version of this reproduction, you would be affected by the delicate pink of the lips, the pale yellow-white through pale yellow-orange of the skin, the blue of the eyes that has a touch of green to warm it, and the orange-brown of the lines. Together, they suggest a lightness of mood and warmth of personality that are less apparent in the black and white version. There you have only the black lines and gray values to respond to, and so the psychological emphasis shifts slightly toward the jaded quality so clearly expressed by the lines.

Practicals for Color

MATERIALS. *A small set of pastels and Strathmore charcoal paper in several hues, including white and gray.*

1. Using white paper, take one hue and make several firm strokes with it. Go over those strokes lightly with another hue. Now make another area of the same base hue, and go over it more vigorously with the second hue. Are the results what you expected from the mixture of the two chosen hues? Did the dominance of one over the other shift? Try other combinations and ask yourself the same questions. Then choose one hue and try to recreate it from a combination of others. Try another. Some will work. Some will not. If you are not confident about which hues cannot be created by mixing other hues, (those that are therefore called primary colors) and which can (all others), consult a book that covers color mixing and read the appropriate section(s). Some references are given at the end of the chapter.

2. With a dark pastel (black or brown), make several lines close together on white paper. Do the same on gray paper. Notice that the dark hue does not look as dark when it is surrounded by the gray paper. Why not? Think about other hue-to-hue relationships. If you put red pastel on white paper and then on red construction paper, the red pastel vividly contrasts with the white but virtually disappears on the red. On pink, there is a partial contrast. If you put white pastel on gray paper, it provides subtle contrast. On black, the contrast is dramatic. The point of this thinking and experimenting is that the appearance of hues is different in different contexts (as are values).

Experiment more on various backgrounds to see what happens. Hues look brighter or duller and darker or lighter depending on the surrounding color. After you have practiced enough to easily see changes taking place, read Josef Albers' slim paperback, Interaction of Color. *It is a valuable distillation of what he learned from forty years of studying color relativity.*

3. As we suggested, all hues but black and white have two characteristics that can be modified: value and saturation. When a hue is made lighter or darker by the addition of white or black, its value is changed. To apply this approach, make areas of tone with each pastel. Then work some white and some black into them. Use white paper.

4. You can change the saturation of the hue in two ways. One is by adding its complement to make it duller or grayer. The other is by adding more of the fully saturated (most brilliant) hue to make it more brilliant, unless it is already as saturated as possible, which is always the case with black and white. (Adding more black to gray makes it darker. Black changes only gray's value; it does not make it more intensely gray.)

Experiment with your pastels. Make a number of magenta (red-purple) lines about ⅛" to ¼" apart. In between each line, insert a green line. Stand back eight feet or so, and see how the eye-mixing of these complementary hues makes each one seem less bril-

liant. Now try actually working these two hues together on the paper, and you get a muddy or grayed color. The amount of graying depends on the amount of complement added. If you add a great deal, the mixture actually takes the hue of the added complement instead of reflecting a graying of the initial hue. If you are not familiar with the concept of complementary colors, refer again to a book on color and study it as well as value and saturation.

5. Look at a color picture through squinted eyes: The more you squint, the more the color turns to gray. Every hue has an equivalent value of gray. Translating the values of colors to gray is a good way to become sensitized to value change.

To develop your visual sensitivity, select a color portrait—either a reproduction of a master painting or a photo that you like—and copy it in graphite pencil. Make all the darks and lights in your copy match the values of the corresponding darks and lights of the color work. Make the head in your drawing at least 4" high.

ILLUSION

Illusion is pretense. An actor pretends and creates an illusion. Portraits are also illusions. They are never the living persons themselves, no matter how realistic they may be. Even Jeri Metz's remarkably lifelike portrait in Figure 10–18 is obviously illusion, constructed by manipulating drawing elements to create illusions of surface textures and of volume in space that look like a particular person.

Volume

Every object has a characteristic three-dimensional form, or volume, that not only makes it recognizable but also shapes the space around it. Creating an interesting visual relationship between the form and space it occupies is important for every artwork, and it is the subject of the second half of Chapter 4. The focus here is on how to create the illusion of that volume in its three-dimensionality on a two-dimensional surface. Doing this successfully requires further understanding of a number of artistic conventions using line, value change, and color.

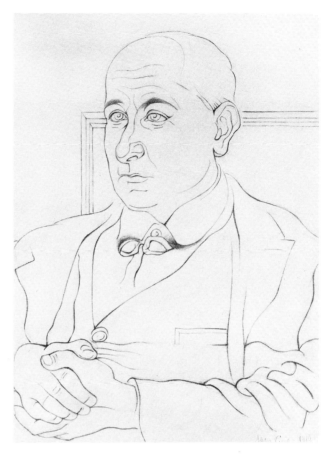

Figure 3-4.
JUAN GRIS (Spanish, 1887-1927).
Portrait of Max Jacob, 1919 (Pencil 14⅜" × 10½").
Collection, The Museum of Modern Art, New York; Gift of James Thrall Soby.

VOLUME FROM LINE: LINE REPRESENTING EDGE

Used to represent edge, line helps to build volume in three ways:

1. It can describe the edges of planes that overlap, seen as behind each other in space. Juan Gris' portrait of Max Jacob (Figure 3–4) contains a number of examples of overlap, the most insistent being Jacob's rounded figure in front of the chairback. The volume of both figure and chair are partially explained by this juxtaposition.

2. It can follow the contour of an object. For example, a wrinkle in a forehead or the edge of a collar going around a neck are lines that suggest volume. (Look again at the Juan Gris drawing.)

3. It can show the edges of objects as they recede into space. This illusion is governed by the dictates of linear perspective (or foreshortening). Look at the photo in Figure 8–1. Compare the subject's right and left forearms. The right one is dramatically foreshortened. (Linear

perspective used to capture the volume of the head is introduced in Chapter 5. For more comprehensive coverage, use the References for that chapter.)

VOLUME FROM LINE: LINE
CONTOURING THE SURFACE

In Figure 3–5, a student drawing, the volume of the shirtfolds is "described" by the stripes that follow the undulations of the cloth. Without the stripes, the folds would be understated or not stated at all. In one of the volume practicals, you will experience striping lines not only as a clue to volume but as the *only* clue.

VOLUME FROM LINE: LINE
CREATING VALUE

When striping lines are placed very close together, they no longer function as a pattern in the cloth but as value. As mentioned in Chapter 2, the process is called *hatching*. If hatching lines are crossed by lines that follow the surface in another direction, the result is called *cross-hatching*. When, as in Figure 1–7, Michelangelo

Figure 3-5.
Student Drawing.

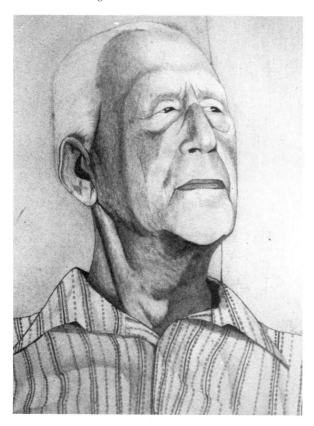

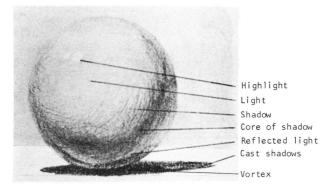

Highlight
Light
Shadow
Core of shadow
Reflected light
Cast shadows
Vortex

Figure 3-6.
From *A Guide to Drawing* by Daniel M. Meldelowitz.
Copyright ©1976 by Holt, Rinehart and Winston, CBS College Publishing.

hatches and cross-hatches to create convincing volume, the result is called "structural drawing" (discussed in Chapter 4).

VOLUME FROM VALUE
CHANGE

Hatching and cross-hatching are ways of creating values and thus volume. Value and value change also result from blending hatching lines made by dry media to create solid areas of tone. What both techniques have in common is that they provide a range of lights and darks that can be manipulated to reveal volume.

Figure 3–6 diagrams the system with a sphere that is shiny and brightly lit. The clear white area represents *highlight*, which is made up of small bright areas found within the light area of shiny surfaces only. They are reflections of the light source. The very light gray represents the *light* area, which is in full light but does not reflect (or mirror) the light shining on it. The lightest value on matte (nonshiny) surfaces, it is less defined than the highlights are as it blends into the next darkest area, *shadow*. Shadow covers the area of a surface that begins to turn away from the light shining on it. Light and shadow are both rather large areas. More clearly defined are both highlight and the *core of the shadow*, which is the darkest area of shadow *on the object*.

Reflected light appears because surrounding surfaces that are also lit tend to reflect some of that light. The dark areas shed by objects on neighboring surfaces are called *cast shadows*. The very darkest area in this drawing is the *vortex shadow*, the narrow area where two surfaces

meet and virtually exclude all light, occurring here at the bottom of the sphere.

Look at Chuck Close's self-portrait (Figure 3–7), and you find the full range of these lights and darks:

- highlights in the glasses and the pupil of the eye
- light in the forehead, cheeks, and other areas
- shadow, such as on the cheeks, and neck
- the core of the shadow along the chin and on the lips
- reflected light also along the chin
- cast shadow from the glasses on the cheek and from the chin on the neck
- vortex shadow in areas such as the nostril and the juncture of hair and forehead.

Distribution of light and shadow is most effective in describing relatively shallow volume. Illusions of volume that recede deeply into space depend more on linear perspective (discussed in Chapter 5) and on the effects of distance on detail, color, and size.

RECEDING VOLUME FROM LOSS OF DETAIL

In Figure 3–8, John Vanderlyn's portrait of Elizabeth Maria Church done in 1799, one way the sense of deep space is created is by showing the leaves nearby in some detail and those in the distance as progressively less distinct. The farther away forms are, the less clearly visible are their value changes until, finally, only one generalized value remains.

Figure 3-7.
CHUCK CLOSE (American, 1940–).
Self-Portrait (Pencil).
Private Collection.

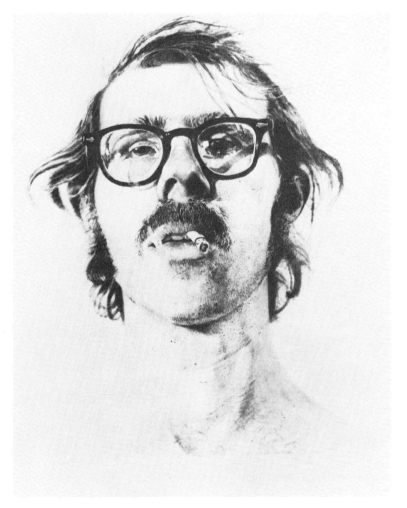

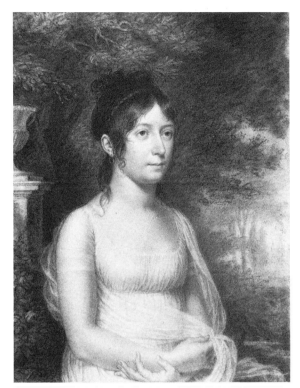

Figure 3-8.
JOHN VANDERLYN (American, 1775-1852).
Elizabeth Maria Church (Chalk and white lead).
The Metropolitan Museum of Art, New York; Bequest of Ella Church Strobell, 1917.

In a portrait (especially in the twentieth century), the impulse to create an illusion of great depth is infrequent. Therefore, the "loss of detail" convention and the two discussed next are not much used, but it is well to know about them so you *can* use them.

RECEDING VOLUME FROM HUE CHANGE

The principle of diminishment with distance applies to hue as it did to detail. Any given color becomes progressively less individual with distance until it blends into a general gray-purple haze. Red and yellow seem to have the greatest carrying power. They are the ones you see most clearly across a football stadium or in the distance as leaves turn color in the autumn.

RECEDING VOLUME FROM SIZE CHANGE

Look at Ranan Lurie's work in Figure 1–11. There is a sense of great space created largely by the diminishing size of the figures as they recede.

Practicals for Volume

MATERIALS. *Your choice.*

1. Put a simple form, such as a box or sphere, on a table. Cover it with a cloth that has a strong stripe. Do several relatively quick studies using stripes to achieve a sense of form beneath the fabric.

Figure 3-9.

2. Take four large newspaper or magazine photos of heads. Using felt tip pen, draw lines about ¼" to ½" apart, horizontally across each face, following the surface contour of each as though you were painting stripes on it. When you are through, take tracing paper and use a wide-tip felt pen to trace just the stripes you have drawn. The result should resemble a striped mask with no openings.

Figure 3-10.

3. Using the diagram in Figure 3–6 as a guide to shadowing, spend about an hour making a drawing, using shadow only—no lines. The subject should be a brightly lit geometric form, a shiny one if possible, but not transparent. Make the form in your drawing at least 6" high. Be very conscious of shadow. Work at it until you have a convincing illusion of the particular volume you are using.

4. As I look out my study window, I see—close enough to touch—a grape vine. Each detail of each leaf is clear. About 25 feet away is a stand of laurel bushes. Each leaf is separately visible, but I cannot distinguish veining. About another 20 feet away are some young trees. Their leaves blend in with one another. If you can find a view of greenery with roughly the same distance relationships, do a line drawing of a cluster of leaves close by, a cluster 20 or so feet away, and a cluster about 40 feet away. This exercise heightens your awareness of the differences in the observable detail created by changes in distance, as well as how these differences can be manipulated to create your illusion of depth.

Texture

All surfaces have textures. They range from the smooth shininess of glass, to the roughness of coarse sandpaper, to the softness of fur, to the bristly quality of a wire brush, to the furrowing of corrugated paper or corduroy. In a drawing, illusions of all textures are created by the distribution of darks and lights. It is that simple.

Look again at Chuck Close's self-portrait (Figure 3–7). An intriguing range of textures is clearly presented: Shiny glasses and eyes. Three different hair textures—soft, wispy head hair, coarser eyebrows, and bristly moustache and sideburns—in addition to the stubble of a day's growth of beard. Smooth skin on the forehead and cheeks. Slightly furrowed skin on the lower neck, delicate furrowing of the lips. The uneven surface of cigarette ashes and the smooth cigarette paper. Each texture is differentiated and made recognizable by the distribution of darks and lights.

Three other aspects of texture are important to consider. So far, the discussion has centered on the texture of the seen object. The texture of the *drawing surface* is also germane, for it is not smooth, it imprints its own signature on your work. Charles Sheeler's portrait of Katherine Shaffer clearly shows the impact of the paper he used (Figure 3–11). In this case, it

is a harmonizing influence, gracefully suggesting not only skin texture but fabric and wall textures as well. The drawing was done in charcoal, and you can see that it is possible to make the texture disappear by heavy application of the medium, as it does here in the dress. But in areas where the medium is more sparely applied, the texture of the drawing surface asserts itself.

The Alice Neel drawing on the cover demonstrates the impact of rough paper on a pen and ink work. The more lightly applied lines have a disconnected quality such as might be created by wax crayon.

The texture of the *medium itself* must also be considered. On smooth paper, a 6H pencil can create only a pale, smooth mark and nothing else. On the same paper, a 6B pencil, charcoal, or Conté is capable of graininess. The visual effect you want determines your choice.

The third texture is that of the *artist's style*. Look again at the Sheeler drawing in Figure 3–11. His personal style is partly defined by its smoothness—he takes the wrinkles and bumps out of everything. On the other hand, Chuck Close in Figure 3–7 leaves them *all* in so that his characteristic texture is consistently naturalistic. Kathe Kollwitz chooses graininess even for skin, which heightens the emotional harshness in the world she shows us (Figure 3–12).

Figure 3-11.
CHARLES SHEELER (American, 1883-1965).
Portrait (Katherine) (Charcoal).
Collection of Constance B. and Carroll L. Cartwright.

Figure 3-12.
KATHE KOLLWITZ (German, 1867-1945).
Self-Portrait with a Pencil (Charcoal).
National Gallery of Art, Washington, D.C.; Rosenwald Collection.

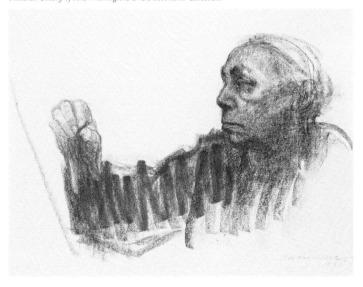

37

Figure 3-13.
Student drawing courtesy John Romaine.

Practical for Texture

MATERIALS. *Pencil or Conté and suitable paper.*

With the student drawing in Figure 3–13 to guide you, set up a transparent bottle and a heavily textured fabric, such as wide-wale corduroy. Light them so that the shininess of the glass and the furrowing of the corduroy are strongly revealed and thus sharply contrasted. Make a modeled drawing that includes both, with the bottle in the drawing at least 8" high. Capture the textural characteristics of each. An added challenge and source of visual interest is the see-through quality of the glass. If the corduroy is visible behind the bottle, it is probably slightly distorted because its image is seen through a double layer of glass. Your job is to draw what you see.

This drawing takes a lot of time, and you may experience some initial frustration. However, if you give it the four to six hours it needs, you will probably make a successful drawing. More importantly, you will finish it with a good grasp of how to draw texture—any texture.

THE IMPORTANCE OF SEEING

I can remember, at the age of 7 or so, the electric moment I first "saw" the shoulder-shape of a profile figure the way it *appeared* rather than the way I "knew" it was. I had been drawing a sideways shoulder, as it is seen in ancient Egyptian art (Figure 3–14a). I knew it wasn't lifelike. Yet I also knew that shoulders were wide and that they came out from the neck like the corners of two squares ⌐⌐. It took me months to *see* that from the side they did not come out that way. In fact, from the side there were no shoulders at all, only the chest and back slopes (Figure 3–14b). That may have been the moment I began trusting my eyes and looking at forms in the way necessary to register their *actual* appearance.

All the advice about art elements and how they are organized into volumes with texture is useless unless you can see those volumes clearly and translate them into a drawing. In her book, *Drawing on the Right Side of the Brain*, Betty Edwards structures a teaching method for drawing, based on the results of clinical research, that identifies the very different roles of the left and right hemispheres of the brain. The left hemisphere specializes in analytic processing (reading, writing, computing, and the like) and the right side in spatial, relational, and comparative functions. She declares (and it makes sense to me) that we use the left side more because we are verbal beings called on constantly to be analytical, both in and out of school. The intuitive and visual right side, although less used and less trusted, seems to let us see what we must see to draw.

It is not what we know that tells us how things look so much as volumes, textures, and colors revealed by light. You may *know* that there are three chairs, a piano, and a couch in your living room, but that is not the same as

Figure 3-14.
Childhood change in awareness from (a) how shoulders *are* to (b) how they *appear*.

(a) (b)

seeing. Theatre in the round often changes scenes under cover of darkness. The stage furnishings you *know* are there disappear without your seeing them go, and, when light returns, knowing is shown to be useless. You must have vision and light. Knowledge has secondary importance in this situation.

You must also be in a somewhat altered state of consciousness, such as that experienced by anyone who is completely lost in thought—a state in which the mind is freed to concentrate on objects and ideas. This state is less dependent on knowing than on seeing, feeling, and making intuitive leaps. It is not an alarming state. No drugs or stimulants are needed to induce it. It is as normal as the other state in which you might make telephone calls or read a book, just not as common. The Austrian artist, Hundertwasser, says that, when he is painting, he is in a dream. When the dream is over, he doesn't remember it, but he has a painting. Whatever the state is called—dream, meditation, centering, altered state of consciousness—it allows what an artist needs to see, to feel, and to create.

For the work you do from this book, I ask you to center on what is visual simply because it works. Figures 3–15a and 3–15b are portraits done by a student of mine, one on the first day of class that met once a week, and the second four classes later. As you do the following Prac-

ticals, consciously look at each source material in an honest way that registers what you actually see. Pursue that approach. Trust it and cultivate it.

When you are able to see things as they *appear* (colors too), Rudolph Arnheim's *Art and Visual Perception: A Psychology of the Creative Eye* can take you even further. The aim of his book is to sharpen visual intuition "by making visual categories explicit, by extracting underlying principles, and by showing structural relations at work" He suggests that "there is no point to visual shapes apart from what they tell us." He uses the analytic tools of gestalt psychology to give us the vocabulary to think about, as well as to communicate what we want to create and what we see. He enlarges creative vision in many areas including balance, shape, growth, color, movement, and expression.

Practicals for Seeing

MATERIALS. *Your choice except as otherwise noted.*

1. Find photos of people sitting down, of three-quarter views of faces, and of hands, birds, flowers, chairs, automobiles, and trucks. Cut the figures or objects out along their edges, and turn them "face down" so that you may see only the shape of the forms. They are sometimes a surprise, changing from the shapes that may come to your mind when you think of a truck or flower or face.

Figure 3-15
Student drawings courtesy Connie Cain. (a) (b)

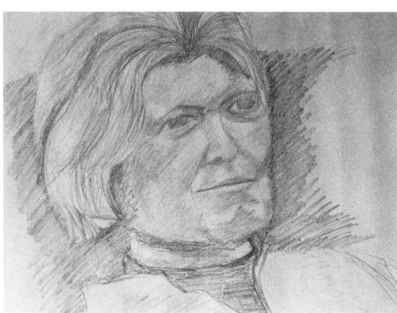
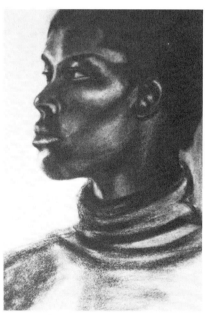

2. Now find photos of a box, a plate, and a glass. Draw their outlines—and only their outlines, with no interior lines at all. The outline of the box will not be rectangular but something like Figure 3–16a. The plate will not be round (unless you stood it on its edge) but an ellipse (Figure 3–16b). And the glass will not be round but shaped something like Figure 3–16c. If your outlines are very different from those in Figure 3–16, try again.

Figure 3-16.

3. Now try more complex forms by turning photographs upside down. *This will release you more fully from your tie to the knowledge of how these forms look and thereby let you look more easily at the* positive *and* negative *shapes or spaces involved. Positive shapes are simply the shapes of the objects you are drawing (such as those in Practical 2, the box, plate, and glass). The negative shapes are the spaces around them. Both are equally important in any artwork, for both have aesthetic impact, and one cannot exist without the other.*

Find a clear photo of a chair with four legs and rungs. Turn it upside down, and draw the outline of the space around the chair, no interior detail at all. Now draw again, but this time draw the positive spaces—not the negative space. The two drawings are similar, but your experiences in drawing them differ because you are concentrating on different sets of shapes. For the first one, you look at and appreciate negative shapes, which is not the emphasis you are used to.

4. Now, if you can manage to find two volunteers, seat them facing each other with the light behind them, so their profiles are silhouetted about six inches apart. On a sheet of newsprint, use Conté or

soft pencil to draw the space between *them. On another sheet, draw them, outline only. In the first, fill in the space between. In the second, fill in the facial spaces. They probably resemble and, when your eye shifts from positive to negative shapes, have the same amusing twist as in Figure 3–17.*

Figure 3-17.
Opposing profiles or a vase?

· · ·

With the information in this chapter and the skills developed through the Practicals, supplemented as needed by the references in the back of the book, you are ready for Chapter 4 and its introduction to useful approaches for utilizing the facts and illusionary devices just considered.

REFERENCES

Drawing Facts and Illusion

1. MENDELOWITZ, DANIEL. *A Guide to Drawing*. New York: Holt, Rinehart, & Winston, Inc., 1976.

2. BEVLIN, MARJORIE ELLIOT. *Design Through Discovery*. New York: Holt, Rinehart, & Winston, Inc., 1980.

3. ALBERS, JOSEF. *Interaction of Color*. New Haven, Conn.: Yale University Press, 1975.

4. ITTEN, JOHANNES. *The Art of Color*. New York: Van Nostrand Reinhold Co., 1973.

The Importance of Seeing

1. EDWARDS, BETTY. *Drawing on the Right Side of the Brain*. Los Angeles: J. P. Tarcher, Inc., 1979.

2. ARNHEIM, RUDOLPH. *Art and Visual Perception: A Psychology of the Creative Eye*. Berkeley: University of California Press, 1974.

CHAPTER FOUR

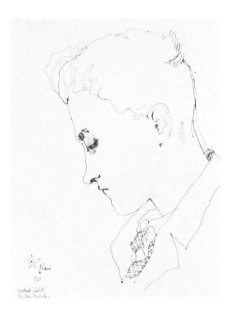

Drawing techniques and visual intrigue

Figures 4–1 through 4–4 present examples of the four different approaches to drawing introduced in this chapter: contour, gesture, modeled, and structural drawing. The first part of this chapter explains why each one has a markedly different appearance. The second part probes beyond approach to show why these and certain other drawings are so arresting. How are artists able to manage materials and elements so as to attract and intrigue the viewer?

DRAWING TECHNIQUES

The four techniques in this chapter are valuable tools for expression, and also extend Chapter 3

because they too help us to see what is before us or visualize what we remember.

Looking at the side-by-side examples in Figures 4–1 through 4–4, you can easily see that each technique is expressive in a different way. Contour drawing is considered and thoughtful-looking (Figure 4–1). Gestural drawing, in contrast, has a spontaneous, lively, quickly stated quality that does not result from any other approach (Figure 4–2). Modeled drawing (Figure 4–3) is more dramatic, often yielding a smooth, elegant appearance, as in Figure 2–14. Finally, structural drawing is really a branch of modeled drawing that has a solid, no-nonsense, bones-beneath/flesh-on-top appearance (Figure 4–4).

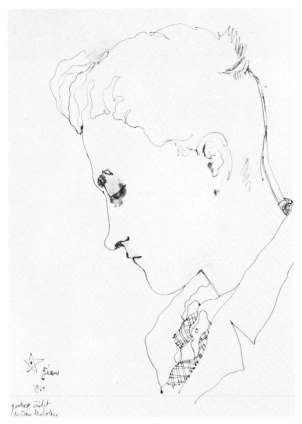

Figure 4-1.
JEAN COCTEAU (French, 1892-1964).
Jean Desbordes (Pen and ink).
The Art Institute of Chicago; Gift of Mrs. Gilbert W. Chapman in memory of Charles B. Goodspeed.

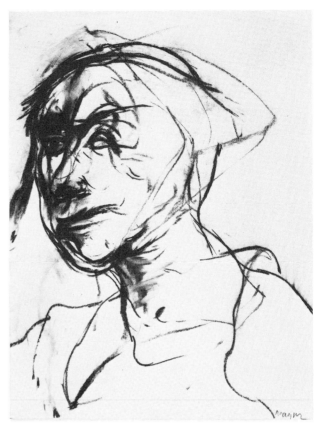

Figure 4-2.
MICHAEL MAZUR (American, 1935-).
"Head"—Study for "Images from a Locked Ward" 1964 (Charcoal).
Impressions Graphic Workshop, Boston. Courtesy of the artist.

Figure 4-3.
CHUCK CLOSE (American, 1940–).
Self-Portrait (Pencil).
Private Collection.

Figure 4-4.
MICHELANGELO BUONARROTI (Italian, 1475-1564).
Head of a Satyr (Pen and ink).
Cabinet des Dessins, Museé de Louvre.

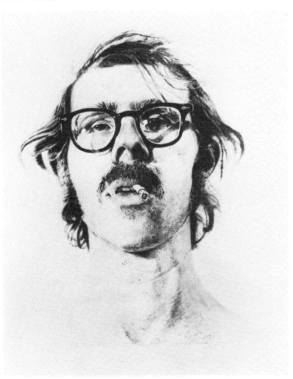

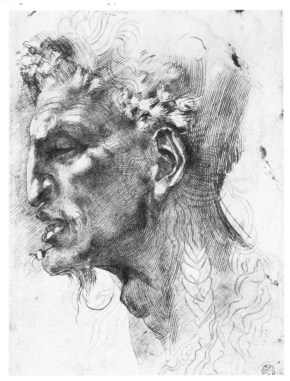

Note that these techniques are rarely seen so purely as in these examples. Usually one approach predominates with others employed to accent or complement it. In Figure 4–5, John Russell's eighteenth-century *Portrait of a Lady*, free gestural lines describe her hair. There is a contour approach to the nose, and modeling is used to develop most of the rest of the face. Even the contour drawing in Figure 4–1 is not pure—there is a touch of modeling at the eye.

Contour Drawing

This is often the first drawing technique introduced to students because it deals only with linear presentation of edges and thus establishes one clearly visible issue to concentrate on. However, it can be developed into quite a sophisticated instrument, as you see in Figure 4–1, in Juan Gris' study of Max Jacob in Figure 3–4, and Wayne Theibaud's drawing in Figure 9–10. Notice in Figure 3–4 how the line width is varied and how skillfully the darkness of the line is manipulated to draw your attention through the drawing.

Look ahead at Figure 9–10 and see how a touch of contour drawing can add important contrast and an accent to the overall study. In that figure, Theibaud has also used such contrast to make sure that you look at all parts of the drawing. Starting with some contour lines in the hair, he leads your eye to another contour line at the left side of the neck. Then he moves you along the lighter ones down the arm and around the fingers, onto the shirt, then across the waist *or* (as an alternative route) down the left leg and up again. The journey continues across the waist, up to the right shoulder, and back to the head.

Contour drawing's primary gift, however, is that it helps to see the edges of forms, to be in touch with their actual appearance. The approach is as thoughtful and focused as the results.

Kimon Nicolaides was a teacher at the Art Students League in New York City for 15 years. There he developed a unique and concrete way to teach drawing, published posthumously by his students as *The Natural Way to Draw*. It is a direct, useful guide to drawing, the first presentation in print of some approaches still widely

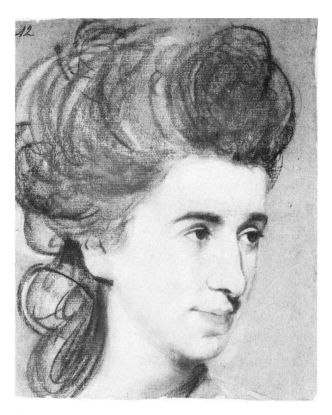

Figure 4-5.
JOHN RUSSELL (English, 1745-1806).
Portrait of a Lady (Colored crayons on blue paper).
Yale Center for British Art, New Haven. Paul Mellon Collection.

used. I am grateful for permission to quote at length from it in the following Practicals.

Practicals for Contour Drawing

MATERIALS. *Felt tip pen and newsprint or bond paper.*

1. Choose a number of forms to draw. Any forms will do—an object, an animal, a plant, or a person. Devote two to three hours to the process, proceeding as Nicolaides directs.

Sit close to the model or object which you intend to draw and lean forward in your chair. Focus your eyes on some point—any point will do—along the contour of the model. (The contour approximates what is usually spoken of as the outline or edge.) Place the point of your pencil on the paper. Imagine that your pencil point is touching the model instead of the paper. Without taking your eyes off the model, wait until you are convinced that the pencil is touching that point on the model upon which your eyes are fastened

Then move your eye slowly along the contour of the model and move the pencil slowly along the paper. As you do this, keep the conviction that the pencil point is actually touching the contour. Be guided more by the sense of touch than by sight. THIS MEANS THAT YOU MUST DRAW WITHOUT LOOKING AT THE PAPER, *continuously looking at the model.*

43

Exactly coordinate the pencil with the eye. Your eye may be tempted at first to move faster than your pencil, but do not let it get ahead. Consider only the point that you are working on at the moment with no regard for any other part of the figure.

Often you will find that the contour you are drawing will leave the edge of the figure and turn inside, coming eventually to an apparent end. When this happens, glance down at the paper in order to locate a new starting point. This new starting point should pick up at that point on the edge where the contour turned inward. Thus, you will glance down at the paper several times during the course of one study, but do not draw while you are looking at the paper. As in the beginning, place the pencil point on the paper, fix your eyes on the model, and wait until you are convinced that the pencil is touching the model before you draw.

Not all of the contours lie along the outer edge of the figure. For example, if you have a front view of the face you will see definite contours along the nose and the mouth which have no apparent connection with the contours at the edge. As far as the time for your study permits, draw these 'inside contours' exactly as you draw the outside ones. Draw anything that your pencil can rest on and be guided along. DEVELOP THE ABSOLUTE CONVICTION THAT YOU ARE TOUCHING THE MODEL.

This exercise should be done slowly, searchingly, sensitively. Take your time. Do not be too impatient or too quick. A contour drawing is like climbing a mountain as contrasted with flying over it in an airplane. It is not a quick glance at the mountain from far away, but a slow, painstaking climb over it, step by step. . . .

Nicolaides goes on to say that you should not worry about proportions. They will improve with practice. Also, ignore shadows—the edge is the same whether shadowed or not. Work hard at not looking at the paper. Ask someone to check you for a few minutes to see if you look too often or draw while you look.

2. Nicolaides' approach can be used for drawing anything you can see. Here you should do five contours in a one-hour block of time. You need a mirror.

a. Your own eye: 10 minutes. (If you finish too soon, do it again more slowly and carefully.)

b. Your own mouth: 5 minutes.

c. Your own hand: 10–15 minutes.

d. Your own face: 15–20 minutes, longer if necessary.

e. A friend's profile, including ear: 15–20 minutes.

Gesture Drawing

Gesture is *movement*, and gesture drawing targets that movement. It offers the artist a way to quickly note the intangible, unifying impulse of a form that is expressed in the direction of its parts. Paraphrasing Nicolaides, it is drawing the action of forms rather than the form—the wind blowing the trees rather than the trees.

In portraiture, gesture drawing is used to capture the first impression, to make the first expressive statement. Michael Mazur's drawing is a striking example (Figure 4–2). Mazur was not looking at edges. He was bent on expressing the spirit of the person as seen in the awkward set of the head, in the ragged, near absence of hair, in the detached expression of the face. Another example is seen in Figure 3–1, where Cecilia Beaux uses a wonderful, direct gestural line to express the position of the shoulder and thrust of the body. Generally, gesture drawings have more of a "scribble" appearance (see Figure 2–2, especially the body area). They are generally exercises or the quickest of studies, and rarely are they regarded as finished works in themselves. Thus, they are usually not preserved, and there are few examples by masters to study.

To draw the gesture of anything, you need to feel the gesture . . . to feel upright as a majestic pine, drooping as a fading flower, extended as a running horse, straight and focused as a diving figure, womb-curled as a sleeping cat, gliding as a skater, and so on. That uprightness, drooping, fading, extension is what you are putting on your paper—not the tree, the flower, the horse.

It is precisely the same with a portrait. A gesture drawing may be just a preliminary, a first step that gives you the expressive essence to build on. Quoting Nicolaides again,

Gesture has no precise edges, no exact shape, no jelled form. The forms are in the act of changing. Gesture is movement in space.

Whereas in contour drawing you "touch" the *edges* of a form, in gesture drawing you must "feel" the *movement* of the form. Again, from Nicolaides:

Try to feel the entire thing as a unit—a unit of energy, a unit of movement. Sometimes I let new students begin to draw on a five-minute pose and then, after one minute, ask the model to step down from the stand. The students stop drawing with surprise. I tell them to go ahead and draw, that they had started to draw and must have had something in mind; but usually they are unable to continue. The truth is that

they had started with some little thing, such as the hair, and had not even looked at the pose as a whole. In the first five seconds, you should put something down that indicates every part of the body in the pose.

With a portrait, too, it is well *not* to start with any one feature but to go for the action of the whole. Relax. Focus. Respond to what you see and feel. Think again of Chapter 3, of seeing with the right side of your brain and the special concentration it requires.

Practicals for Gesture Drawings

MATERIALS. *Felt tip pen, soft pencil, charcoal, and newsprint.*

1. *Make a great many gesture drawings because, by their nature, they are quick.*

You might be asking yourself at this point, Where will I get models to do even fifty portrait gestures? You probably can't, unless you use photographs. Clip as many as possible from magazines and newspapers. Look through slides and family albums. Find some photos with unusual tilts to the head, and look for various camera angles, even a few taken from behind. You are not after exact likeness or exact detail here, just gesture.

Allow yourself 30 minutes for 15 gestures. Then, after a break, try 15 in 15 minutes. Use a timer. You can use the same photos more than once. Take another break, and then do 25 more at a pace that is comfortable for you. Then do 10 more, allowing yourself only 10 seconds each.

Refer again to Michael Mazur's drawing in Figure 4–2 for an example of how quick and free your drawings can (and should) be.

2. *If children are available, try doing their heads as they play a board or video game. Ask a friend to give you 15 minutes and 15 poses—head down, up, thrown back, laughing, grouching, screaming, twisted over one shoulder and then the other, eyes closed and resting, hand over mouth in alarm, over forehead in pain, finger at mouth saying sh-h-h, and so on.*

3. *Do gesture drawings from TV shows where heads are often the focus, such as newscasts, panel shows, and late night talk shows. Aim for 25 drawings.*

4. *Now add the upper body to your efforts. Work with your friends and with children. Draw yourself in a mirror. Do 15 drawings in 15 minutes.*

Modeled Drawing (Drawing with Value Instead of Line)

With modeled drawing, the focus shifts again. Edges are not the issue. Gesture is not the issue. The issue is volume as revealed by light and shadow, by changes in value. Look again at Figure 4–3. Of the four drawing techniques shown there, modeled drawing creates the most realistic illusion, the one in which the viewer has to do the least visual imagining. Your work on value in the last chapter was an important preliminary to this approach. It sensitized you to value change, to its possible range, and to its use as a tool for creating the illusion of three-dimensional form.

Modeled drawing results whenever areas of value are used to build volume. The naturally suited media are those that blend—charcoal, pastels, soft pencil. But ink and hard pencil can also be used. In Rudolfo Abularach's large eye done in pen and ink you see an example of pen and ink hatching (Figure 6–1). The lines are so fine that they look as though they blend. John Wilde used hard pencil with similar results (Figure 2–14). At times, an artist uses an easily blended medium in a controlled, unblended way. In Figure 2–19, Lilian Westcott Hale used charcoal to create a blended appearance, but the drawing is actually constructed of nothing but fine, vertical lines (a nuance of style all but lost in reproduction).

The defining characteristic of pure modeled drawing is that, though lines may be used, value change carries the message. In Abularach's drawing, we register the hills and valleys of the eye because of value change, not because of line. When you look at your own eye in a mirror, the same is true. Modeled drawing, like nature, relies on value change to reveal form.

Not only does modeled drawing create the illusion of volume, it also yields a sense of light and dark and thus of time or place and of mood. A drawing that is largely dark creates a sense of the absence of light, of night or a room with drawn curtains and of a subdued atmosphere, as in James A. McNeill Whistler's *Study for "Weary"* (Figure 4–6).

With more of a balance between values, there is less drama and a sense of no particular

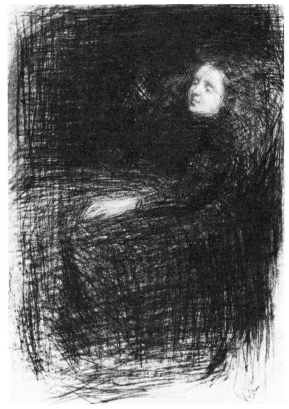

Figure 4-6.
JAMES A. MCNEILL WHISTLER (American, 1834-1903).
Study for "Weary" (Black chalk).
The Sterling and Francine Clark Art Institute, Williamstown, Massachusetts.

time or place. For a good example, look again at Gorky's portrait of his mother (Figure 1–9).

If the drawing is predominantly in light values, the effect is of a well lit setting.

The amount of light in a drawing and its distribution can also help create clear-cut mood statements. In the Gorky drawing in Figure 1–9, the balanced tones suggest restraint, or quiet desperation and quiet strength. In Kathe Kolliwitz' self-portrait, the values are exaggeratedly dark, helping to create the feeling of anger against injustice that permeates much of Kolliwitz' work (Figure 3–12). (See Chapter 9 for more discussion of expressiveness in portrait drawing.)

Practicals for Modeled Drawing
Look at the work you did in the value practicals in Chapter 3. Reviewing it helps to reinforce the base you built there for modeled drawing.

MATERIALS. *Soft pencil and charcoal with appropriate paper.*

1a. Seat yourself comfortably before a mirror. First, using a soft pencil and 18"×24" charcoal paper, *make a 2-minute head-to-waist gesture drawing of yourself using the full sheet of paper.*

b. Now, over the gesture, do a contour *drawing using felt tip pen. Allow 30 minutes.*

c. These preliminary drawings give you the gesture of your own figure and information about the edges. With these drawings in place, use compressed charcoal on top of the gesture and contour to lay in value information, to create a modeled drawing. Observe the lightest areas closely, especially just where these areas begin to turn away from the light, as revealed by a change in value. Strive for as wide a range of value as you can see so that the finished drawing presents lights, shadows, reflected light, core shadows, and vortex shadows (as described in Chapter 3). Also include cast shadows if there are any. Do not work for accuracy of detail or great likeness. Your main objective is value changes that show shifts in the direction of the planes of your face and body. Also show the values of the background. *Note where the value of the figure is the same or nearly the same as the background, perhaps making one scarcely distinguishable from the other. When you have finished, this drawing may not be a thing of beauty. It may well look overworked due to the buildup of marks from three separate and complete drawing processes. The experience, rather than the result, is what counts.*

You would profit from repeating this exercise, again using yourself as a model, but in a different pose. Then do it using someone else, who understands that you are not trying to create a finished work but want to practice a useful process (one that could well be a preliminary to any portrait drawing you ever do).

2. With charcoal, do another drawing of yourself in the same pose as in Practical 1a. This time, use only value to create your work. No lines, either gesture or contour. Allow about 30 minutes. Again, do not strive for detail or likeness. Aim instead for volume created by value change as in the student drawing in Figure 4–7. Your drawing, when completed, may look incomplete and in need of the added strength and accent of at least some lines. As mentioned before, drawings are rarely pure, rarely just one technique or another. The techniques are mutually supportive and you should avail yourself of them as necessary.

Structural Drawing

Structural drawing is a special form of modeled drawing, but, because it emphasizes the struc-

Figure 4-7.
Student drawing (detail) courtesy of Connie Cain.

ture of a form as well as the volume, it deserves separate attention. In structural drawing, hatching lines that cross the surface are drawn close enough together to create an area of value. But those lines *first* and most importantly describe *underlying* structure, the size and the direction of what lies underneath. Then, almost as a byproduct, those lines also describe value.

In Chapter 2, hatching was described as a means for creating value. Michelangelo's *Head of a Satyr* was cited as an example (Figure 4–4). Look at that drawing again. The volume expressed by Michelangelo is dictated by the underlying bone/muscle of the head and neck. The lines reveal it by following the curves of the surface and by their density. Look at the nose—you are able to see where and how the bone and cartilage are structured beneath the surface drape of the skin. The same is true throughout the drawing. Look further. Study especially the cheekbone area, the jawbone terrain, and the eye in its socket.

The drawing by George Bridgman is another crystal clear example of the results of structural drawing (Figure 4–8). Both bones and muscles of the work are amply revealed. They are the visually readable substructure.

Practical for Structural Drawing

MATERIALS. *Conté pencil, HB pencil, or pen and ink, with the appropriate paper, 18"×24".*

Add another self-portrait to those you did for modeled drawing. This time, of course, use hatching to communicate structure, i.e. the bone and muscle

beneath the surface of your body. If you feel uncertain about that structure, you may wish to read the section of Chapter 5 on anatomy first.

VISUAL INTRIGUE

The subject of many books on design, visual intrigue is what makes you look twice at a work. A drawing that is technically skillful and emotionally satisfying still needs the visual intrigue that results from imaginative design.

To design imaginatively, you first need to understand the basic nature of design, which is to bring *order out of chaos*. Whether you are planning a drawing or a shopping mall, you must take disparate elements and organize them into a successful whole. Five hundred people in a room are just people milling about. Give them chairs, an agenda, and a moderator, and they become a town meeting. Give them a cause, banners, and a marching permit, and they become a demonstration. They can be organized effectively in a variety of ways, but, without organization, they are nothing in particular. So it is with art.

Design Process

There is no magic formula for good design. There is, however, an identifiable process leading from disarray to design, and it can be ap-

Figure 4-8.
GEORGE B. BRIDGMAN.
Untitled drawing of the neck.
Reprinted by permission of Sterling Publishing Co., Inc. from *Bridgman's Complete Guide to Drawing from Life* by George B. Bridgman ©1952 by Sterling Publishing Co., Inc., New York.

plied to any project from a drawing to a shopping mall. The stages are outlined as follows, based on a hypothetical project. (Note: This process is derived from the one presented by Marjorie Bevlin in *Design Through Discovery*.)

A. *Preparation*

 1. *What is the project?* An assignment to draw a child, a modeled drawing, due in two weeks.

 2. *What are the limitations?* Only those stated in the problem. It is to be a drawing of a child, modeled, due in two weeks.

 3. *What are the freedoms of choice?* Medium, size, paper, source of image, whether it is to be done in color or black and white, and the age, sex, pose, and setting of the child and whether or not it is to be a close-up.

 4. *What influences these choices?*

 a. *Practical Considerations:* Choice and availability of models and how much time is to be spent on the project.

 b. *Personal Preferences:* What materials do you like? What size surface? What pose appeals to you? What setting? What mood do you want to establish? Do you prefer close-ups? What kind of source material do you prefer: sketches, photos, or a live model?

B. *Production*

 1. *Intuition, Inspiration, Outside Comments:* Though you have worked through many questions, this part of the process is a time when you are deeply immersed in the work and in tune with the part of yourself that makes possible inspirational and intuitive leaps. At this point, you take the various elements you have chosen and decide how you will combine them into a well designed whole. You also listen to the comments that informed viewers make on the work.

 2. *Modification:* Based on inspiration, intuition, and the comments of others, many alterations may take place. Each bit of progress in the drawing can, in turn, suggest other modifications that could not have been thought of before. Willingness to alter your work all through this stage is important.

C. *Post-Production*

 1. *Self-Critique:* After the work is completed, set it aside for a day or longer. Come back to it when your mind is as cleared as possible of the creative process. Subject it to your most rational, severely critical eye. Rarely does a work meet expectations. As you look at it, you should objectively assess the strengths and weaknesses so you can mobilize your insights for change in future work.

 2. *New Ideas:* After completion, your drawing may suggest directions for future work quite unlike what you have been doing. Welcome these possibilities, for it is through them that any work offers growth potential to an artist.

In the "production" stage, you must consider basic traditional design issues, as you search for your personal plot for visual intrigue. These issues can be grouped broadly as *issues of contrast* and *issues of unity.*

ISSUES OF CONTRAST

The aspects of drawing that we have already considered or that we will consider later—line, value, color, shape, space, volume, texture, depth, even mood—all provide myriad possibilities for contrast that help us to recognize and respond to what we see.

Value contrast reveals form. Form contrast reveals the three-dimensional world to us. Line contrast can be an electric accent. Color contrast bears on mood, meaning, and personal response. Mood contrast is not common, but it can be used to reveal abstract truths. A somber face for example, in a cheerful environment might put both in sharper focus because of the contrast.

So contrasts are essential to our perception and understanding. But they must be organized in some way, or they are simply confusing.

ISSUES OF UNITY

All the elements of drawing in their great diversity and potential for contrast are available for use in any work. An artist must have some means of bringing them into harmonious relationship with one another. In addition to the discipline of the whole design process, as outlined, these means include use of focal point, balance, rhythm (repetition with variation), tension, weight, and transformation.

In Figure 4–9, you see three arrangements of just seven lines. Even though all contain elements that can be described as seven lines, the three arrangments are very unlike. Why? And which of the means of unity just mentioned brings those lines into harmony in each arrangement?

In Figure 4–9a, the lines are rhythmical. They are all straight lines, but they differ in their length and direction; they are repetitious yet varied. All have about the same visual weight. Together, because they are closely clustered in one area, they form a focal point for the whole piece. So rhythm, weight, and focal point provide the unity in this figure.

Figure 4–9b presents seven quite different lines. They vary from straight through curved and from meandering to erratic. They also vary in direction and in length. With so much contrast, what holds them together and allows them to function as a unified design? There is no clear focal point. Yet there are points of tension where two lines come very close to each other, "trying" to touch, or where they intersect. Altogether, these tension points are located so as to guide the eye through the lines, creating not a focal point, but a focal path. And they are all lines, one not much more fragile or much stronger than the rest. There is a family resemblance, a rhythm. Finally, there is transformation in this arrangement. A straight line gradually becomes more curved, then disorderly, and finally a scribble. Unity, then, results from tension, rhythm, and the process of transformation.

One "intrigue" of both Figures 4–9a and 4–9b, comes from playing a group of lines against unoccupied space. In Figure 4–9b the lines function together almost as one moving organism traveling to the right into the void and thus actively involving that space. In Figure 4–9a, the unoccupied space is abundant but involved by the barely disciplined line group because it suggests imminent dispersal in all directions.

In Figure 4–9c, both balance and focal point are radically different. The balance is basically symmetrical. (A line can be drawn that divides the piece into two roughly equal parts.) The focal point is clearly the hub from which the lines radiate. This arrangement creates a more traditional design, a design that engages its space more completely and arranges the lines in

(a)

(b)

(c)

Figure 4-9.

order from straight through scribble, an easily perceived transformation. The rhythm, again, flows from the repeated lines and their repeated, though very varied, curves. It is a stronger beat because, in addition, there is a repetition in placement. All the lines are roughly equidistant, but only roughly—there is some variation. The placement repetition is balanced by more variation in the length of the lines than there is in Figures 4–9a and 4–9b. In this example, unity results from symmetry, focal point, sequential transformation, and repetition.

The Path to Visual Intrigue

To further see how organized contrast yields visual intrigue, let's analyze two master works that are clearly intriguing. The question to be answered is, Why are they intriguing? A general response, of course, is the fascination with images of our own kind, as mentioned in Chapter 1. The viewer is almost automatically intrigued. What does the artist contribute? Study the analyses, question them, and see if you agree. And use what you learn to make your own work fascinating.

Chuck Close's self-portrait, reproduced in Chapter 3 (Figure 3–7) and again in this chapter, should be familiar by now. The diverse textures identified in Chapter 3 are related by means of an overall unifying mood. They are also related by being all white, gray, or black—no other color—by being done entirely in pencil, and by our familiarity with all these textures as possible when the human face is the subject. The textural variety is intriguing, but there is more to it.

First of all, the drawing is large—about 29″×23″. The head is twice life size. On the wall, the image is compelling if for no other reason than its scale. In the smaller-than-life-size reproduction however, large scale has nothing to do with its intrigue. What else is involved?

The placement of the head is of interest. It is within a fraction of an inch of being dead center from side to side, and there is more space at the bottom than at the top. Very traditional. The head also looks immobilized, as though Close had a brace on his neck so he could pose that way for 15 minutes. This sense of rigidity is reinforced by the frontal view and by the dark-rimmed glasses that look like a vise gripping the head and evoke a business or professorial image. The traditional placement, the pose, the glasses, and all they evoke make for a delicious contrast to the unconventional appearance of the subject. This tension creates paradox—a vital element in the intrigue of this work.

If you look at the drawing so objectively that you can see it simply as a collection of shapes (squinting helps), those shapes all have something in common. In spite of the disparate textures, in spite of the appearance of untidiness, all those shapes are related by the absence of straight lines. They all curve. Out of this unity comes another contrast: soft, gentle curves versus the subject's appearance of toughness.

The expressed attitude also deserves comment. Who displays himself in such a ragged manner? Whatever became of traditionally pleasing portraits? This disregard for pleasantry comes across as honesty. The observer is prepared to believe that this is the essence, the *real* Chuck Close, and that the artist has focused an uncompromising eye on himself. To our present-day satisfaction, he accepts what he sees and presents it—larger than life—for all to see. We are repelled and attracted at the same time. A remarkable portrait.

The other subject of our intrigue analysis is very different in a number of ways: the medium (charcoal versus pencil), the subject (a neighbor, a woman, versus male self), the pose (near profile, looking down rather than frontal view seen from below), and most especially, the mood. The work is *Reverie: Portrait of Agnes Ruddy*, done by Lilian Westcott Hale (Figure 4–10, which you may remember from Chapter 2).

This portrait was done forty years before Chuck Close did his, but the distance seems greater. One reason is that the mood, while it expresses emotion as understandable as Close's, is developed through the presence of a person so lovely and womanly that we are drawn irresistibly to her rather than repelled. Almost every visual element is consistent and harmonious with the "reverie" of the title and with the gentle softness of the person. The undercurrent of sexuality, however, isn't gentle. Its existence is underscored by the evocative touch of the tassle on the chair, suggesting sultans' cushions, harems, and lust. It is further underscored by the long, abundant, soft black hair set free before our very eyes—a private vi-

Figure 4-10.
LILIAN WESTCOTT HALE (American, 1881-1963).
Reverie: Portrait of Agnes Ruddy (Charcoal).
Private Collection.

Figure 4-11.
Diagram of compositional diagonals in Figure 4-10.

sion made public. Therein lies the chief mood contrast—the softness, the fragile appearance, the touch of sadness in the reverie, the downcast eyes versus the intense womanliness and sexuality.

Another major contrast is quite obvious: the wealth of black hair and barely visible dark eyes, against the rest of the drawing.

Further, the still mood contrasts with the active diagonals on which the whole composition is based. These diagonals are moving through the drawing with vigorous strength (Figure 4–11). As a result, Hale's drawing, compared to Close's, has great motion, which is in direct contrast to the stillness of mood. Close reveals personal force held in control by compositional stillness. Hale gives us mood stillness activated by compositional motion.

Like Close's work, Hale's is unified by the controlled use of a one-color medium throughout. In Hale's work, there is also a unity of touch. Everything is soft. Further, major diago-

nals form three sets of parallels. Thus is intrigue built. Contrasts are established and then are harmonized by design controls.

The following Practicals help you to absorb this concept even further.

Practicals for Contrast/Unity/Intrigue

1. Select from this book five varied portrait drawings that you like very much. Analyse their organization in terms of contrasts and the forces that unify those contrasts. Consider all sources of contrast and all means of creating unity so that you can identify those operative in each of the drawings. Save these analyses, and, if possible, share them with a peer or someone more experienced for their reactions and additional ideas.

2. Now select the two best drawings you have done for Practicals in this book, and analyze them in the same way. By doing so, you are strengthening the invaluable capability of evaluating your own work.

REFERENCES

Techniques

1. KAUPELIS, ROBERT. *Learning to Draw.* New York: Watson-Guptill Publications, 1966.

2. MENDELOWITZ, DANIEL. *A Guide to Drawing.* New York: Holt, Rinehart & Winston, Inc., 1976.

3. NICOLAIDES, KIMON. *The Natural Way to Draw.* Boston: Houghton Mifflin Co., 1975.

Visual Intrigue

1. ARNHEIM, RUDOLPH. *Art and Visual Perception: A Psychology of the Creative Eye.* Berkeley: University of California Press, 1974.

2. BEVLIN, MARJORIE ELLIOTT. *Design Through Discovery.* New York: Holt, Rinehart & Winston, Inc., 1980.

3. LAUER, DAVID. *Design Basics.* New York: Holt, Rinehart & Winston, Inc., 1979.

CHAPTER FIVE

Building a foundation: interior anatomy and exterior geometry

More often than not, people (especially adults) compose their faces into masks, allowing their masks to express what they wish them to express. The fascination of good portraits is that they are created from these masks but the personal, subjective, and emotional responses of the artist allow more to be revealed.

At the same time that the artist is expressing a personal vision, factual vision is also required, utilizing anatomy and geometry to make a subjective drawing objectively convin-cing. Specifically, the head must look as though it is built from the bones of the skull, and it must look as though its structure occupies real space—has real depth. On this solid understructure, a portraitist can move further and add the surface features to create a particular likeness.

When these two skills—building an understructure and adding surface likeness—are well developed, artists are in a strong position to cultivate personal responses to what

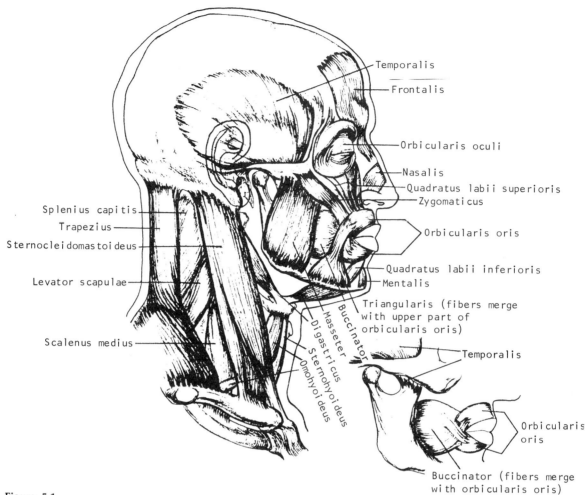

Labels on figure: Temporalis, Frontalis, Orbicularis oculi, Nasalis, Quadratus labii superioris, Zygomaticus, Orbicularis oris, Quadratus labii inferioris, Mentalis, Triangularis (fibers merge with upper part of orbicularis oris), Splenius capitis, Trapezius, Sternocleidomastoideus, Levator scapulae, Scalenus medius, Buccinator, Masseter, Digastricus, Sternohyoideus, Omohyoideus, Temporalis, Orbicularis oris, Buccinator (fibers merge with orbicularis oris)

Figure 5-1.
Untitled drawing of the bones of the head and neck
adapted from *The Human Figure: An Anatomy for Artists* by
David K. Rubins.
Copyright 1953 by David K. Rubins. Copyright renewed 1981 by David K. Rubins.
Reprinted by permission of Viking Penguin Inc.

they see and to express their responses in individual ways. Pablo Picasso's abilities were developed in that order. Few of us have Picasso's towering genius, but it is encouraging to see from his early works that he began by learning underlying structure and by acquiring great skill at creating surface likeness. These capacities were prerequisites to personal expression. They helped give him the confidence and ability to mold human form in whatever way would convey what he felt, as you will see in Chapter 7.

Your personal sensitivities may also lead *you* in a number of directions. To begin the process, however, everyone needs the foundation provided by studying the body structure and visualizing the basic forms of the body as geometric solids. This chapter focuses on that foundation. Chapter 6 discusses adding surface features, and Chapter 8 examines personal responsiveness. You therefore will experience in some depth a three-part system of access to portraiture.

Many portraits include much or all of the figure. However, this book concentrates on the head, neck, and shoulders, because they are the special focus of portraits. The structure of the whole body is properly the subject of an entire book devoted to anatomy for artists, and several

good ones are listed in the References section. If you do not already own such a book, you should consider acquiring one or more.

FIRST, THE BONES

Head Bones

While the study of bone structure is important to all artists interested in the human form, it is especially vital to the portraitist. Unlike the rest of the body, the bony support is the strongest influence on the surface appearance of the head because so much of it sits so close to the surface.

To test this statement, look at the skull drawings in Figure 5–1 and refer to them whenever specific bones are mentioned in the following discussion. Take your fingers and place them behind your head at the base of your skull. Run them over the back of your head and feel the bone—hard and curving—just beneath the hair and covered only thinly with skin. Continue exploring up and over the top of your head. It's the same.

Now look in a mirror so you can not only feel but also *see* as you go on to your forehead. There the covering is slightly thicker because flat muscles lie beneath the skin. But the bone, curving forward to the eyebrows and to both sides toward the temples, still determines the shapes you feel and see. All of the area you've felt through your skin so far makes up the cranial vault. In adults, it is a hard, rigid form designed to contain and protect the brain.

Now run fingers across each eyebrow and around your eyes, following the hard edges of the eye sockets (orbital cavities). Press two or three fingers of each hand downward from the bottom of the eyes. You can feel your cheekbones (zygomatic arches) extending down about an inch and curving around to each side, going all the way to the ear and on behind it. The cheekbones are covered not only by muscle beneath the skin, as the forehead is, but also by flesh. The amount of flesh depends on age and weight.

Still looking in the mirror, put a finger between your eyes. You can feel the turning inward of the forehead and the pushing forward of the nasal bone, a short bone that goes only about one-third of the way down your nose. It is joined to a flexible cartilage that forms the rest of your nose. Wiggle the bottom of your nose

just to see how movable the cartilage is, how rubbery compared to the bone above it. Then press up on the bottom of your nose, and you discover another bit of bone support for the nose. A spur projects from the upper jawbone (maxilla) to participate in supporting the nose.

Continue by pressing two or three fingers of each hand against your upper lip, from just beneath your nose downward to your mouth. The hard support you feel this time is the upper jawbone plus half of the only visible bones in your body, your teeth. The lower lip is supported by a similar arrangement, teeth inserted into the lower jawbone (mandible).

Let your fingers travel down your lower lip to your chin, the hard projection of the jawbone. Move one hand to the left and the other to the right, and you can follow that hard bone almost to where your ears are attached. That long edge that does so much to form your face describes the direction of the lower jawbone, the only movable bone in your head. It moves easily up and down so that you can chew, talk, yawn, smile, and otherwise manipulate your mouth. It even moves a bit from side to side to allow you to grind your food between your molars.

Hold your hands on each side of your face, and press in gently so that you can simultaneously feel both prominences that are the boundaries of the cheek: the cheekbone at the top and the lower jawbone at the bottom. Between those bones is the fleshy curtain of the cheek covering a number of much used muscles. Except in starved faces, visual contact with these bones is lost.

Then move back toward your ears (which are also flexible cartilage) and behind them. Again you feel the hard cranial bones. You are back where you started.

One more bone area of the head must be mentioned, although it is not important in the surface we see. It is the point at which one of the most visible muscles of the head-neck-shoulder region begins. That muscle is the sternocleidomastoid (discussed later). Note the location of the mastoid process, to which one end of it attaches.

Neck Bones

The bones of the neck are the first seven vertebrae of the spine (cervical vertebrae). While the

head bones are close to the surface, the neck bones are not. They have a substantial overlay of muscle, which in turn is covered by flesh.

The neck vertebrae, however, have some influence on the form of the neck, which is only very roughly round or cylindrical. It is flattened at the back where the vertebrae present a wide, rather flat, winglike surface. The projection in the front of the neck, the Adam's Apple, is formed not by bone but by the thyroid cartilage that protects the larynx or vocal cords. It is more prominent in men than in women.

The other visible force on the neck portion of the S-shaped spinal column comes from its slight forward thrust at the top of the S, which is perceptible in Figure 5–1. Even when you throw your head back for a hearty laugh, your neck still tilts a bit forward in relation to the head. This tilt is especially important in profile portraits. Look at Figure 1–7. Michelangelo was well aware of the tilt of the upper end of the spinal column and its effect on the neck-head posture.

The top neck bone (the Atlas bone) joins the skull by cupping in its wings the two rounded projections at the very base of the skull (Figure 5–1). The resulting joint allows a rockerlike motion of the head back and forth. The side-to-side motion occurs because the first neck bone and the skull, together, rotate on the bone below. The arching or curving of the entire neck in all directions results from the simultaneous motion of neck bones two through seven.

Shoulder Bones

At the shoulder, bones begin to sprout out, like branches, from the spinal column. Beginning with the ribs, these bones all occur in symmetrical pairings with the spinal column as their axis.

The first pair of ribs starts the shoulders. Then the second pair of outward-reaching bones, combined with those ribs, makes the rest of the structure called the shoulder girdle. Figure 9–4 shows these bones in front and side views. The structure thrusts slightly forward and backward, as well as far to the right and left. In the back, it offers two large, flat, roughly triangular bones called shoulder blades (scapulas). They are slightly curved to conform to the

Figure 5-2.
ANGUSTUS JOHN (English, 1878-1961).
Self-Portrait (Red chalk on wove paper).
Yale Center for British Art, New Haven, Paul Mellon Fund.

shape of the rib cage under them. Because they are not attached in back, they tend to stick out in certain positions and look like fledgling wings—when you hold your arms behind your back, for example. The shoulder blades connect to the rest of the skeleton only by touching the slender bones that curve forward from them to the breastbone (sternum), where they attach. Completing the shoulder girdle, these slender bones are the collar bones (clavicles), which you can easily see and feel on yourself. They sometimes emerge as a strong element in portrait composition because they form a frame under the face or a base for it (Figure 5–2) or because the space between their ends creates an engaging hollow (suprasternal notch) at the base of the neck.

Functioning chiefly as movable supports for the arms, the shoulders move independently of the neck and spine. They are capable of tilting and twisting in all directions.

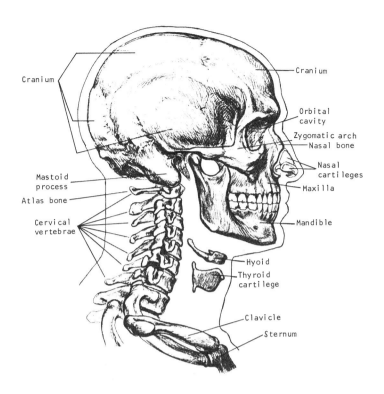

Labels on figure:
Cranium
Cranium
Orbital cavity
Zygomatic arch
Nasal bone
Nasal cartileges
Maxilla
Mastoid process
Atlas bone
Cervical vertebrae
Mandible
Hyoid
Thyroid cartilege
Clavicle
Sternum

Figure 5-3.
Untitled drawing of the muscles of the head and neck from *The Human Figure: An Anatomy for Artists* by David K. Rubins.
Copyright 1953 by David K. Rubins. Copyright renewed 1981 by David K. Rubins. Reprinted by permission of Viking Penguin Inc.

NEXT, THE MUSCLES

The body has so many muscles that the prospect of dealing with them all can be awesome. However, an artist needs to learn only about those that influence surface appearance. In the head, neck, and shoulders, very few of the existing dozens are important enough in that respect to merit attention.

Muscles of the Face

A great variety of facial expressions are controlled by the contraction and expansion of the muscles shown in Figure 5–3. You should be aware of some of the things these muscles are able to do, although you need not necessarily master their names.

The frontalis muscles (a) cover the front of the cranium and let you wrinkle your brow or raise your eyebrows. The corrugator, a muscle that runs beneath the frontalis (and is therefore not shown on the diagram), is at the center front of the cranium. It enables you to wrinkle your skin by frowning or by pulling your eyebrows together. The orbicularis oculi muscles (b) allow you to close and squint your eyes. Combinations of other muscles (c through j) let you open and close your mouth, grimace, play the flute, smack your lips, and make other movements. When you pout or your chin quivers, the muscle labeled as "k" is responsible.

The results of the contraction and relaxation of these muscles is highly visible, but the form of the muscles themselves is rarely apparent due to the amount of covering flesh. An emaciated face may reveal one or two. Conse-

quently, Figure 5–3 serves as a reference for the facial muscles, but you need to become specifically acquainted with only two, the masseter (l) and the zygomaticus (d).

Stand again in front of the mirror and clench your teeth. Observe that the masseter contracts and bulges outward in a rich curve over each jawbone. Put your hands over the masseter and clench again. You can feel the contraction/relaxation process occur beneath your fingers. (You now have an idea of how every muscle in your body behaves, whether or not you can see and feel it.)

Finally, note the zygomatic muscle (d). It creates a subtle facial "edge," a turn from the front to the side plane, as seen in Figure 5–2. Though subtle, the turn is a structural landmark for the face.

In Chapter 10, the effect of the passage of time on facial muscles and the visible results are explored.

Muscles of the Neck and Shoulders

As with the head, the neck-shoulder region contains a number of muscles. But only two of them have a surface effect that can generally be observed. In Figure 5–3, look at the trapezius (r) and sternocleidomastoid (s). Unhappily, there are no short or common names for these muscles, although knowing *why* (s) has such a long name may make it easier to remember. One end attaches by tendon to the sternum and clavical, and the other end connects to the mastoid bone at the base of the skull, which was pointed out earlier. Hence sterno-cleido-mastoid.

These two pairs of muscles are always involved in the movement of the head, neck, and shoulders, and they are often very visible, as you can see in Figure 4–8. The sterno-cleidomastoid is the long, cylindrical muscle. The trapezius begins that way, but it becomes flatter, spreading out over the triangular shoulder blade. These two muscles are involved in all the motions of the head and shoulders, looking slightly different in each position. It is therefore important for you to seek out the surface effect they create each time you work on a portrait in which they are visible.

BETWEEN MUSCLE AND SURFACE

Between the muscles and the skin, there are veins and blood vessels, which generally have so little effect on surface appearance that they are not considered here. Sometimes, in thin or elderly subjects, veins stand out in the temple or throat areas. Occasionally, they are included in portraits because they enhance a special effect.

In addition, there are layers of fat which vary greatly depending on age, sex, body type, and weight. The fat gives a smooth contour to the body surface. Women develop less muscle and more fat than men, and they therefore usually have a smoother, more rounded appearance.

GEOMETRY

Two "geometry" approaches will help you to see and to draw the three-dimensional form of the head: One employs curved planes; the other, flat planes and angles. It is useful to be able to use both because some heads are quite rounded and others quite angular.

APPROACH 1

Think of the head as an egg-shaped form on top of a cylinder (the neck). This way of looking is useful later in placing features, for in reality our features exist on a curved plane. It is also usually helpful in seeing the shadows on the sides of the face, which reveal the planes turning away from the light (Figure 5–4). This "egg-form" way of looking is also a familiar one. From earliest childhood, we represent a head as a rounded shape.

Figure 5-4.
Geometry of the head: curved planes.

APPROACH 2

Seeing the head in an angular way, specifically as a rectangular solid or box, is perhaps more difficult but very useful. It is a way to see the linear perspective involved in the planes of the head as it tilts and turns (Figure 5–5). The angular approach can be carried through to the shoulders by threading the head like a bead through the neck to another rectangular solid, the upper torso.

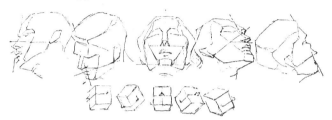

Figure 5-5.
GEORGE B. BRIDGMAN.
Untitled geometric drawings of heads.
Reprinted by permission of Sterling Publishing Co. from *Bridgman's Complete Guide to Drawing from Life* by George B. Bridgman. © 1952 by Sterling Publishing Co., Inc., New York.

Seeing as boxes and rounded solids is a good first step to assessing the volumes of the human form as they exist in space. You can also learn a great deal about this technique from the books by George Bridgman, which are full of his figure drawings based on rectangular solids. One of those books is listed at the end of this chapter.

ONE- AND TWO-POINT PERSPECTIVE

To get the most from Bridgman, and the process he and others espouse, some familiarity with one- and two-point perspective, as applied to rectangular solids, is essential. Very careful observation reveals how forms look as they turn in different directions, just as it did to Leone Battista Alberti who wrote the first treatise on perspective in the 1400s. (It was 400 years before his observations were proved to be accurate by the objective eye of the camera.) With a few of Alberti's perspective principles and some practice, you will learn to estimate perspective well enough to let you deal rapidly and usefully with rectangular solids (such as heads) from a variety of angles. Don't become discouraged by the following introduction. It may seem complex, but a little practice dispels the complexity, and reveals its usefulness.

Figure 5-6.
Horizon line location.

Perspective is always related to the viewing level, or eye level, of the artist. The eye level is a line parallel with the horizon and as far away as the eye can see. If vision is unimpeded all the way to the horizon, then eye level coincides with the horizon line. If vision is interrupted by a wall, a mountain, or some other form, then the line lies across whatever that interruption is. *It is as high or as low as the viewer's eyes,* as in Figure 5–6.

When you are working on a portrait from a model and cannot see the horizon, the solution is to decide where on your drawing surface you would like to place the head. Then look straight before you, and assess where your eye level falls in relation to the head. Is it above? Below? Are you looking right at the face so that your eye level bisects it? Draw a horizontal line across your paper in correct relation to the head. That line serves accurately as a horizon line.

When you first look at a head and you are just getting used to establishing a horizon line, it is helpful to have some clues. If you are looking up at a head, the horizon line is *below* the head. You know that you are looking up because you see some or all of the underside of the chin. If you are looking down, with the horizon line *above* the head, you see the top of the head. If you are looking straight ahead, you see neither the top nor the bottom. (See Figure 5-7.)

To test these guidelines, take a small box that is roughly a cube. Draw features on one side. With that side facing you, hold it above your eyes. You see more and more of the bottom of the box as you raise it higher and higher. Now move it down below your eyes. You see the top. Practice establishing a horizon line with this box. Draw the front side of the box in various relations to the line—above, intersecting, and below.

Figure 5-7.
Clues to horizon line location.

To draw the *bottom* view of the box above your eye level and the *top* of the box below your eye level, look again at Figure 5–8. The dot in the middle of box 2—the point on the horizon line where a line drawn from your eye intersects it—is the vanishing point. This point is another useful concept because lines drawn to the vanishing point from the corners of boxes 1 and 3 in Figure 5–8 look like the sidelines of the bottom and top respectively of those boxes, as shown in Figure 5–9. Now all you have to do is draw lines parallel to the bottom of box 1 and the top of box 3 in the place that will complete and look right for a cube. This is how you use one-point (one-*vanishing*-point) perspective. (See Figure 5-10.)

You can check the visual truth of what you are doing with your small box with a face on one side. Raise it above your eye level. Look at the shape of the bottom as it *appears*. You *know* it is square, but you *see* a trapezoid. Now, in the same position, turn the face side *down*. You instantly realize that the face could just as well be in that position if the subject were looking down. (See Figure 5-11.)

As just seen, cubes drawn in this way can become heads looking down, up (when the box is below the horizon line and the face is on the top side), or straight ahead. All, however, are positioned directly in front of the viewer.

What remains is looking at heads that are to the left and right of center, that is, at an angle to your straight-ahead line of vision. When you do this, you see two or three sides of the head cubes, rather than one or two as you do when the form is directly in front of you. (See Figure 5-12.)

The single most important fact you need to know to handle this situation—which is two-point perspective—is that the top and bottom lines *always* slant toward the horizon line. When extended, they meet at vanishing points, one to the right and one to the left. One or both vanishing points may be off your drawing surface,

Figure 5-8.
Locating the front of the box in relation to the horizon line and the location of the vanishing point.

Figure 5-9.
Side lines drawn toward vanishing point.

and establishing them on an adjacent surface is awkward. But if you remember the principle—bottom and top lines tilted toward the horizon line—you can satisfactorily approximate accu-

Figure 5-10.
Completing the cube.

Figure 5-11.
Box with face side down.

rate perspective (Figure 5–12 again). *And* you can draw the box in any relationship to the horizon line, with any side as the face or features side.

So much for erect head positions.

If heads are tilted so that the sides of the heads are no longer at right angles to the horizon line (as is very often the case when dealing with real-life situations), then you have to tilt your horizon line until those sides are again at right angles to it. Then slant the tops and bot-

toms of the heads toward the *tilted* horizon line. See Figure 5–13 for an example of the process and of the sort of result you get.

Each of the following Practicals is designed to give you experience that is important in building portrait drawing skills. Do them all. There are no time limits. Give each the time needed to do a fully satisfactory job.

A list of books recommended as sources for further information on anatomy and perspective can be found in the References section.

Figure 5-12.
Viewing at an angle: 2-point perspective.

Figure 5-13.
Tilted horizon line.

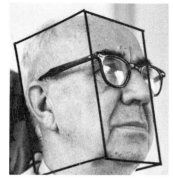

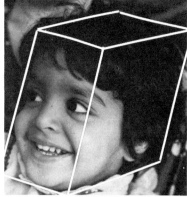

Figure 5-14.

heads in the photos should be fairly large, at least 2" to 3" from top to chin. With each one, determine first the vantage point of the camera—above, below, to the right, and so on. Then draw around the heads rectangular solids that follow the planes of the heads. Use soft pencil or magic marker.

To give you a start on this problem, Figure 5–14 shows two examples. It is a difficult process, but persistence pays off in your knowledge of, and confidence with, the exterior geometry of the head.

REFERENCES

Anatomy

1. BRIDGMAN, GEORGE B. *Bridgman's Life Drawing.* New York: Dover Publications, Inc., 1971. Bridgman calls this "the story of the blocked human form where the bending, twisting or turning of volume give the sensation of movement held together by rhythm." Thus it combines both the anatomy *and* geometry of the human body.

2. GORDON, LOUISE. *How to Draw the Human Figure: An Anatomical Approach.* London: Penguin Press, 1980.

3. ———— . *How to Draw the Human Head.* New York: The Viking Press, 1977.

4. KRAMER, JACK N. *Human Anatomy and Figure Drawing: The Integration of Structure and Form.* New York: Van Nostrand Reinhold & Company, 1972.

5. RUBINS, DAVID K. *The Human Figure: An Anatomy for Artists.* London: Penguin Books, 1975. This volume includes some information on the aging process.

6. SCHIDER, FRITZ. *An Atlas of Anatomy for Artists.* New York: Dover Publications, Inc., 1929. Schider does not present female anatomy. The text is separated from all illustrations and therefore awkward to use. However, backmatter of great interest such as numerous hand studies, good proportion charts, Muybridge photos of the figure in action, and more than 70 anatomical drawings by the old masters has been added in American editions.

Perspective

1. COLE, REX VICAT. *Perspective for Artists.* New York: Dover Publications, Inc., 1976.

2. WATSON, ERNEST W. *How to Use Creative Perspective.* New York: Reinhold Publishing Company, 1974.

Practicals

MATERIALS. *For Practicals 1–5, white paper or newsprint, and a pencil (HB or softer).*

1. To understand more fully the skull as the understructure of the head, make a contour study from the profile skull drawing in Figure 5–1, enlarged to life size. As you do this study, think of the push and pull of the surface, of the way the planes turn. (If you can gain access to a human skull through the biology or art department of a local school, make a profile contour drawing from it instead.)

2. If you can find a skeleton to draw from, do a close-up contour drawing—life size or larger—of the seven neck vertebrae, thinking as you do them of how they function.*

3. Again, if you can gain access to a skeleton, do contour drawings of the shoulder girdle from several angles. Consider, as you do them, how the structure forms the shoulder, supports the arm, and promotes motion. Think of the space these bones occupy.

4. From Figure 5–3 showing the muscles of the face, make a life-size drawing, doing only the outlines of all the muscles. Think about the functions of each as you draw them.

5a. Place several boxes (white if possible) that are roughly cubes and roughly head-sized on a surface below your eye level (most tables or desks will do). The boxes should not touch and should be at different angles. Draw them from several different positions. Notice which sides are in shadow, and fill them in with an appropriate shade of gray.

b. Arrange the same boxes on a surface that is above your eye level. Proceed as in Practical 5a.

c. Do the same as in 5a and 5b with a grouping of three eggs.

6. Gather at least a dozen newspaper or magazine photos of heads taken from various angles. The

**If a skeleton cannot be found, use the Kramer book listed in the references, and draw the vertebrae and shoulder bones from its illustrations, enlarging them to life size.*

CHAPTER SIX

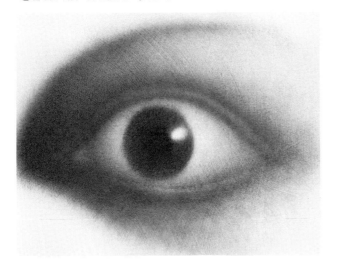

Structuring the surface: features and their geometry

In Chapter 5, the understructure and resulting geometric presence of the head and shoulders were discussed. The goal of this chapter is to make the transition from generalized geometric forms to the distinctive features of individual heads, which, of course, is what turns those forms into portraits. In the process, you will become more familiar with the complex surfaces of heads, as well as with the way those complex surfaces relate to interior structure.

FEATURES

Dividing the head into features is artificial because we look at the whole, and the whole is more than the sum of the parts. Much of a person's spirit and personality is conveyed through the expression or "set" of the features functioning together in the face. Nevertheless, the process of investigating the structure and appearance of the head is more manageable if it is considered one feature at a time.

Eyes

Drink to me only with thine eyes
And I will pledge with mine

Ben Johnson, *Celia*

63

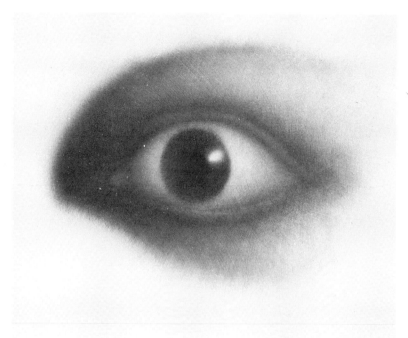

Figure 6-1.
RODOLFO ABULARACH
(Guatemalan, 1933-).
Circe (Ink), 1969, 23″×29″
San Francisco Museum of Modern Art; Gift of San Francisco Women Artists.

The subject of romantic verse and song, as well as focus of most portraits, our eyes "speak" for us to each person we meet. To express the romance and mystery of eyes, it helps to understand their structure.

An eye is roughly a sphere. The visible half is white, with a center opening (pupil) that looks black and expands and contracts depending on how much light falls on it. It is surrounded by the iris, a ring of color ranging from light gray, gray-green, and blue through browns that can be so dark they seem almost black. The iris contracts when the pupil expands and vice-versa. Thus eyes, especially those with a light colored iris, may look surprisingly dark if the black pupil is wide open. A transparent cornea covers and projects from the iris and pupil enough to make the eye bulge a little. The complete eyeball is held in place by muscles that fasten it in back, and by upper and lower eyelids that embrace it in front (see Figure 6–2).

The surface form of the eye is that of a sphere, swelling forward from the depth of the eye socket and causing the eyelid to follow its form. Conveying these spherical presences is most important. One way is by showing clearly and accurately the curve of the eyelid edges as they go across the eye. Note in Figure 6–1 just how three dimensionally compelling that arch-

ing edge is. The eyelids sometimes reveal the bulge of the cornea, which moves as the eyeball turns from left to right and up and down. In Figure 6–3, you see the bulge in Bridgman's structural analysis of the eye.

In Figure 6–4, you can also see that each eye is different. The standard of beauty, an almond shape ⬯ almost never occurs. Eyes vary from that standard because of the way the lids curve, for example ⬯ . Further, eyelids, which do much to communicate the three-dimensionality of the eye, are themselves three-dimensional, as you can see for yourself in a mirror and in Figures 6–1, 6–2, and 6–3.

Figure 6-2.
Diagram of the eye.

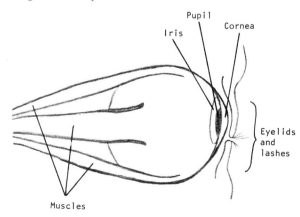

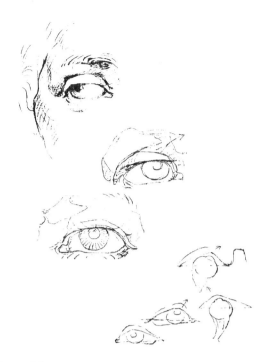

Eyelashes, the delicate feelers that make the upper eyelid close when they are touched, always grow from eyelids, yet they are seldom seen in a drawing or even a photograph except in profiles . At a distance of a few feet, eyelashes lose their individual character (unless they are heavily made up or false).

When you see a drawing with eyelashes carefully and separately drawn in, you may conclude that the artist was functioning on the basis of what was *known* (eyelashes exist that way), not on what was *seen* (eyelashes create only a generalized darkness along eyelid edges). Look at the drawings in this book to see how masters have handled this question. Notice especially Figure 6–1. Abularach has drawn one eye 23″×29″—a *dramatic* enlargement. You would expect eyelashes there if anywhere, but is the effect less realistic without them?

If on occasion you *need* to draw eyes with eyelashes, you should observe that they grow in three rows and are longer in the center than toward each end. Otherwise, they may be straight

Figure 6-3.
GEORGE B. BRIDGMAN,
Untitled drawings of the eye.
Reprinted by permission of Sterling Publishing Co., Inc., from *Bridgman's Complete Guide to Drawing from Life* by George B. Bridgman. ©1952 by Sterling Publishing Co., Inc., New York.

Figure 6-4.
Eyes of various shapes.
Photos by Phoebe Francis.

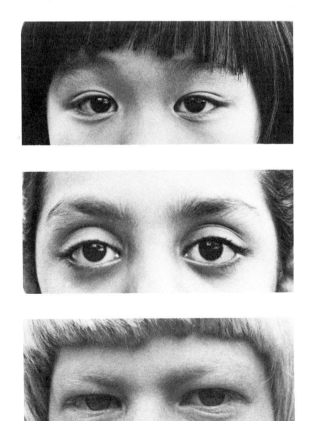

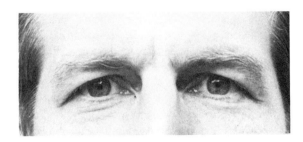

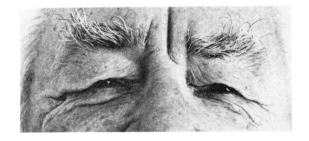

or curved, light or dark, thick or sparse, long or short. If eyelashes are short, sparse, or light, they are all but invisible, even at close range.

Although eyes play a major role in expressing feelings, in and of themselves they can show no feeling—no joy or grief or surprise or fear. It is not the eyes but the eyelids that change. Eyes appear to change expression only because the flesh around them moves.

Look into a mirror. As you smile, look surprised, or squint, the eyelids move, chiefly the uppers. The contours of the whole face support the eyes in this emotional expression. Note in Figure 6–5 (close-ups of eyes showing different feelings) that, while it is possible to identify the emotions in a general way, you miss the supporting environment of the rest of the face to help distinguish awe from terror or anger from seriousness.

One last point about observing and drawing eyes. The "whites" of the eyes usually appear to be gray. The lightness or darkness of the gray depends on how shadowed the area is by the hood of eyelashes. As the surface turns away from the light, it appears even grayer. This is very important because "whites" that are too white appear to pop out of their sockets.

Practicals for Drawing Eyes

MATERIALS. *Pencil or Conté pencil, felt tip pen, and white bond or rough newsprint.*

1. To experience different eye shapes, take large newspaper photos and outline eyes with a fine felt tip pen. Choose faces at various angles. Notice the curves of eyelids as they follow the surface of the eyeball. Notice the depth of the eyelids. Do ten or more. Keep a few to remind you of how varied eye shapes can be.

2. To reinforce your observations in Practical 1, copy the eye in Figure 6–1 using pencil or charcoal.

3. Choose any one of the photos of eyes in this chapter, and, on separate sheets of paper, draw one of the eyes, then the other. Are they symmetrical, one to the other? Choose another photo in which the eyes are seen from a different angle, and do both eyes at once, a task different from the last because it requires relating the eyes to the nose/forehead area between them.

4. Seated very close to a mirror, draw one of your own eyes. Study both of them first. Notice how different they are, perhaps in size, in the position of lids, or in their angle or height on your face. Choose one and do separate gesture, contour, and modeled

(a)

(b)

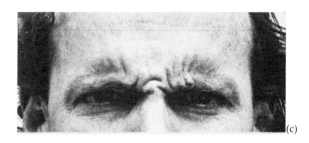
(c)

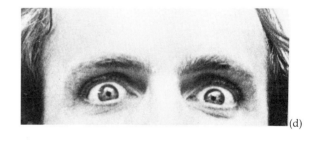
(d)

Figure 6-5.
Eyes from faces showing (a) Pleasure, (b) Sadness, (c) Anger or seriousness, (d) Surprise or fear.
Photos by Phoebe Francis.

drawings of it, life size or larger. Now, on another sheet of paper, do the other eye. Then do both together on one sheet.

5. Ask a friend or family member to sit for you, and repeat the sequence in Practical 4.

Eyeglasses

Though people are not born with them, eyeglasses are as much a "feature" of some people as the eyes behind them. My husband has worn

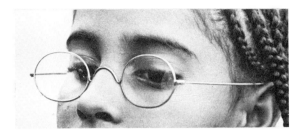
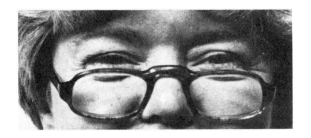
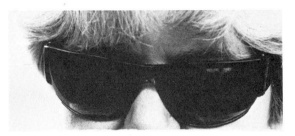
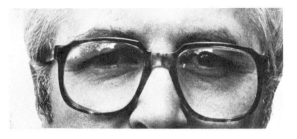

Figure 6-6.
Eyeglasses: a part of the face.
Photos by Phoebe Francis.

glasses since he was 18 months old and has never been able to see himself without them. Who would do a portrait of him without his glasses? He would look like a stranger. My own glasses became a fixture only recently. Friends know me with or without them. If I were doing a self-portrait, I would have a choice.

The point is that glasses are a visual part of some people, so you must be able to handle them as necessary. Doing so requires that you (1) analyze their shapes and (2) deal with their glossy surface. You should also realize that thick glasses distort the wearer's eyes by making them look larger or smaller, and, from certain angles, they also distort the line of the face. If the distortion is great, you may wish to modify it somewhat so that the distortion itself does not become the focus of your work—unless that is the emphasis you seek.

In analyzing the shapes of glasses, each lens looks different, unless you look at a person straight on, as Chuck Close did in his self-portrait (see Figure 3–7). In Figure 2–2, the glasses are in fact round, but we see ellipses, each one different from the other, because the view is not straight on. Lenses may also be larger than you think. Observe carefully and record what you see, not what you know.

Look again at Figure 3–7. Notice that in order to convey a sense of the texture of the glasses, Chuck Close has shown light reflecting from the surface. And, of course, he has dealt with their transparency and has drawn one eye significantly larger than the other. You may find less information is needed to suggest the glass. For example, if highlights are distracting, omit them.

Sunglasses pose another condition. They mask eyes partially or completely, and their inclusion in a portrait indicates either a person partly recognized by them, or a bright-sun environment (beach, ski slopes) that calls naturally for them. In some cultures, they are worn a great deal. I remember being told of a Latin American politician who, when he wanted to go unrecognized, took *off* his dark glasses. Ordinarily, though, they are to be avoided in portraits. They block out the very feature that is so often the physical and emotional focal point of the face.

Some artists would caution you to underplay glasses. I prefer giving them the visual weight they have. Large, horn rims have more visual impact than rimless granny glasses. So be it. The type of glasses people select tells the world something about them.

Practicals for Drawing Glasses

MATERIALS. *Pencil, Conté, or felt tip pen on appropriate paper.*

1. Do life-size contour drawings of a pair of glasses from different angles:

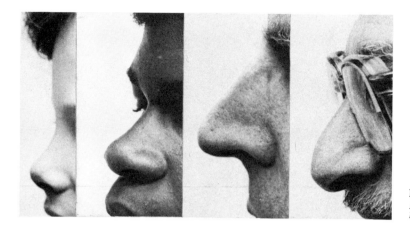

Figure 6-7.
A variety of noses.
Photos by Phoebe Francis.

 a. *straight on,*

 b. *side,*

 c. *three-quarter view,*

 d. *looking down on them on the table next to you,*

 e. *looking up at them. Be aware of the change in the* lens shapes.

 2. *Returning to your three-quarter view, shade it to establish the shiny surfaces. Recall your experience drawing glass in Chapter 3.*

 3. *If you wear glasses, do a contour drawing of yourself with them on.*

The Nose

If eyes inspire adoration, noses inspire humor. Comedian Jimmy Durante poked fun at his own large "proboscis." The fictional Cyrano de Bergerac was hilariously defensive about his enormous nose, and Pinocchio's nose grew when he lied. Noses are the source of sneezes, sniffles, snoring, and little that is pleasant, and often they just aren't the desired shape or size.

So noses may be a sensitive subject. I did a drawing of one of the most attractive men I know, and he saw nothing in it but the shocking size of the nose. I hadn't exaggerated it, but my accuracy hit a sensitive nerve. I don't suggest flattery—just be aware of the problem.

In addition to the possible sensitivity of your model, noses are also difficult to draw. The bone and cartilage understructure projects a complex form. The approach taken by George Bridgman is helpful (Figure 6-8). He searches out the basic truncated pyramid shape of the nose and then modifies it to resemble individual mounds and slopes.

Those mounds and slopes may include a bend where bone meets cartilage. If they join in a straight line, the nose is straight. Otherwise a visible bend creates either a bump outward or a ski-jump or pug nose. Noses end in a ball from which nostrils flare back, separated by a fleshy strip that goes from the ball-like tip to the groove in the upper lip.

In drawing the nose, search out accurate edges. Work hard to see what is really there. An

Figure 6-8.
GEORGE B. BRIDGMAN.
Untitled drawings of the nose.
Reprinted by permission of Sterling Publishing Co., Inc. from Bridgman's Complete Guide to Drawing from Life by George B. Bridgman. ©1952 by Sterling Publishing Co., Inc., New York.

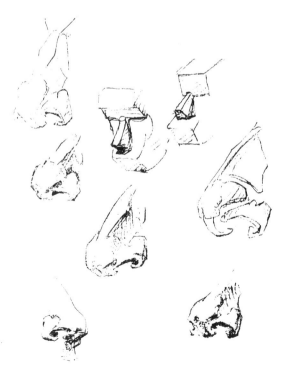

approximation won't do. The only departure that I would suggest comes in drawing the opening in the nostrils. Deeply shadowed and therefore very dark, they can be visually distracting. Since you want a viewer to take in the whole face, not focus on the nostrils, making them lighter than they are can be useful. But be attentive to their shapes. They are often drawn too large or too round. Look through the drawings in this book, as you did for eyes, and study the noses. Notice the shapes, sizes, and darkness of nostril openings. Learn again from the masters.

Finally, remember that drawing a nose (like most things in art) is mastered through practice both in seeing the shapes as they appear and in drawing what is seen.

Practicals for Drawing Noses

MATERIALS. *HB pencil or Conté pencil, white bond or rough newsprint.*

1. Copy the Bridgman drawing in Figure 6–8. Make every effort to absorb the simplified geometry of the nose as he presents it.

2. Using the photos in Figure 6–7, make a drawing of each of the four noses shown using the Bridgman approach. Look for the basic geometry, which is similar but different in each case.

3. Now turn to your own nose, the one you know best. Make three drawings from the same angle: the first a gesture, the second a contour, and the third modeled.

4. With another model, repeat the process in Practical 3.

Ears

Like most noses, ears are not inspiring. At best, they are odd-looking projections. They can be hidden by the subject behind hair or by the art-ist in shadow. In a drawing, often one of them is not seen due to the angle of the head.

When ears are in shadow, they need only be *suggested* by the artist. Like nostrils, ears are not the focal point of the portrait. Nevertheless, they are part of the overall head shape and one of the characteristics that makes an individual recognizable. In Kathe Kollwitz' self-portrait (Figure 3–12), her ear, barely a shadow of itself, is essential to the completion of the head form.

When you need to draw ears, you should understand the structure of the outer ear (or auricle). Ears are as individual in their convolutions as fingerprints, yet there are common denominators. First, of course, they all attach to the sides of the head, flaring out from the tops of the jawbones. They are bigger than most people think, generally occupying a space that runs from the top of the eyes to the mouth, though variation in size from person to person can be great (as you can see in Figure 6–9).

Ears are also almost always attached at an angle. If you draw a line from the lowest tip of the lobe to the highest point at the top of an ear, it is usually about parallel to the line of the nose, as shown in Figure 6–10. In Figure 6–11, you see that the flared shape of the ear folds out at the outer edge (helix) and dents in and out again (antihelix) as it goes toward the central core. Then it has another paired duo of shapes (tragus and antitragus) leading downward toward the soft earlobe. Again, Bridgman is a good reference for structural analysis, as you can see in Figure 6-12. Note his experiments with nose-ear parallelism.

Exercise your powers of observation by noticing the differences in the ears of the people you see every day. Sketch them whenever you have a chance. Observation and practice together will yield skill.

Figure 6-9.

Photos by Phoebe Francis.

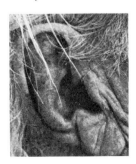 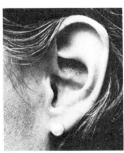 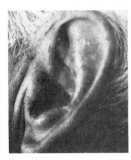 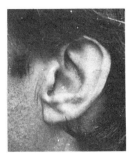 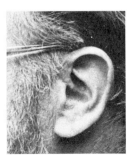

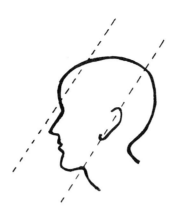

Figure 6-10.
Ear/nose parallelism.

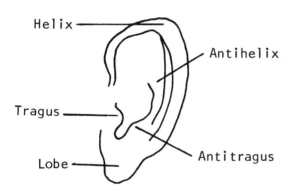

Helix ──────

────── Antihelix

Tragus ──

Lobe ◄──

────── Antitragus

Figure 6-11.
The parts of the outer ear.

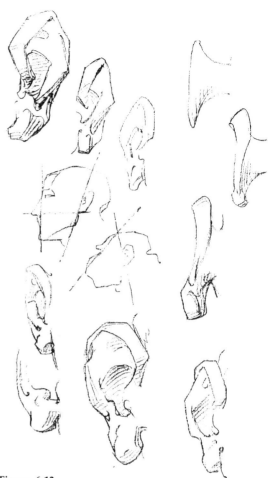

Figure 6-12.
GEORGE B. BRIDGMAN.
Untitled drawings of the ear.
Reprinted by permission of Sterling Publishing Co., Inc. from *Bridgman's Complete Guide to Drawing from Life* by George B. Bridgman. ©1952 by Sterling Publishing Co., Inc., New York.

Practicals for Drawing Ears

MATERIALS. *HB pencil or Conté pencil, rough newsprint or white bond.*

1. Copy Bridgman's drawings in Figure 6–12. As you do so, concentrate on the basic geometry of the ear.

2. Draw each ear in Figure 6–9 Bridgman fashion, life-size or larger. Then try to do one from memory to see if you have the parts well in mind.

3. Choose one of the Figure 6–9 photos, and do it first as a gesture drawing, then as a contour drawing, and finally as a modeled drawing—all life-size or larger.

4. Do quick sketches of 25 ears, using family, friends, photos, and TV shows to work from. These drawings may be smaller than life size.

Mouth

The mouth, the most flexible feature of the entire face, participates in a variety of actions. It enables a person to eat, talk, make music, and express emotions. Each action rearranges the mouth-related muscles and thus the surface appearance not only of the mouth but of the cheeks as well.

The mouth divides neatly into two parts: upper lip and lower lip. The upper lip begins with a curtain of skin that descends from the nose and curves around the teeth and upper jawbone, ending with a rose-tinted, roughly bow-shaped area. The "curtain" has a groove in the center, which creates the dip in the rosy part:

Figure 6-13.
Mouths: various sizes, shapes, and actions.
Photos by Phoebe Francis.

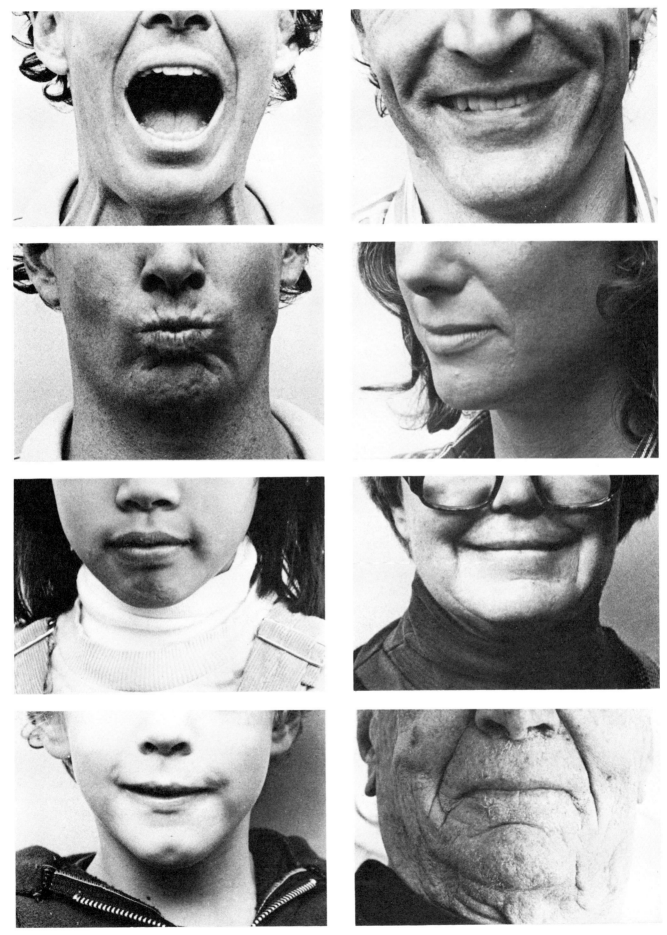

In the everyday world, light most often comes from above, so that light is not able to shine on the rosy part of the upper lip as it turns in toward the teeth. It is therefore shadowed and clearly defined. (Look again at Figure 6–13).

At the same time, the rosy part of the lower lip, roughly a very elongated oval, is usually lit. The result is a range of values from vortex shadow (the line between the lips) to shadow, light, and even highlight if the lips are moist. Edges are less easily seen than you might imagine because they are not defined by shadow but seem to blend gradually into the non-rosy part of the skin.

The lower lip also includes a curtain of skin running downward to the horizontal groove that begins the chin. Like the upper curtain, it is flexible, and it curves around the lower teeth and the lower jawbone.

In Figure 6–14, Bridgman has drawn a study of the general structure of an immobile, closed mouth. Note that the curve of the lip structure is clearly reflected in the line where the upper lip meets the lower lip. Depending on whether you are below, on a level with, or above a face, the line between closed lips appears curved upward, straight, or curved downward.

In the history of art, most mouths have been shown in repose. Artists rarely captured fleeting expressions—models can't hold them. Try it yourself. Smile at your mirror, and see how long it is before the smile freezes. Capturing a smile when it becomes unnatural so quickly is a challenge for any artist unless photographs are used as source material.

Practicals for Drawing Mouths

MATERIALS. *Your choice.*

1. Make a gesture drawing of each of the mouths in Figure 6–13. As you do each, think about the action of the mouth. Let your own mouth go through the same motions. Try to feel the movement, and let the feeling participate in making the drawing.

2. Now do a contour study from each photo. Think about how the edges of the mouth express the gesture you just drew.

3. Finally, do a modeled study from each. Go slowly. Think about where the light is coming from, as well as how the darks and lights relate to the expression and reveal the forms that create it. Squint to help yourself distinguish the subtle value changes.

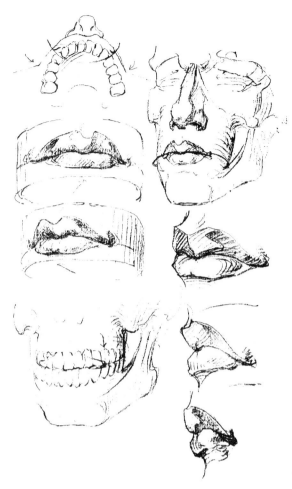

Figure 6-14.
GEORGE B. BRIDGMAN.
Untitled drawings of the mouth.
Reprinted by permission of Sterling Publishing Co., Inc. from *Bridgman's Complete Guide to Drawing from Life* by George B. Bridgman. ©1952 by Sterling Publishing Co., Inc., New York.

4. Now do two sets of three drawings (gesture, contour, modeled) of your own mouth in repose: first looking straight at it and then looking at a three-quarter view. Be just as thoughtful as you were with Practicals 1 through 3.

Teeth

Teeth are rarely dealt with in books on portraiture simply because teeth are rarely in a portrait. In the history of art, some works catch fleeting expressions, including toothsome smiles. In general, however, the faces looking out at us from canvas and paper are a closed-mouth group. A remarkable example is the drawing in Figure 1–2 of Mrs. Casamajor and eight of her twenty-two children. Though one child is riding a goat and all are in lively poses, not one has a mouth open to speak or laugh.

72

In fairness to artists of the past, dentistry was, until relatively recently, mostly concerned with pulling bad teeth, not filling or straightening them. They were usually unsightly or gone by age 20. Closed mouths were therefore a visual kindness. *And* smiling photos were not available as source material. So the study of feminist Ethel Smyth, done by John Singer Sargent, is all the more remarkable (Figure 6-15). To capture this moment, Sargent suggested that Smyth play the piano and sing spirited songs, which she did for an hour and a half. Look at the drawing carefully and notice that, though he had ample time, Sargent refrained from drawing each tooth in detail. He simply noted the general form of the upper band of teeth, shadowed them appropriately, and left it at that. More detail would have created a complicated group of forms drawing more attention than he wished to Ethel Smyth's teeth.

Of course, sometimes more detail is appropriate, as in John Wilde's self-portrait with partly opened mouth (Figure 2–14). An understanding of the tooth system, coupled with observation, enables you to handle teeth as you wish. To aid my own understanding, I accepted my dentist's offer of impressions made when I had a tooth capped. Ask your dentist for a set (most people don't want them). You will always have an available reference for how each tooth is shaped and for how all of them are set into gums in rows that follow the curves of the upper and lower jawbones.

If you are faced with a subject with unattractive teeth, the simplest solution is to draw the person with a closed mouth. The next simplest is to generalize the forms as Sargent did.

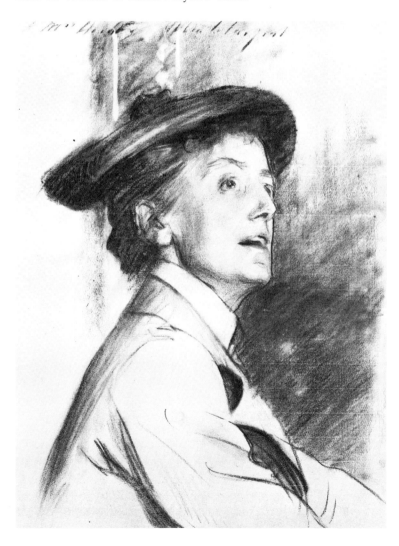

Figure 6-15.
JOHN SINGER SARGENT (American, 1856-1925).
Ethel Smyth (Black chalk).
National Portrait Gallery, London.

Practicals for Drawing Teeth

MATERIALS. *Your choice.*

1. If possible, get a set of impressions, and do contour drawings of them from several angles: front, three-quarter view, and side, both closed and propped open. This process acquaints you with the shapes and relative sizes of teeth, as well as their placement on the jaw curve.

2. Now look again at the modeled drawing you did of the smiling mouth in Figure 6–13. Do the teeth seem overly dark, light, or distinct (even though accurately copied from the photo)? Do they distract your eye from the whole? If so, redo that drawing and transform the teeth so that they become part of a visually unified, harmonious whole. The changes might involve graying some white areas, lightening dark areas, or losing some sharp definition. Tinker with the value relationships until you like the overall effect.

Cheeks and Chin

Cheeks, like the mouth, are a very mobile part of the face. They are bound at the top of cheekbones and at the bottom and side by jawbones. These boundaries, as major structural markers in the head, are important for drawing the basic mass of the head. The configuration of the flesh between these boundaries changes in response to the movements of the mouth and its related muscles. To a lesser extent, raising eyebrows affects cheeks by stretching them slightly upward. Stand before your mirror again, and observe how the cheeks behave when you smile, yawn, purse your lips, or raise your eyebrows. Observe other people, noticing how the cheeks change as expressions change.

The jawbones that outline the far sides of the cheeks end with the chin. Depending on the *length* of the jawbone, chins recede, protrude, or fall somewhere in between. Depending on the *end-form* of that bone, chins are V-shaped, rounded, or rectangular, and they may be quite smooth or cleft. Sometimes in men, chins are not seen, serving chiefly as structural support for a beard.

The Practicals for cheeks and chins are combined with those for hair and skin.

Hair

Most features do not change over short periods of time. The dramatic exception is hair, which may be changed at will. Straight hair can be curled. Dark hair can be lightened. Abundant hair can be thinned. Clean-shaven faces grow beards, moustaches, and sideburns. The most stable person among us changes hairstyle from time to time. It isn't feasible to try to cover the possible variations here, only to offer a few general guidelines.

First, don't try to draw every hair. In Figure 2–1, Jack Beal conveys the straightness and unruliness of his hair with just a few quick lines. The drawing by Lilian Westcott Hale, although it is entirely composed of fine, vertical lines, presents a shifting value for hair that creates a soft, fluffy effect (Figure 2–19).

Cecilia Beaux's portrait of Henry James shows a man with very little hair, lightly toned in with a dark line as an edge accent (Figure 3–1). Finally, in the drawings by de la Tour (Figure 1–6) and John Wilde (Figure 2–14), hair is omitted altogether, the burden of likeness falling to other features. In none of the cases where hair is described is it done with a hair-by-hair drawing. From a distance of a foot or two, individual hairs appear to blend. Even Jeri Metz, photorealist, generalizes a little (Figure 10–18).

Skin

Human skin varies primarily in color and texture, and it exists in a great array of both. Colors range from nearly black through a range of dark and light browns to nearly white, any of which might be tinted with red, yellow, gray, or blue. Skin color is important as a distinguishing feature, and many take pride in its particular tone. So observe with care, especially if you are working in color.

As for skin texture, it goes from smooth to coarse to scarred to wrinkled to deeply corrugated. Skin texture is often related to age and is thus important in giving a complete picture of a person. Regarding skin blemishes, I have almost never seen a portrait in which they were noticeable.

When drawing women, consider makeup. The use of color on cheeks and eyelids may make facial planes appear more or less prominent, leading you to structural inaccuracy. To avoid such error, you need to observe closely and call on your knowledge of anatomy. In addition, you may need to diminish the color of the makeup. Bright red lips may be too strong a note in your drawing. Eye makeup, faithfully

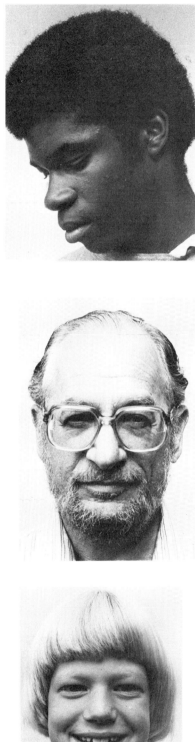
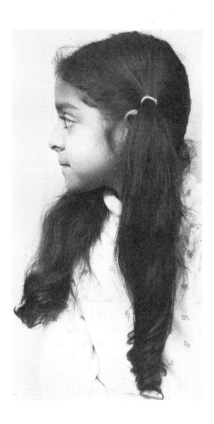

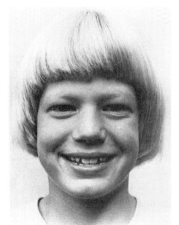
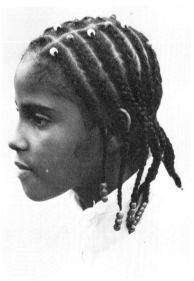

Figure 6-16.
Distinctive hair styles.
Photos by Phoebe Francis.

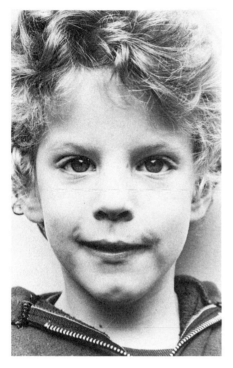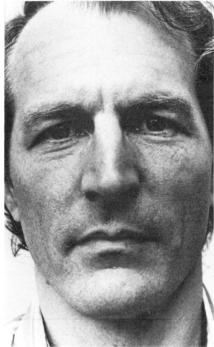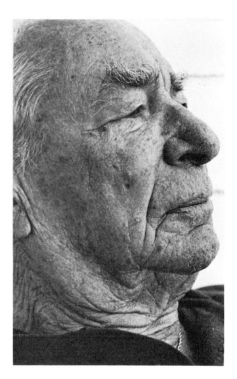

Figure 6-17.
The textures of child, adult, and elder skin.
Photos by Phoebe Francis.

presented, may look bizarre. On the other hand, some artists exaggerate makeup for expressive purposes. Apply aesthetic judgment.

Practicals for Drawing Chins, Cheeks, Hair, and Skin

MATERIALS. *Your choice.*

1. Collect clear, large newspaper or magazine photos of people with different hairstyles and textures, with different skin textures, and with different skin colors. Make drawings, at least as large as the photos, of the hair, chin, and cheek areas. With as few marks as possible, capture the texture, style, and weight (thin, thick, wispy) of the hair in each photo. Be sensitive to areas of highlight where little or no drawing is needed.

With the skin-cheek-chin areas, strive for textural likeness. Remember that all texture is revealed by the distribution of darks and lights. Think also of what is below the surface, and draw so that the viewer senses bone and muscle.

2. Now put together everything you have been drawing for the Practicals in this chapter. Do a self-portrait. Start with preliminary gesture and contour drawings. Then do a separate modeled drawing approximately life size. Work at integrating the features, and avoid overworking an area (applying too

much medium or erasing too much). If at any point you feel stumped, reread appropriate sections of this and other chapters, and refer to master drawings.

MORE GEOMETRY

A useful first step consists of investigating the geometry of the head, neck, and shoulders by reducing them to the simplest common denominators of egg forms and rectangular solids (as you did in Chapter 5). The next step—a more complex one—is the detailed expression of forms pushing from below to produce a particular complex of features.

Vincent Van Gogh's drawing is unusually explicit about every plane of the surface that results from forms pushing from beneath (Figure 6–18). Sargent's approach in Figure 6–15 is more typical.

If you put a towel on a table top and beneath it put a book, a cube, and a ball—whatever basic forms you have at hand—those underlying objects rise against the towel and give a clear idea of their sizes and forms. The forms beneath human skin, do the same. The cube doesn't look like the ball any more than the sternocleidomastoid looks like the Adam's apple.

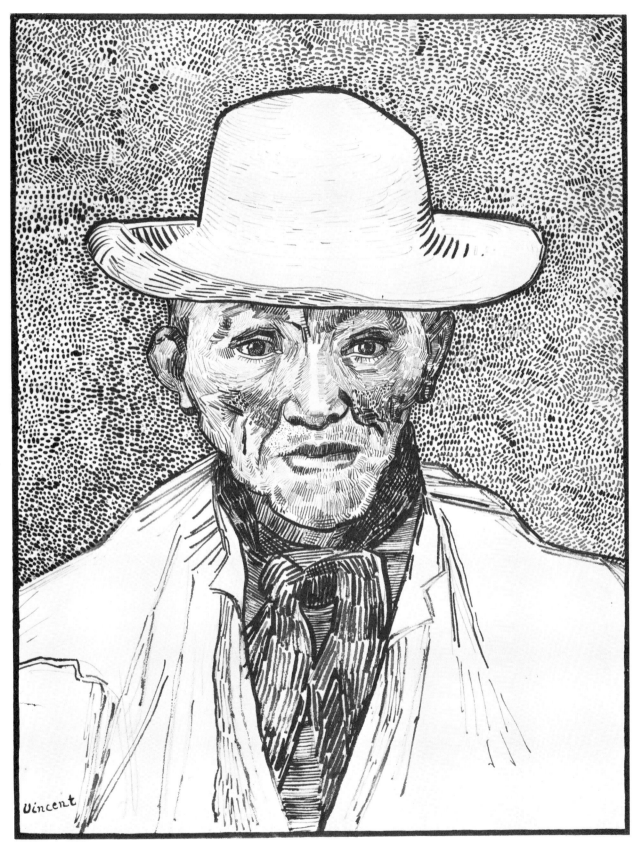

Figure 6-18.
VINCENT VAN GOGH (Dutch, 1853-1890).
Peasant of the Camarque (Quill and reed pen and brown ink).
Courtesy of the Fogg Art Museum, Harvard University, Cambridge; Bequest of Grenville L. Winthrop.

77

Following instructions given in the last chapter, you explored the structure of your own upper body, thinking in terms of large basic forms. Now you need to register the structural specifics discussed in this chapter. Go once more to a mirror. Look at your forehead. Notice the way it rolls to each side, flattens in the center, bulges a little over the eyebrows. Continue the process. Look at your nose, at the particular widths, lengths, slopes, angles that make it individual. Look at the shadowed upper lip, the lighted lower lip, their fullness, their curves. All follow the structural instructions of the bone and muscle beneath and can be analyzed in terms of simple geometric forms—spheres and rectangular solids. The same is true of the particular complex of planes that make up your cheeks, chin, ears, neck, and shoulders. Study the Bridgman drawings in this chapter some more, and look at his books.

Once again, all this geometry is revealed by value changes. Practice seeing them whenever you look at a face or at anything.

Geometry Practicals

MATERIALS. *Your choice.*

1. Put several simple objects on a low table and cover them with a soft, clinging fabric with no pattern. Arrange the cloth so that the forms are recognizable beneath the fabric. Make a drawing of this assembly. Clearly, you can better recreate the forms as revealed by the fabric (or the forms beneath a face) if you are familiar with what is underneath. Also think of composition. How can you present all this in the most interesting way?

2. Study again Figures 5–1 and 5–3, showing the profile skull and the muscles of the head. Notice that a line is drawn outside the bone and muscle to show the space that flesh and skin occupy. That line always relates to the bone and muscle structure. An exception occurs if excessive layers of fat obscure the jaw and chin lines. Yet even in obesity, the skull, forehead, and nose structures emerge.

Now take large newspaper and magazine photos of heads. With a felt tip pen, go along the outlines of the head, jaw, chin, nose, eyebrows, and eye sockets—wherever inner structure determines an outer edge. Focus on how that inner structure relates to the surface. The objective is to build in a permanent, constantly operative sensitivity to this relationship.

REFERENCES

1. BRIDGMAN, GEORGE. *Heads, Features, and Faces.* New York: Dover Publications, Inc., 1974.

2. GOLDSTEIN, NATHAN. *Figure Drawing: The Structure, Anatomy, and Expressive Design of Human Form.* Englewood Cliffs, N.J.: Prentice-Hall, Inc., 1981.

CHAPTER SEVEN

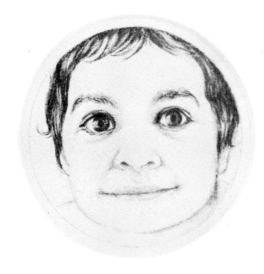

Sources of imagery— especially photographs and live models

Sources of imagery are what you choose to draw from. As a matter of good practice, any source that results in a telling image can, and should, be used. What it is doesn't matter. What does matter is the *change* the artist works on the material as it passes through a personal creative process. An artist perceives source material, understands it in a personal way, and then includes or excludes parts, emphasizes or deemphasizes certain aspects, and chooses materials and scale, all according to personal vision. The result, regardless of the source material, is an individual and therefore original statement.

Figures 7–1 and 7–2 present a clear example of the transforming nature of this process. Figure 7–1 is a publicity photo for a 1916 Ballet Russes tour (showing Pablo Picasso's first wife, Olga, in the foreground). Figure 7–2 is the drawing Picasso did from the photo some years later. That the two are closely related is clear from the subject matter, the juxtapositions of the figures, and the angles of their arms and legs. The imprint of Picasso's vision is equally clear. The drawing is linear, not modeled. The forms are bulky, unusually proportioned, uniquely Picasso's. Somehow they capture more of ballet's essential lightness and motion

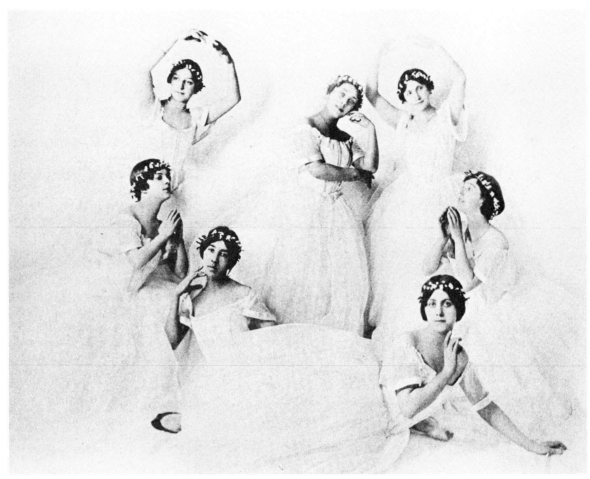

Figure 7-1.
Publicity photograph for Ballets Russes on their
New York Tour, 1916.
Collection of the Stravinsky-Diaghilev Foundation, New York.

than the photograph does. In this chapter, we look almost exclusively at works by Picasso, so as to introduce you to one artist using many sources.

The most common sources of imagery for creative expression are:

1. photos (often works of art themselves),
2. memory,
3. imagination,
4. works by other artists, and
5. live models.

The last four have been used for centuries, but photos are Johnny-come-latelies, arriving only with the camera's invention around 1840.

PHOTOGRAPHS

These portrait source latecomers have long been controversial. Artists who simply copied photos, making very dull "photographic" paint-ings, drawings, and prints, offended those who knew and cared about art. Photos were blamed for this dullness, but the real culprits were the unimaginative artists. To balance the scales, not only Picasso, but Manet, Courbet, Degas, and other remembered artists used photos as sources, transmuting them brilliantly into their own work (look again at Figure 7–2).

The immense impact of photography's first century or so is described briefly in Chapter 1 of this book and in fascinating detail in Aaron Scharf's *Art and Photography*. In his introduction, Scharf notes the usefulness of examining

the way in which artists employed photographs, not just to copy from, not as a matter of convenience or to satisfy the current dictum of pictorial truth, but to try to capture in their works the novel delicacies or the astounding aberrations to be found in those images. In their repudiation of convention, artists on the search for fresh visual ideas often found photographs immensely pertinent. In this way the less apparent though intrinsic peculiarities of the photographic im-

age were absorbed into the vocabularies of painting and drawing. Often artists found, in those very irregularities which photographers themselves spurned, the means to create a new language of form. Thus, ironically, through its own vernacular, photography offered ways to overcome a commonplace photographic style.

Though Scharf seems to dismiss it in the quotation above, convenience is an intrinsic and attractive aspect of using photos. It can reduce the anxiety of the portrait-making process considerably. For the artist, photos are "models" that are available whenever needed for as long as necessary. They do not have to be scheduled. They do not need rest breaks, special lighting, heaters, food, a salary, or entertainment. And they are not critical! For the *subject* (especially of a commissioned work—see Chapter 10), the use of photos can eliminate hours of tedious posing, relief that is especially welcome to the person who lives a tightly scheduled life.

In addition, photos provide a heretofore unknown flexibility in choice of models. Andy Warhol can work with Marilyn Monroe, Golda Meir, Albert Einstein, and others, not only when they are unavailable as living models but even after they are dead (Figure 1–9).

Unusual angles, actions, and expressions are also available in photo sources. And photos are useful as ready references for easily forgotten details.

By the same token, the camera is mechanical and records only details that its "eye" can see. Much detail is lost forever in shadows. When that occurs, artists may turn to the live subject or to memory, or they may invent what isn't there.

Photos are also flat. The camera has already translated three-dimensional material into a two-dimensional image. The job for the artist becomes partly one of reinvesting an image with a three-dimensional quality. Such reinvesting requires sound understanding of anatomical structure and keen observation of value change.

Choosing photos to use is a very personal process. I like to take my own with a good 35mm single lens reflex camera to get high-quality results. I also like a number of varied photos of the subject, and sometimes utilize those that are not good in terms of photographic quality. The attraction might be minimal value

Figure 7-2.
PABLO PICASSO (Spanish, 1881-1973).
Seven Dancers (Pencil).
Musée Picasso, Paris.

contrast—an overall gray softness. Or it might be a particular congruence of shapes—such as a shadow on the cheek that is rounded and echoes the shape of eyeglasses and curves in the hair. Whatever it is, the choice is not guided by what someone else likes, but by what my eyes find interesting.

Once chosen, these photos are used like any other source. I modify composition or mood and handle the background however it best suits my view of the subject. As an example, in Figure 7–3, you can see a few photos that I took of my daughter. Figure 7–4 is the resulting portrait, based strongly on one of the six photos, but modified to express the strength of purpose she has always shown. The strength made her seem older than eighteen months, and I tried to show that.

Students sometimes ask me if using photos is "cheating." Photos can be used in a personal and imaginative way as Picasso did or impersonally and unimaginatively by merely copying. But "cheating" occurs only when you

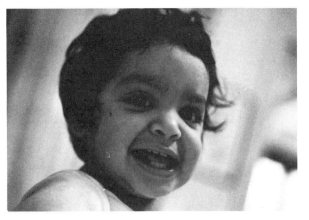

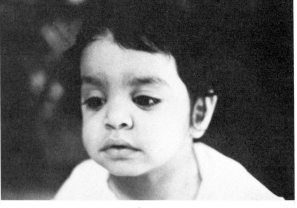

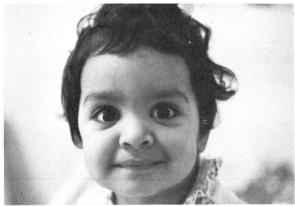

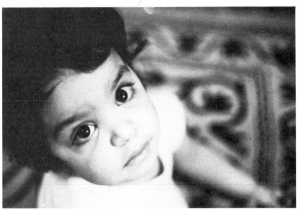

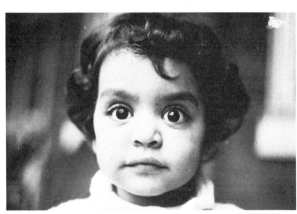

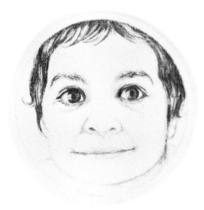

Figure 7-3.
Photo source material used for *Marguerite* shown in Figure 7-4.

Figure 7-4.
LOIS MCARDLE (American, 1933-　).
Marguerite (Pencil).
Collection of the Artist.

make a work and attribute it to someone else or make an exact copy of someone else's work and claim it as your own. If cheating by using photos is a concern for you, set it aside permanently and open yourself to the potential usefulness they offer.

MEMORY AND IMAGINATION

Memory and imagination are closely entwined, probably influencing each other most of the time, perhaps working independently some of the time. What I want to say about these image sources is speculative and personal.

Most of my own drawings are done from life or photos. When I draw from *memory*, I drift away from likeness to impression, to spirit, to invention. I did the little memory sketch of my mother in Figure 7–5 while I was thinking about this chapter. It's not quite what she looked like, but it captures her bumpy nose, dowager's hump, fluffy hair. And it suggests her fragility and playfulness. As I was doing it, memory managed to hold me. It kept me drawing a particular individual and focused on that person's features and personality, even though the result was not close likeness.

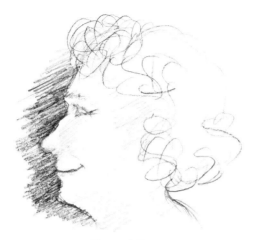

Figure 7-5.
Memory sketch.

Imagination is a fertile source for art in general, but not for portraiture. Portraits are images of real people, and drawing from imagination leads to the expression of a concept. (Michelangelo did it in his *Head of a Satyr* in Figure 1–7.) Or it can lead to the syndrome seen in some comic strips—creating faces that all resemble each other because they all come from the imagination of the same person.

The great beauty of memory and imagination is that they are always available. No need for a camera and film. No elusive models. And drawing from memory can be helpful as an exercise in recalling important details. So highly regarded was that facility in the 1800s that students were asked to reproduce from memory museum pieces they had seen *once*. Today, the need for such discipline is reduced because we can turn to photos and because an artist's personal vision is prized above simple recall.

Imagination has another role essential to all creativity. In his *History of Art*, H. W. Janson refers to "leaps of imagination," those wonderful occasions of the brain that allow us to juxtapose images (or ideas) in a way never before tried. To illustrate, Janson uses a Picasso sculpture, a choice that is brilliant not only for its simplicity as an example, but also as a work. Picasso took two objects that are familiar as bicycle parts and, with a flash of recognition of a new relationship they might have, he created the piece you see in Figure 7–6.

Probably, a series of such flashes enabled him to create a new relationship for the features of the face, a relationship that enables a viewer

Figure 7-6.
PABLO PICASSO (Spanish, 1881-1973).
Head of a Bull (Assemblage of bicycle saddle and handlebars).
Musée Picasso, Paris.

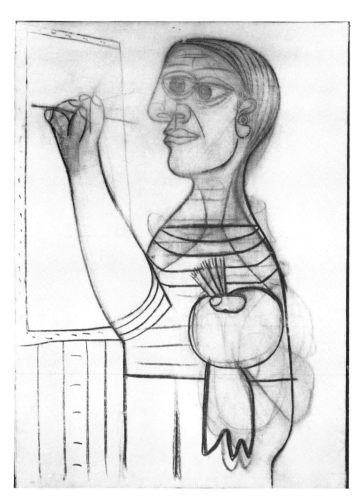

Figure 7-7.
PABLO PICASSO (Spanish, 1881-1973).
The Artist before His Canvas (Charcoal on canvas).
Musée Picasso, Paris.

to see more than one side at a time, as in his *1983 Self-Portrait* (Figure 7–7). His multiview results in a high degree of distortion. Its achievement (almost magical) is that it is truer to the subject than reality. Picasso captured surface appearance plus his own astonishingly intense drive.

WORKS BY OTHER ARTISTS AND WRITTEN MATERIAL

As a young artist, Picasso painted in the styles of admired older masters (as young artists often do). For example, Picasso was introduced to the work of Henri de Toulouse-Lautrec in 1899. That year, he produced a menu cover for his favorite cafe, much in the style of Lautrec's posters and unlike his own earlier work (Figures 7–8 and 7–9).

Later in life he paid homage to Cranach the Elder, Grunewald, Velazquez, Rembrandt, Manet, and other artists by adopting their compositions and subject matter and then by transforming it through his own vision. You saw an

Figure 7-8.
PABLO PICASSO (Spanish, 1881-1973).
Menu of Els Quatre Gats (Printed).
Museo Picasso, Barcelona. ©S. P. A. D. E. M., Paris/VAGA, New York 1982.

Figure 7-9.
HENRI DE TOULOUSE-LAUTREC (French, 1864-1901).
La Goulue at 'The Moulin Rouge'(Colored poster).

Figure 7-10.
MATTHAIS GRÜNEWALD (German, 1480?-1528?).
The Crucifixion, from the *Isenheim Altarpiece* (panel detail).
Musée Unterlinden, Colmar. Photo by O. Zimmerman.

example of such change when he used photo sources. When using another person's work, the process was similar.

An example derived from Grünewald also highlights the use of written sources as inspiration for work that goes beyond illustration. In Figure 7–10, you see Grünewald's painting of a Biblical event, the *Crucifixion.* Figure 7–11 is one of several drawings Picasso derived from that painting and thereby from the same Biblical source material.

The first is the simple expedient of taking a class in portrait drawing. If one is not available, ask permission to enroll in another course that provides models (such as figure drawing) for the purpose of doing portraits. If neither option is possible, you might suggest to a local school that a portrait class be offered. Many schools are responsive to requests from community members, especially through adult extension programs.

LIVE MODELS

The traditional way of making portraits is to work live from the subject of the work. Millions of portraits have been made that way, and millions more will be. Thus knowing how to obtain models is important, as well as how to provide a setting and integrate their costume into it, how to make them comfortable, and how to light them satisfactorily.

Obtaining Models

When you have drawn willing members of your family and accommodating friends, there are still two good ways to acquire models without excessive cost and, at the same time, get intruction and/or comments from peers.

Figure 7-11.
PABLO PICASSO (Spanish, 1881-1973).
Study for the Crucifixion, after Grünewald (India ink).
Musée Picasso, Paris.

A second approach is to join with others who want to work from live models, find a suitable location, set a mutually conveneient time, hire models, and share expenses. You should embellish this approach by occasionally offering a fee to a professional teacher/portraitist for a critique session. And you should avoid taking too seriously either the criticism or compliments of friends and relations who are well meaning but untrained.

How can a self-formed group find models? Art schools sometimes share names. Some model agencies can provide relatively low-cost models for such jobs. And you can model for each other. For older models, organized housing projects for the elderly might cooperate and suggest residents who would be good subjects and interested in the adventure.

If you want a child as a model, perhaps a member of the group has one. Not only would the child have to be willing, but the parent would have to devote the session to entertainment. Modeling is tedious for a child. If someone reads or tells stories, and short poses are acceptable, a child might be able to sit still and do the job.

Brainstorm the problem. Other good ideas will emerge. You need only to pursue them.

Costume, Setting, and Comfort

After you have arranged for a model, give some thought to costume. If the intention is to work just from the head, then consider only head gear and what goes around the neck. If anyone in your group wishes to work with more of the figure, then everything the model wears deserves attention.

WHAT A MODEL WEARS

Clothing, as an extension of an individual, informs a viewer in several ways. It can indicate position in a hierarchy or membership in an established professional group (Queen of England, 32nd-degree Mason, nurse, nun, Rabbi). It can suggest an avocation (riding, flying, fishing). It can suggest ethnic origin (Indian sari, Japanese kimono, Spanish mantilla). It can suggest presence (regal, businesslike, sensual).

With a hired model, you can dictate in advance what you would like worn and devise a suitable setting. Or you can work with whatever the model chooses to wear and modify the setting to suit it. In either case, costume should be-come an integral part of the overall composition, harmonious and intriguing as part of the general distribution of colors and shapes.

THE SETTING FOR A MODEL

Setting, like clothing, is an extension of a person. In the eyes of the viewer, the subject is related to surroundings. A person eating a hotdog in a diner is seen differently from the same person dining in an elegant restaurant.

When you are part of a group working from a hired model, there are definite limitations. The choices are not a diner or a restaurant to best suggest the character or mood of the model, but, given the space you are in, which chair or lamp or drape is most suitable.

When I set up a model for class, I don't try to transform the classroom, but to modify a portion of it. First I look at the model. What are the hues, values, and brightnesses of the clothing worn? What is the skin color? Hair color? How small, large, light, or heavy is the person i.e., what mass is involved? Then I look at the setting as it is and consider what modifications would be most interesting, given this particular model. Perhaps I decide to provide contrast for light hair or dark clothes. Perhaps I choose strong geometric elements to offset a lot of curves. Or perhaps I set up diagonals in one direction to balance diagonals in another, as I did in Figure 7–12. Many approaches are possible. The objective is always visual interest.

Figure 7-12.
Classroom model.

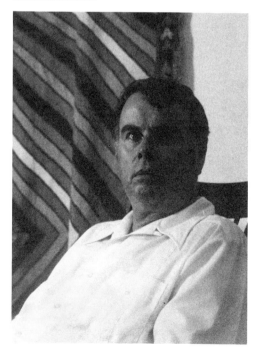

(a)

(b)

(c)

(d)

(e)

Figure 7-13.
Student drawings from the model shown in Figure 7-14.

Every person who works from a set-up gives a different and personal emphasis to it. In Figure 7–12, you see a photograph of the model (my husband) showing the back of the rocking chair he is seated in and a deeply folded drape with strong diagonals. In Figures 7–13 you see five student drawings done from that pose. What variation! Students are admittedly drawing from different angles, so that the aspect varies. Yet all saw the same person, the same drapery, the same soft white shirt and pale skin

contrasted with the black enamel geometry of the rocker, the same opposing diagonals, and the same dramatic lighting that put one side of the face in deep shadow.

In Figure 7–13a, the student chose to ignore drapery, chair, and much shadow to put the primary focus on the force of the figure's volume and the staring eyes. Abundant empty space above the figure absorbs that force.

Figure 7–13b creates a sense of an encompassing space, clearly defined by the black

rocker, in which the face is the clear, strong focus. Again, lighting is underplayed.

In Figure 7–13c, drama is abandoned altogether in favor of subtle, internal qualities: dignity and kindliness. The white shirt almost becomes a prophet's robe.

In Figure 7–13d, the subject becomes even kindlier. No shadow, no active drape diagonals, no chair to distract from a gentle study of the side of his face not in shadow.

By contrast, Figure 7–13e is a shock. Instead of gentle inner qualities, all visual elements have been marshalled to depict the meanest man in town.

At a more advanced level, imagined images or collage elements can be added to what is seen. Peter Milton, for example, creates fascinating works by integrating material from a variety of sources (Figure 7–14).

THE COMFORT OF A MODEL

Models pose in the same position for 20 or 30 minutes again and again. Special effort should be made to insure maximum comfort consistent with an interesting pose. For example, my husband, a tall man 50 years old, who weighs about 210 pounds, is not experienced as

a model (Figure 7–12). I knew that a standing pose would be fatiguing. I brought a particularly comfortable chair from home that looked strong, to harmonize with his strong presence. Seated and relaxed, he felt he could easily hold his head at an interesting angle. It worked well. (I also asked him to remove his thick glasses, but only because some of my students were inexperienced and would find them very difficult to draw. Normally, a person who always wears glasses would be drawn with them on.) He was so comfortable that he posed for 45 minutes at a time—a significant reward for a little thought given to his well being.

It is also necessary to arrange lights so they do not shine in a model's eyes. Eye fatigue can bother a model and result in altered facial expressions.

An adult model can tell you of any discomfort, help to eliminate problems, or ask for extra breaks if needed. But, with a child model, the situation is different. A 3-year-old who did a remarkable job posing for one of my classes, at one point began to look pained. A bow in her dress was hurting her back, but the child didn't understand what was wrong. She became tense and wiggly until her mother (who had come to read to her) discovered the problem.

Figure 7-14.
PETER MILTON (American, 1930-)
Daylilies (Etching). *Courtesy Impressions Gallery, Boston, Massachusetts.*

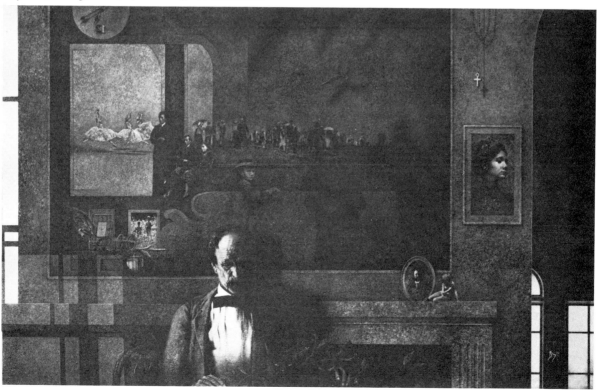

With both child and elder models, it takes special effort to stand in the person's shoes, to feel the energy of the child that is denied by sitting still, or to understand that, at 70 or 80, there is little energy or agility. Elder models may need to be picked up and driven to the modeling job, or they may need help climbing up stairs or on to a modeling platform. Making special accommodations for models at both ends of the age spectrum is well worth the effort. They present challenges that often stimulate artistic growth and generate good drawings.

Lighting for a Live Model

Artificial light or daylight through windows can illuminate a model from any direction. For the sake of this discussion, five general directions are used:

a. below,

b. above,

c. behind,

d. to the side (left or right) and

e. in front of the model.

a. A light *below* the model, such as from a candle or a low lamp, creates a sense of drama

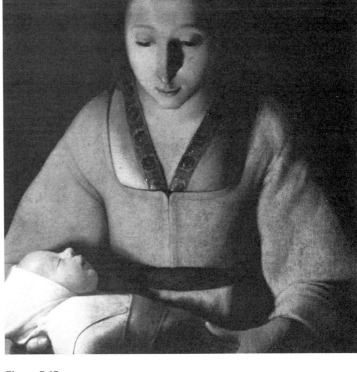

Figure 7-15.
GEORGES DE LA TOUR (French, 1593-1652).
The Newborn, detail (Oil).
Museum of Fine Arts, Rennes.

and mystery with the strong contrasts produced. Not often used, it can be compelling, as in Georges de la Tour's *The Newborn* (Figure 7–15).

Figure 7-16.
LEO DEE (American, 1931-).
Self-Portrait (Pencil and collage). *Collection of The Newark Museum.*

89

Figure 7-17.
FEDERICO ZUCCARO (Italian, 1540-1609).
Portrait of an Old Lady, Half-Length (Black and red chalk).
Trustees of the Chatsworth Settlement, Derbyshire; the Devonshire Collection.

c. A light placed *behind* a subject can also produce striking effects, creating a kind of halo, giving fluffy hair near luminescence, and putting the face in an even, dim light. Even lighting also occurs when light on a face is blocked as it is by a hood, in Figure 7–17.

d. Light projected from *one side or another,* either a little above or just even with the face is the most common direction for light in modern portraits. Examples are seen in many works in this book. It is chosen often because it provides a full range of values in the face, thus allowing viewers to see features clearly. Yet it can be dramatic, as in Figure 7–12, or very gentle, as in Figure 5–2.

e. Lighting from the *front,* with the subject's face looking directly into the light source, tends to reduce value changes and thus flatten features. It can be flattering because it deemphasizes lines and wrinkles.

Any effect of indoor lighting can be modified—softened or made stronger—by light from additional sources. Of course, the artist may soften or strengthen the effects in the drawing, as some of my students did in Figure 7–13.

Outdoor light differs from indoor lighting because it gives a more generalized effect. The light source is so far away that the illumination is a very wide ray that envelops all we can see. It can be very attractive, but daylight has distinct disadvantages. Shadows are cast from clouds, trees, and other objects, creating dappled, constantly changing effects. And light conditions are altered rapidly as the sun moves east to west. Outdoors, the only thing that is guaranteed is change. I prefer to use outdoor settings only for quick sketches or for photos that record a given lighting condition and hold it still for later use.

b. A light *above* the model—from a ceiling light, tall standing lamp, or skylight—also produces strong shadows. This too is seldom used. The Leo Dee drawing in Figure 7–16 is an example of the strong shadowing that results and of the way that shadowing effectively supports a strong, serious mood statement.

REFERENCES

HORENSTEIN, HENRY. *Beyond Basic Photography: A Technical Manual.* Boston: Little, Brown and Co., 1977. See Chapter Five, "Lighting."
or

UPTON, BARBARA AND JOHN UPTON. *Photography.* Boston: Little, Brown and Co., 1981. See Chapter Nine, "Lighting."

CHAPTER EIGHT

Additional key issues

Having worked through the first seven chapters of this book, you are now ready to use your knowledge of drawing materials, techniques, illusion, composition, seeing, anatomy, surface geometry, and imagery sources to begin your own adventure with portraits.

PRELIMINARY DRAWINGS

The first and essential step in putting this knowledge to work is to make quick, preliminary drawings that are an extremely useful pre-lude to more sustained work. These first drawings should be small "thumbnail" sketches in which you try different compositions. Forms that might be included are arranged and rear-ranged to see how various combinations look.

Also try these drawings in different formats to find the one most suitable. For example, with a standing model, as in Figure 8–1, you might include the whole person in a tall, thin, vertical composition (Figure 8–2a), emphasizing the height of the figure and perhaps a mood—alone, aloof, strong. Being a somewhat unusual

Figure 8-1.
Standing model (left).
Photo by Phoebe Francis.

(a)

Figure 8-2.
Compositional variations
derived from Figure 8-1.

(b)

(c)

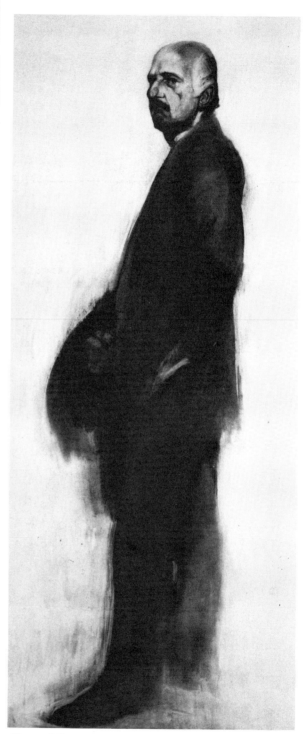

Figure 8-3.
HERBERT KATZMAN (American, 1923-).
Portrait of John Bageris (Sepia chalk).
*Collection University Gallery, University of Minnesota,
Minneapolis; Gift of The American Academy of Arts and
Letters.*

92

(a)　(b)　(c)

Figure 8-4.
Value studies from Figure 8-1.

Figure 8-5.
More detailed value study from
Figure 8-1.

shape, it might initially attract a viewer for that reason alone. Herbert Katzman's striking study of John Bageris in Figure 8–3 is an example of a portrait that uses this compositional format very effectively.

In a second thumbnail, you might try a large rectangle in which the standing figure has more space or air around it (Figure 8–2b). The arrangement can be freer and more open, and it can include an environment that relates to the life of the subject. Chalfant's portrait of Mary Dupont provides an example of the kind of visual statement that this format can make (Figure 1–11).

Rather than work with the entire figure, you might decide on a close-up of just the head in an appropriately proportioned rectangle, oval, circle, or square (Figure 8–2c). This "intimate" approach can be intense, eliminating all costume or environment and putting the viewer in direct, unflinching contact with the subject. Look again at Figures 1–10, 2–14, 3–7, and 7–4.

You can see the special contact that such a tight focus yields.

You should always make preliminary sketches, thinking constantly about what kind of space the face or figure needs, about what would be the most interesting format, and about what the psychological implications of that format might be. There are many possibilities, and sometimes you will be surprised by the format that evolves. It might be more evocative than you expected, or it might be one you would not have thought of immediately.

When you have chosen the best compositional form, move on to a second-state preliminary drawing. In this second drawing, a quick-value sketch, you rapidly lay in darks, lights, and middle tones to get a further idea of how you want your composition to progress. Using the photo in Figure 8–1 again, you might get a first value sketch like Figure 8–4a. If the *actual* value distribution doesn't suit you, you can deliberately rearrange it and devise a new

compositional structure and emotional emphasis. Figures 8–4b and 8–4c are sample variations. In a, the whole figure is a "sculptural" entity against a flat ground, very much as it appears in the photo. In b, the shift in value emphasis unifies the figure with the background, at the same time drawing more attention to the upper torso. In c, figure and ground recede in shadow, and the head is strongly emphasized.

Continue doing value sketches until you have an emphasis and balance that strike you as right. If you have enough time with the model, enlarge on this process by doing composition thumbnails and value studies from different angles. If there is not enough time, taking photos can be a useful alternative and even a boon. They provide a "memory" for detail, and an inexpensive extension of time with the model, as well as a reminder of value relationships.

One more note on value studies. They can be more specific than those in Figure 8–4. Figure 8–5 shows the value sketch in Figure 8–4a carried further. You see more value added in the middle range. A fuller breakdown of plane changes is presented. Whether or not you take this added step depends on how completely you want to make aesthetic choices before you begin the final work. You can always depart from preliminary studies in the more sustained work. In fact, an essential attitude in making art is a willingness to think about possible modifications as you progress and to make them if they seem valid. A well thought-out value sketch simply gives you a basis for starting.

Every person develops an individual approach to preliminary drawings that fits personal needs. Some do more drawings than others. Some carry them further. Some always have a small sketchbook handy for quick "notes" that might be useful later in ways not yet imagined. Some find black-and-white sketches to be adequate. Others insist on color notes. At first, the important thing is to *do* them. Personal requirements gradually emerge and become clearer, and then you can tailor the process to your needs.

A very important note: Some preliminary drawings have great beauty in their own right, and they should be saved. Try to see this beauty yourself. If someone else tells you that a particular sketch has merit, even if you don't agree,

study it again. You may have overlooked something special.

ACHIEVING LIKENESS

The most anxiety-producing pressure on a newcomer to portraiture is that of creating an "exact" likeness. Often a second, sometimes conflicting, pressure is to make the subject conventionally attractive. These pressures come primarily from within, for no one wants to offend a subject or to make a portrait that looks like a different person. Let met try to reduce those inner pressures.

First, look at the portraits of George Washington in Figure 8–6. They were done by two skillful artists who saw the man. The first, by Gilbert Stuart, is the best known, and thus it may seem the most believable. Yet there is *no* way to determine which is most "accurate." What we do know is that different artists saw the same person differently. Refer to Figures 7–12 and 7–13. The photo and each student drawing are part of the truth about the subject. Your work can be very individual and yet still be a valid likeness.

Second, if you modify what you see to make a person more attractive, you risk losing the uniqueness of that subject—the most precious quality of your drawing. I have done some drawings—honest drawings—of people I cared for that have disappointed them. I prefer that consequence to flattery, which alters likeness for the sake of the subject's vanity. Distortion is acceptable, of course, when it contributes to emotional content.

Third, professional models, such as those you find in an art school, are not unnerved by any drawing done of them. Only with family, friends, and other amateur models do wounded feelings need to be considered. Be sure to tell them in advance that they may be surprised at what they see, just as they are by some photos that are taken of them.

Given that a very wide range of likenesses is possible for the same subject and given that flattery is unnecessary, the question remains as to how to achieve likeness, even a personal version.

Figure 8-6(a).
CHARLES BALTHAZAR JULIEN FEVRET DE SAINT-MEMIN
(American, 1770-1852).
George Washington (Engraving).
National Portrait Gallery, Washington, D.C.

Figure 8-6(b).
GILBERT STUART (American, 1755-1828).
George Washington (Oil).
National Portrait Gallery, Washington, D.C.

Proportion and Placement

The features of the face are the most arresting part of a portrait. It is tempting to become altogether involved in eyes, or nose, or mouth, even before the gesture of the whole has been noticed. Avoid the temptation *always*! The result of constructing a head one feature at a time is an awkward assemblage. It is essential to capture the overall gesture, the planes, and the structure first, as you did in the Practicals for Chapters 4, 5, and 6.

After capturing the whole, it is time to check proportions. With the head, neck, and shoulders, first check the width of the head in relation to its length. It is widest at about eyebrow level and a little narrower at the eyes, perhaps two-thirds as wide as it is long (viewed from the front). It may be a little more or a little less. Check it to make sure.

Now check the length and width of the neck. Note in Figure 8–7 the contrast between the male and the female. Men's necks are generally more muscularly developed and therefore thicker. This is especially true for younger men, aged 18 to 40.

The next consideration is the width of the shoulders in relation to the *length* from top to chin of the head. Generally speaking, women's shoulders from side to side are one and one-half heads wide, and men's are two heads wide (Figure 8–7). The most common misproportion seen in shoulders is an exaggerated width for men.

When the general structure and planes of the head are well noted and head-neck-

Figure 8-7.
Contrast of male and female head, neck, and shoulder proportions.

Head length

95

Figure 8-8(a).
Right feature placement.

Figure 8-8(b).
Wrong feature placement.

shoulder relationships are accurate, you are ready to begin locating the features. As you start, think about their placement, which is always in response to the bony structure of the skull. If you repeatedly remind yourself of that, you are less likely to go astray.

Of the two "diagrams" in Figure 8–8, the one on the left is acceptably proportioned, while the one on the right exhibits some of the common first errors in shaping and placing features. As if it were a "what-is-wrong-with-this-picture" game, try to identify misproportions and misplacements of features in Figure 8–8b before you look at the following discussion.

a. No matter what the subject's hairstyle, from slicked-down to full and fluffy, there must be full space for the cranial vault beneath it. Otherwise, the head is malproportioned, and the likeness begins to slip away. The beginner's tendency is to allow too little space, as in Figure 8–8b.

b. In an adult, the eyes are usually located about halfway between the bottom of the chin and the top of the skull (not the hairline, but the top). Eyebrows, forehead, and hair occupy the half above the eyes. The nose takes up the quarter under the eyes, with the mouth and chin in the bottom quarter. (Child and elder proportions differ, as you will read in Chapters 9 and 10.) In Figure 8–8b, the eyes are too high.

c. Because the eyes are high in Figure 8–8b, there is not enough room for the upper eyelid, the eye socket, and the forehead. Space is "borrowed" from below the eyebrows, and they are therefore drawn too close to the eyes, yielding a flat, staring, pasted-on look.

d. Eyes are generally about an eye-width apart, as in Figure 8–8a. In Figure 8–8b, they are too far apart, giving the face an unfocused look. This results from not observing the distance

from the corners of the eyes to the side of the face, or from not realizing that eyes come right up to either side of the nose. Or it may grow from a desire to flatter, since one standard of good looks is widely set eyes.

e. Noses are often wider at the nostrils than perceived, and nostril openings are not round. Mouths are nearly always wider than noses. Narrowness in either or both gives a pinched and pursed look, as in Figure 8–8b.

f. Ears are bigger and located lower on the head than many people think. They usually go from eye level to the bottom of the nose, and, in a side view, they slant at an angle roughly parallel with the nose (Figure 6–10). A common beginning error is to place them high and make them small, as in Figure 8–8b.

g. The outer edge of the head in Figure 8–8b is too perfectly oval. Seen from the front, heads are roughly oval in shape, but they deviate from that oval in several ways, such as flatness at the temples, a widening at the cheekbones with an indentation beneath, and squaring at the chin. The too perfect oval confers a primitive, wooden quality on the face.

h. As discussed in Chapter 6, eyes are rarely almond-shaped, as often drawn and as shown in Figure 8–8b. They have different curves at top and bottom, curves that must be sought out for each subject. Along with the too oval face, the almond eyes give a work a primitive look.

CAUTION.

You can see that the misplacement or misproportioning of one feature can have a ripple effect. Eyes that are too high, used as a guide to placing ears, lead to high ears. Eyes that are not wide enough and that are used as a measure for the space between eyes cause close-together eyes. And so on.

IMPORTANT.

Always check the proportions of your drawing at an early stage when you can still adjust without making extensive, disfiguring corrections. At the same time, remember that suggestions on placement and proportion are only guidelines. My nose is less than one-quarter the length of my head. Yours may be more. My eyes are just an eye apart. Yours may a fraction more or less. Such variations individualize appearances and make them arresting.

Internal Measurement

Once you understand the importance of proportion and placement, a system of internal measurement provides further help in capturing likeness. Consider again the work you did for Practical 1 in Chapter 6. In addition to having certain identifiable sizes and shapes, the objects beneath the cloth are in particular distance relationships to each other (as are bone and muscle forms beneath the flesh). Look at Figure 8–9. How far is shape a from shape d? You can estimate, but doing so may lead to inaccuracies. The alternative is to establish a unit of measurement within the setup, such as the width of shape a. Using that, you find that the distance to c is about three widths of a.

Another use for internal measurement is determining the slant of a line, shape, or form. Edges in the face may be compared to a real or imaginary vertical, horizontal, or diagonal line to see if the slant is right. Or they may be compared to each other. For example, how does the slant of the jawline compare to that of the ear? Of the nose?

This is easy to say, but *how* do you measure either the width of shape a or the slant of the ear in a usable way? You may have seen an artist holding a pencil at arm's length, looking intently at it, with one eye closed (as in Figure 8–10). This is the key to internal measurement. Try it yourself with the pencil held so it coincides with the width of a person's mouth. With your thumbnail, hold the place on the pencil that shows the width the mouth appears to be. Now, holding the pencil at the same distance from you, move it so it goes across one of the person's eyes. How wide is the eye on the pencil? One-half the width of the mouth? A little more? Whatever it may be, it gives you a helpful relationship between the two features that you can translate to your drawing. If the eye is half the width of the mouth, and, on your paper, the eye is 1″ wide, then you know the mouth on your paper should be 2″ wide.

For angles, hold your pencil in front of you in the same way, but this time align it with the slant of the ear. How different is that angle from the tilt of the jaw?

This approach can be used to locate or measure any feature or shadow, as well as to determine any angle in your drawing. It is so

Figure 8-9.

useful that you should practice it until you feel comfortable with it and it is an automatic part of your drawing routine.

SEEING WITH THE HEART

And now here is my secret, a very simple secret. It is only with the heart that one can see rightly; what is essential is invisible to the eye.

Antoine de Saint Exupery,
The Little Prince

Understanding of anatomical structure, sensitivity to value change, use of proportion and placement and internal measurement, and a good sense of visual intrigue are all very important to portrait interest and to likeness. Yet none of them alone nor all of them together can make portraits seem alive and vital. They must combine with what has earlier been referred to as "universality" or "emotional content"—with whatever it is that distinguishes a good work from a great one. That elusive something is the spirit of the subject. Most of us, given time and effort, can become good portrait technicians—

Figure 8-10.
Photo by Phoebe Francis.

and that achievement is essential. Beyond that, the great challenge is expressing the inner life of the subject.

That capacity, elusive though it may seem, begins to develop the moment you look at your subject. Before a mark is on the paper, before there is a thumbnail sketch, before you have any plan, you have a *feeling* about the subject. What you see stirs you. And out of this feeling your inner response and your drawing begin to take shape.

As you study a subject, ask yourself what *that is visual* causes your felt response? Even though Saint Exupery says what is important is "invisible" to the eye, we may read into his statement that what is important is subtle, half hidden, elusive. Observing it takes sensitivity to the subject, and the emotional content of the portrait is proportional to that sensitivity. Much about a person emerges through the posture, the tilt of the head, the way hands are positioned, and so on.

This body language is picked up in your first gesture drawing, and your response to what you see begins to find expression. That gesture drawing is the first "seeing with the heart" and it is the core that pervades the drawing.

Look at Figure 8–11. This primarily gestural study by Michael Mazur is filled with the initial excitement of the artist as he responds to the subject, to the gesture of the whole head and of its parts—the nose, mouth, eyes, and to the excess that led to dishevelment.

With gesture as the core of the felt response, Mazur moved on to more specific expression. He reworked areas to relate them more rightly to the framework he established with the first marks.

He devised lines that create a family of irregular, curvilinear, open shapes (shapes whose edge lines do not connect). The lines suggesting the form of the head are echoed in the neck and the part of the arm seen on the

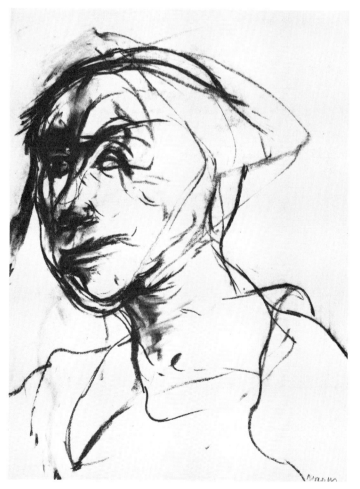

Figure 8-11.
MICHAEL MAZUR (American, 1935-).
Head Study for "Images from a Locked Ward" (1964) (Charcoal).
Impressions Graphic Workshop, Boston, Massachusetts. Courtesy of the artist.

Figure 8-12.
JACK LEVINE (American, 1915-).
Boy's Head in Profile (Pencil).
*Courtesy of the Fogg Art Museum, Harvard University,
Cambridge; Bequest of Dr. Denman W. Ross.*

right. The lines of the work, all very gestural and unstable, combine to create a form that is forceful yet expresses extreme human instability. A haunting, painful image.

Mazur's responsiveness is gestural, but in Figure 8-12, Jack Levine articulates his felt response primarily with *shapes* which join in stable volumes, in the head and in the screen of triangles constructed between it and the viewer. The initial gestural lines that inform the work and are grouped to create modeled form are still detectable where they haven't been erased to make way for the screen of straight lines.

Straight lines were also used to show the edges of the head and its features, though shifts in their value and width give some of them a gentle and curving presence. Modified straight lines together with the "gestural" modeling create the strong, quite naturalistic forms of the head.

The screen is delicate, almost web-like, but at first glance appears so irregular that it might be badly cracked glass. And yet, there is regularity—in the parallelism of the cracks and the centered isosceles triangle that houses a perfect octagon, and in the lines that divide the drawing in four equal parts.

The subject looks so very vulnerable, and the fractured quality of the screen comments on that quality. But the face is also strong and intelligent looking. The vulnerability is intentional sensitivity—just as the "fractured" screen is an intentional structure.

In Levine's and Mazur's works, *line, shape,* and *form* have been emphasized as agents of expressiveness. That is not an exclusive list. All aspects of drawing are potentially expressive: the shape of the space you draw within, the texture of the surface you draw on, the medium you choose to draw with, the color, the source

99

material you choose and any distortions of it. They are all instruments of your expressive intent.

For the finest lessons in turning insight into art, examine the master works in this book and elsewhere. As you study them, try to discover how each artist made a unified response to what was seen and felt. Absorb ways in which line, value change, or color makes visible the insight of the work. Understand that it was necessary for the artist to work that way. Individual techniques and individual insight are united to form the content of the work.

There is a lot to be learned, and not everything can be absorbed at once. But constantly challenge yourself. With each drawing, try to bring your work closer to the expressive depth you feel. When you approach your *own* drawing, whether you are a beginner or experienced,

believe in your own responses. Work for the penetrating, responsive, and, above all, personal image.

THE SUPPORTING ROLE OF HANDS

Expressiveness

The expressiveness of a great many beautiful portraits is greater due to the gesture of a hand or of both hands. They participate in the expressive theme in a seemingly endless variety of ways. For a sampling, look at Figures 2–14, 3–12, 7–16, 9–2, and 9–8. In each, hands reinforce the artist's message.

In Michael Lewis's *Imitation of the Dream Dancer* in Figure 8-13, the subject's hands have a strong visual role both as interesting forms

Figure 8-13.
MICHAEL LEWIS (American, 1941-).
Imitation of the Dream Dancer (Charcoal and black crayon).
Courtesy of the Fogg Art Museum, Harvard University, Cambridge; Purchased by the Margaret Fisher Fund for Drawings.

and as strong design elements. In addition, they are an active factor in the emotional content of the work. They temper the power of the face, which otherwise might overwhelm a viewer with its fierce anger. The lower, fully seen hand, in particular, sends a more peaceful message. It is groping, not yet united with the face in anger, not forming a clenched fist or grasping a weapon. Its noncommittal posture offers some hope for a civilized outcome to whatever is happening.

In Figure 8–14, a student work shows hands carrying an even greater part of a portrait's expression. They make an intriguing enclosure for part of the space illusion created in the drawing, and they share equally with the face in setting a thoughtful mood.

Even though hands can be desirable and expressive design elements, they are sometimes avoided as being difficult to draw. They are not easy, but they are no more difficult than, say, noses. And the reward for mastery is the ability to enrich drawings as Lewis and many others have done.

Figure 8-14.
Student drawing.
Courtesy Richard Pessin.

Hand and Wrist Structure

To be able to make full use of the expressive potential of hands, you must know something of their structure. They are complex. Each hand

and wrist contains over 10 percent of the bones of the entire body, plus the muscles and tendons needed for motion.

Focus for a few minutes on Figure 8–15 to study that 27-bone structure. Bones 1 (radius) and 2 (ulna) of the forearm attach to the eight

Figure 8-15.
Bones of the Hand, Dorsal View from *Twenty Plates of the Osteology and Myology of the Hand, Foot, and Head* by Antonio Cattani.
Courtesy Boston Medical Library in the Francis A. Countway Library of Medicine, Harvard University

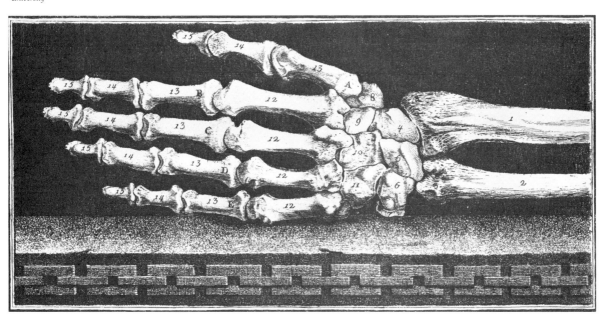

carpal bones of the wrist (4 through 11). (The radius and ulna are pictured here because the forearm is always involved in the form and action of the hands.) The body, or back/palm part of the hand, is supported by the metacarpals (all numbered 12). The rest of the bones, numbered 13, 14, and 15, are the phalanges, the bones of the thumb and fingers.

The wrist is not correctly located by some students. Look at Figure 8–15 again. It is made up of bones 4 through 11, located just beyond the radius and ulna. The bones of the wrist form a compact mass, and they are joined with the hand bones in such a way that the wrist and hand move back and forth together. They are therefore thought of as part of the hand. Visually, the wrist bones slope down to the hand bones, which in turn flare, giving the hand its characteristic shape.

Five fingers extend from the hand. Only the thumb projects from the side and has two joints. The other fingers extend from the lower end of the hand, have three joints, and are different lengths. Together they form a wedge shape, such as this.

Each of the finger bones has a shape that is slender in the middle and knobby at each end. The knobby portions join together and create knuckles, the thicker parts of each finger. The wrist-hand-finger bones are linked by muscles and tendons and covered thinly by skin on the back so that the underlying structure is quite visible. The inside of the hands and fingers are padded with a layer of fat beneath the skin and the underlying structure is much less apparent.

Action of the Hands

Hands are so versatile. Do they have limitations? If you have ever seen a mannequin in a store window with a hand attached in an unnatural way, you know that some hand movements are not possible. So that you don't draw impossible hands, keep the following movement limits in mind.

1. The wrist-hand-finger complex is not capable of independent rotary motion. When you turn your hand from back side up to palm side up, your whole forearm shifts. The rotary motion comes from the elbow. So the hand, wrist, and fingers need always to be related to the arm correctly.

2. Fingers bend in only one direction—in towards the palm. The thumb bends at right angles to the other four fingers, but still in toward the palm.

3. The wrist bends forward and backward on the arm at something less than an 180° arc.

A few people with flexible joints can force their hands into positions that are painful for most.

4. Fingers can spread just so far, though in cartoons you often see them very wide apart.

5. If you use your own hands as a model, remember that the portrait is *facing* you and that the hands must be reversed. Use a mirror.

Proportion

Two fairly common misproportions occur in drawings of hands.

1. They are drawn too small, sometimes so small that they look shrunken and deformed. With awareness, this problem quickly disappears.

How big should hands be? Put your hand over your face. If you are a fully grown adult, your hand is probably the length of your entire face, from chin to hairline. At the broadest point, just where the fingers join it, a hand is about as wide as the middle finger is long.

2. Fingers are drawn too long, perhaps to flatter. Long slender fingers are much admired. But look at your own hands. The middle and longest finger is about as long as the distance from that finger to the

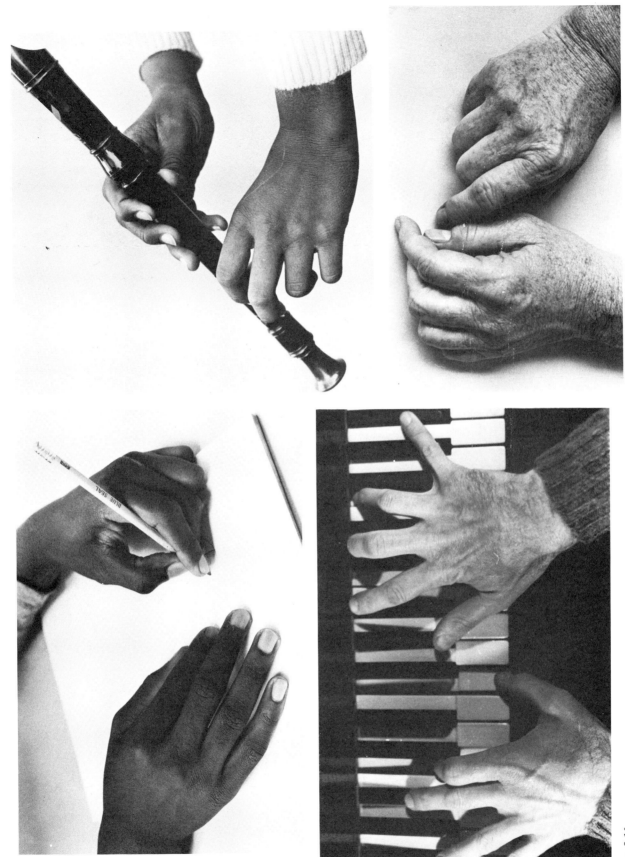

Figure 8-16.
Photos by Phoebe Francis.

104

Figure 8-17.
Photos by Phoebe Francis.

wrist. The other fingers are shorter. The pinky is the shortest, and the thumb is just a little longer. As with head-neck-shoulder proportions, hand proportions are rough guides. Many hands differ in some particular way.

Practicals for Drawing Hands

MATERIALS. *Pencil or Conté and white bond.*

1. Let your nondrawing hand assume a palm-down position, propped up on a small pillow with fingers spread wide apart so that you see clearly the back of the wrist, hand, and fingers. Make sure the hand is directly in front of your line of vision as you turn your head slightly to look at it. You do not want to see the sides of the fingers.

Make a quick, life-size gesture drawing of it. Over that, draw the contours. Keep the bone structure in mind. Notice the surface ridges radiating from the wrist caused by the metacarpals. Look at the shape of each finger, at the wideness of joints, and at the wrinkles in the skin that let fingers bend.

2. Now turn your hand over. What a change in terrain! No bony manifestations. Instead, there is irregular "quilting" to make bones comfortable when the hand is gripping something. The myriad fine lines come from the constant folding of the skin.

Following the same drawing process: gesture and then contour. The two drawings that result from these Practicals have quite different characters.

3. First, obtain if you can and study the Book of One-Hundred Hands *by George Bridgman (see References that refer to this section). Then, turn your own hand so you see the back at an angle. This time, on top of your initial gestural statement, search out the geometric forms you see. This is an essential step toward structural understanding and making your hand drawings look three-dimensional.*

4. In Figures 8–16 and 8–17 you saw photos of hands that differ not only in appearance but in position. Draw them all. Begin with gesture. Then block

in geometric forms. Finally, add value change where (and only where) it helps to explain form. Note: These Practicals are difficult. Don't rush. Allow time to try and try again if you are not satisfied with the first results.

. . .

This chapter, in surveying useful tools for achieving likeness, has added two new challenges: expression of a subject's inner being and faith in your own responsive ability. With both tools and challenges understood, you are in a good position to take the visual journey in the next two chapters through the aging process, learning how it affects all people.

REFERENCES

Responsiveness

1. GOLDSTEIN, NATHAN. *The Art of Responsive Drawing.* Englewood Cliffs, N.J.: Prentice-Hall, Inc., 1977.

2. FAST, JULIUS. *Body Language.* New York: Pocket Books, 1981.

Hands

1. BRIDGMAN, GEORGE. *Book of One-Hundred Hands.* New York: Dover Publications, Inc., 1972.

2. BURNE, HOGARTH. *Drawing Dynamic Hands.* New York: Watson-Guptill Publications, 1977.

3. KRAMER, JACK N. *Human Anatomy & Figure Drawing: The Integration of Structure and Form.* New York: Van Nostrand Reinhold Company, 1972.

CHAPTER NINE

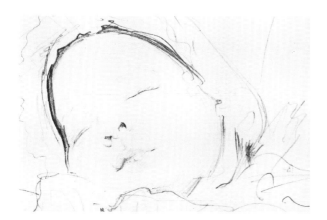

Children

Perhaps because they evoke the protector and lover of the helpless in each of us, portrait drawings of children can be appealing beyond measure. They can also be unusually satisfying to the artist, even though they unquestionably involve special difficulties, discussed later.

Look at the John Singer Sargent portrait in Figure 9–1 and see how completely any difficulties can be overcome and how choice the results can be. Though you are not yet a John Singer Sargent, you share with him, to a greater or lesser extent, the vital assets that determine the success of every drawing of a child. The most basic asset is some *knowledge* of child body structure. The second is *responsiveness* to children.

The third is your *skill* with materials, techniques, composition, and creating illusion. And the fourth and fifth are your growing *abilities to see clearly* and *see with your heart*.

A combination of these prepares you to express creative impulses. Your particular combination is unique and at the same time changeable. Consequently, even if you are a new student, you are potentially an intriguing and good portraitist.

Adding to your knowledge, extending your responsiveness, and furthering your technical and visual skills with more applied drawing problems are the purposes of this chapter. It also covers the "special difficulties" that chil-

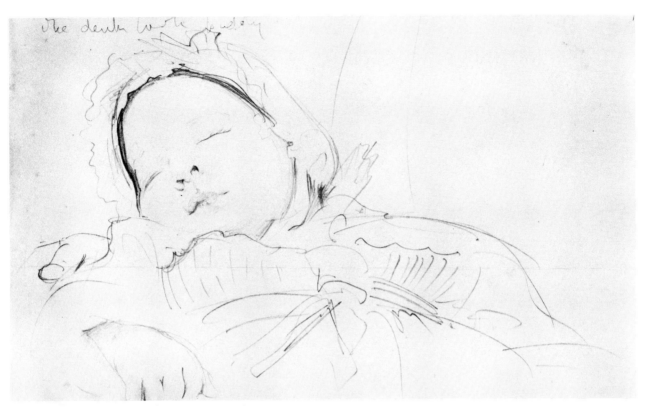

Figure 9-1.
JOHN SINGER SARGENT (American, 1856-1925).
Jack Millet as a Baby (Pencil).
Fitzwilliam Museum, Cambridge, England.

dren's portraits entail, expanding what was said in Chapter 7 about always active youngsters as models.

PHYSICAL DEVELOPMENT

You need to know how children are physically different from adults and how their proportions change as they grow. Otherwise, you may find the baby you portray has the proportions of an older person. Jim Dine, one of the twentieth-century's finest draftsmen, used malproportion for effect in his *Third Baby Drawing*, thereby creating an elderly baby (Figure 9–2). In the Persian miniature shown in Figure 9–3, you see not a baby but a dwarfish adult, because the artist did not consider the different body proportions of an infant to be important.

This chapter deals with the anatomy and development of the whole child (not just the head, neck, and shoulders) because it will be such difficult information for you to find. Most anatomy books for artists touch on child structure very lightly.

Growth

All the following observations are meant to serve only as guidelines. Children grow and de-velop according to an internal clock and their own gene potential, rather than according to an external chart. A 9-year-old may be 4 feet tall and weigh 55 pounds or 5 feet tall and 85 pounds. In either case, the child is considered to be developing normally.

Depending a great deal on genetics and prenatal care, a full-term baby weighs about 7½ pounds and is about 20″ long. A full quarter of that length is head—a head that has greater circumference than the chest—for that head has already grown to 70 percent of its full adult size. Yet the body attached to it is only 25 percent of its final length. In the next 18 years, the relationship of these parts reverses radically. The head ends up being not a quarter of the total body length, but between one-seventh and one-eighth. By constrast, the body triples in length and adds 15 to 25 times its weight.

Growth of the Head

The part of the head that is most nearly adult size at birth is the cranial vault, which encloses the already well developed brain. The face is short. In comparing the child and adult skulls in Figure 9-4, you observe that the jawbone is small at birth and produces a short, receding chin profile. In growing, the jawbone alters its

108

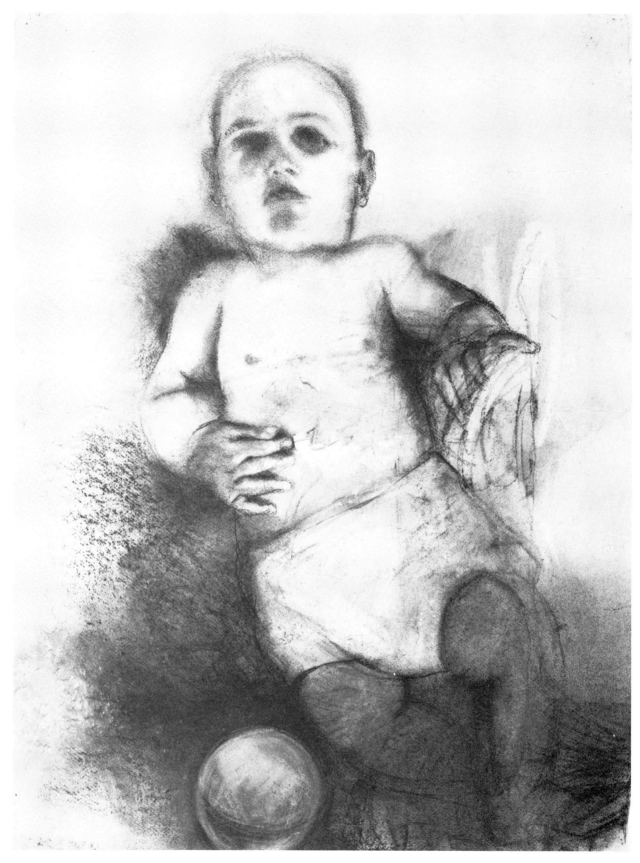

Figure 9-2.
JIM DINE (American, 1935-).
Third Baby Drawing, 1976 (Charcoal and crayon), 39-⅞″ × 29″.
Collection, The Museum of Modern Art; Gift in honor of Myron Orlofsky.

Figure 9-3.
ANONYMOUS (Isfahan, c. 1640-1650).
A Lady Suckling a Baby Under a Tent (Ink).
*Los Angeles County Museum of Art, Nasli and Alice Heeramaneck
Collection: Gift of Joan Palevsky.*

angle rapidly, and the apparent misproportion of the newborn profile adjusts so quickly that, by the end of the first year, the chin usually has the expected prominence.

The facial bones, especially the jawbones, continue to grow and change shape at a greater rate than the rest of the skull, partly to accommodate first the baby teeth and later the adult teeth. Thus the face lengthens greatly. One clue to these changes is the eye location. In a newborn, it is about five-eighths of the way down the head. In an adult, it has gradually shifted to half way. Robyn Wessner's *Self-Portrait* with its drawing of her baby face superimposed on the photo taken of her as an adult clearly illustrates this shift (Figure 9–23).

Growth of the Body

Neither head nor body growth is an even, steady process. During the first year, the face lengthens a bit and the legs grow a little, but the greatest change is in the torso. At age 1, the baby has grown from 20″ to 30″, and 6 of those 10 new inches are in the torso. While length increases 50 percent, weight leaps 300 percent from 7½ to 22 pounds. The infant who was once nearly scrawny is now rounded and chubby with generous deposits of baby fat.

Figure 9-4(a).
Cloquet: *Skeleton of an Infant* from *An Atlas
of Anatomy for Artists* by Fritz Schider, 1957.
Permission Dover Publications, Inc., New York.

Figure 9-4(b).
The Skeleton (adult) from *An Atlas of
Anatomy for Artists* by Fritz Schider, 1957.
Permission Dover Publications, Inc., New York.

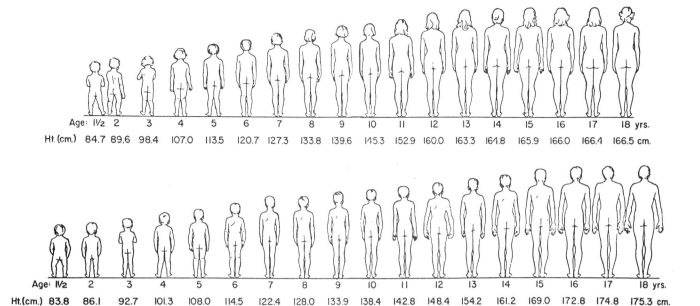

Age:	1½	2	3	4	5	6	7	8	9	10	11	12	13	14	15	16	17	18 yrs.
Ht.(cm.)	84.7	89.6	98.4	107.0	113.5	120.7	127.3	133.8	139.6	145.3	152.9	160.0	163.3	164.8	165.9	166.0	166.4	166.5 cm.

Age:	1½	2	3	4	5	6	7	8	9	10	11	12	13	14	15	16	17	18 yrs.
Ht.(cm.)	83.8	86.1	92.7	101.3	108.0	114.5	122.4	128.0	133.9	138.4	142.8	148.4	154.2	161.2	169.0	172.8	174.8	175.3 cm.

Figure 9-5.
Changes in proportions and stance of males and females, 18 months to 18 years.
From *Growth Diagnosis* by L. M. Bayer and Nancy Bayley. Permission University of Chicago Press, Chicago.

The result is a 1-year-old whose head and torso are proportioned more like an adult's. The head is now one-fifth instead of one-quarter of the total body length, but the legs look shorter than ever. They also have a held-apart appearance due to fat and a slight bowing of the bones (accentuated by diapers). And the 1-year-old has a characteristically protruding abdomen because it contains some internal organs that later drop into the pelvic cradle.

After a child's first birthday, the legs grow faster than any other part of the body, and that growth relationship continues for all the years until puberty when the torso again takes the growth lead. By 18, the legs are about 50 percent of the total height. (At birth, they are about 30 percent.)

In her book, *Dynamics of Development: Euthenic Pediatrics*, Dorothy Whipple tells us that, also after age 1, the fat stored beneath the skin begins to disappear, the legs and feet come together so that the bowlegged look disappears, the abdomen is increasingly held in, and, over the next 5 years, the slim, lithe body of the school age child emerges. The shape—long-legged and slender—is the same for boys and girls until the onset of puberty. In fact, before puberty, clothed girls and boys cannot be distinguished by shape; gender differences have to be signalled by clothing or hairstyle. Dr. Whipple goes on:

The changes that take place at puberty involve almost every structure in the body. Puberty begins approxi-

mately 2½ years earlier in girls than in boys, so that for a few years girls are larger than boys of the same age. Growth of the skeleton and of the soft tissues is stimulated. Growth of the trunk is more rapid than that of the legs. The later puberty occurs, the longer the time that the legs grow rapidly. Those children who mature early end up with shorter legs than those who mature later. Boys, as a whole, maturing later than girls, have 2 to 2½ years more of rapid leg-growth time than do girls. Men are therefore longer-legged than women As a result, when men and women are seated, their heads are much more nearly on the same level than when they are standing

The relation of shoulder and pelvic width also changes. Girl's shoulders become broader at a much slower rate, so that the mature adult male has shoulders much wider than the adult woman, even if she is as tall as he. Pelvic width increases in both sexes, and in the female the pelvis also evolves from an oval to a round shape. In addition, while boys actually lose fat during this growth period, it again increases in girls, and one area of concentration is around the hips, buttocks, and thighs. Women's hips are wider (and longer from top to bottom) than men's, but they seem even wider than they are in comparison to relatively narrow shoulders. When fat appears at the hips and thighs, it also accumulates in breasts and in a layer over the entire body that softens curves and makes women look smoother and rounder than men. Again citing Dr. Whipple:

The *muscle mass* constitutes the largest portion of the total body, hence its growth dominates the growth of

111

the body as a whole. Muscle mass increases rapidly during infancy, grows slowly during childhood, spurts during puberty, and then increases slowly for a few years after sexual maturation has been reached.

These cumulative differences create another difference, which is in posture. A girl's weight distribution around the hip area causes her lower spine to curve more and her legs to curve slightly toward each other tending toward knock-knees. A boy's structure creates the opposite tendency, bowlegs. These tendencies range from imperceptible to very noticeable. In fact, posture shifts occur all through growth, not before differentiated by gender. Figure 9-5 is a guide to these shifts as well as to the changes in proportions that occur all during the first 18 years of life.

Facial Changes

Infants and toddlers have mouths that are very flexible and soft. The corners are actually pulled down by the weight of the plump cheeks and thus create the characteristic baby pout.

In early years, the eyes are larger in proportion to the total face than they will be later. Eyelashes may be very long and full, creating a strong, blurred outline to the upper eye (not individual lashes).

Baby faces, as we saw earlier, are wide in relation to height. Slowly they lengthen and seem to get narrower as baby fat disappears. In middle to late adolescence, noses grow longer and features sharpen, a development we see clearly in Michelangelo's drawing of a boy about 16 years old (Figure 9–6).

Baby skin, not fully formed and subject to usually temporary blotching and peeling, becomes for the period of childhood, the ideal, clear, glowing covering celebrated in song and story. In adolescence, the skin reflects hormonal changes necessary for the child to become an adult. Sebaceous glands enlarge and begin to produce oil. Acne appears. Also during adolescence, male facial hair appears.

For those who are interested in more detail on the physical maturation of children, the first two references given for this chapter are helpful and should be available in most medical school or hospital libraries.

RESPONSE TO CHILDREN

For success in drawing children, you must be able to put yourself in their shoes. You have to respond to and respect their personality and behavior. Your reaction comes through in your drawing. Behavior growth, which is just as remarkable as body growth, is therefore of considerable importance to an artist trying to interpret a subject. If your experience with children is limited, the two child behavior references given at the end of the chapter will introduce you to what you can expect from children at different ages. Some attitudes toward children as subjects of art can be extremely troublesome and must be thoughtfully considered. Exaggeration, sentimentality, emotional strength, and flattery are among them.

Exaggeration

It is tempting to achieve a childlike quality by exaggerating the physical hallmarks of children's faces—their big, innocent eyes, their soft or fluffy curls or straight elfin locks, their round cheeks and soft lips. The result might make an appealing greeting card, but it does not present a "real" child. It does not intend to be a portrait. If you have a greeting card with a baby on it, compare it to John Singer Sargent's drawing in Figure 9–1. You will see that Sargent, appropriately, is more individual, is presenting a particular child—has made a portrait rather than a general statement.

Sentimentality

Sentimentality, the other unwelcome intruder, makes its way into work via fluffy kittens, baseball caps on backwards, and pigtails with perfect ribbons. These and similar contrivances can bring on a case of terminal cuteness in an otherwise fine work. Children are naturally appealing without any exaggeration or sentimentality. You can count on it.

Emotional Strength

With regard to emotional content, it is appropriate to look briefly at the work of literary illustra-

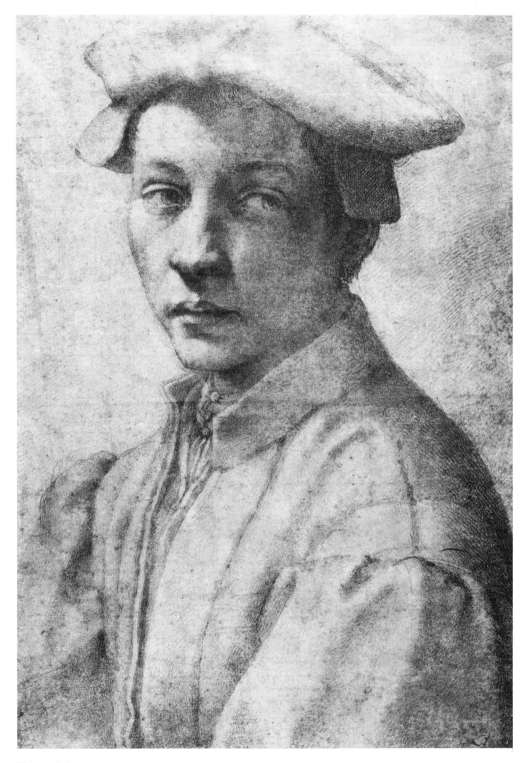

Figure 9-6.
MICHELANGELO BUONARROTI (Italian, 1475-1564).
Andrea Quaratesi (Black chalk).

tors. While their intention is not to do portraits, they often present children who are individual and seem to be taken from life, and their technique and design quality are frequently very beautiful.

However, illustration may engage us more with prettiness and nostalgia than depth of emotion. Make a comparison between Figures 9–7 and 9–8. Jessie Wilcox Smith's mother and child remind us of the past and make a pretty pair, but Mary Cassatt shows us more real tenderness. Whether the drawing represents past or present becomes irrelevant. Illustration may also create a line between itself and portraiture that is more one of the degree of visual complexity than of emotional depth. Compare Donna Diamond's very fine work in Figure 9–9 to Wayne Theibaud's *Mallary Ann* in Figure 9–10. In both, there is a similar, strongly communicated emotion. But in Diamond's drawing there is an overall evenness of visual emphasis that makes it, appropriately, less involving than Theibaud's.

Study these contrasts carefully, for, as satisfying as the work of these illustrators is, a good portraitist must go in the direction of unique and personal responses to achieve emotional and visual complexity. Because Wayne Theibaud does this, he has produced a beautiful portrait rather than a beautiful illustration.

Flattery

A close relative of exaggeration and sentimentality—and just as tricky—is flattery. My students frequently smooth away the "imperfections" they see in a model. The impulse is even stronger when the model is a child. It sometimes seems unkind to be visually honest. For example, my husband is fond of saying that children are like kittens—they are all appealing. I almost agree. But some *are* more attractive than others, and some are appealing due more to their sparkling personalities than to perfection of feature.

Bear in mind that all people are more arresting or attractive from certain angles, in a certain light, or with certain expressions on their faces. These are valid considerations. Just be sure to make a distinction between flattery and a sensitive assessment of what it is about a child that you or others appreciate and love.

SOURCES OF IMAGERY FOR CHILD PORTRAITS

How can anyone draw a moving object? How does anyone get children to pose long enough to make drawing them possible? This great problem requires ingenious solutions.

First, where can you locate children to model for you? You do not find their names on an art school model roster. Model agencies charge too much. I turn to my own children and to those of friends and students.

In my portrait classes, I sometimes have children pose. But having them do so is not easy, and it is rarely altogether successful. It requires not only a youngster who wants to cooperate and who has a long attention span, but also, if the child is younger than 9 or 10, a parent or babysitter. A very mature 3- or 4-year-old can sit for 10 minutes at a time *if* a parent is at hand and reading something very entertaining. Even then, a child's expression changes if the story is amusing or sad, or the child squirms if bored or uncomfortable. (A chair that is neither too small nor too big, too hard nor too soft, is extremely important for any child model.)

Six- or 7-year-olds can do better, possibly 15- or even 20-minute poses, as they become involved in hearing a long story. They can also be motivated by the prospect of doing such a grown-up thing as modeling, by seeing the drawings as they develop and by the idea of making money.

Bowing to necessity and having both a child *and* a parent before you can be a real bonus. If you draw both, you get not only double practice, but you can often work at expressing the emotional bond between parent and child.

At 9 or older, many children can be very adult and may not need special attention, though music or stories on cassette tapes can be helpful.

Since modeling is hard work for any child (and impossible work for a toddler or infant), you must consider drawing them at the times when they are voluntarily still: when they are listening to a record, watching television, sleeping. Look again at the beauty of Sargent's drawing at the start of this chapter. Excellent results can be had from taking the path of least resistance.

Figure 9-7.
JESSIE WILCOX SMITH (American, 1863-1935).
First the Infant in its Mother's Arms.

Figure 9-8.
MARY CASSATT (American, 1845-1926).
Sleepy Baby (Pastel).
Dallas Museum of Fine Arts; Munger Fund purchase.

Figure 9-9.
Illustration by Donna Diamond from *Bridge to Terabithia* by Katherine Paterson (Thomas Y. Crowell, Publishers).
Copyright ©1977 by Katherine Paterson. Reprinted by permission of Harper & Row, Publishers, Inc.

By all means, use photos. For very young children, photos and sleep times are the only chances you get at a still subject. Take the photos yourself and take lots of them—as many as 30 of one child. Include close-ups. Your skill grows with experience. Your reward is interesting photos that are where you want them when you want them, and they stay still for as long as you want them. They are an invaluable aid to anyone serious about child portraits.

One cautionary note: I avoid including studio photographs of children in my source material because the poses tend to be stiff rather than natural. Facial expressions often seem self-conscious. For a studio sitting, parents usually dress a child in special-event clothes and curl, slick back, or beribbon hair so that the total effect is not the norm. If you *want* that degree of formality, then studio photos may be useful. (See Chapter 7 for general discussion of the advantages and disadvantages of using photos.)

Finally, use master drawings, such as the "portfolio" at the end of this chapter. They are not only legitimate source material, they are richly endowed "teachers." You can learn about structure and proportion. You can observe a master's use of materials, the skilled organization of portrait elements, the touch with the softness of a child's face, the choice of scale. These are all ways in which a master produces a fine drawing.

If you are drawing from life, draw the children you are interested in *now*. They grow and change fast. The 3-year-old you wish to portray is in no time (it seems) 6 and losing teeth, or a young adult, beyond childhood altogether.

Practicals for Drawing Children

MATERIALS. *As noted in each practical.*
1. Draw one of the infant skeletons pictured in Figure 9–4. Enlarge it, using paper at least 11"×14". If you have the rare good fortune of access to a small child's or infant's skeleton, draw from it instead. Use

116

Figure 9-10.
WAYNE THEIBAUD American, 1920-).
Mallary Ann (Pencil).
Collection of the Artist.

an HB, 2H, or 2B pencil on bond paper. Allow your-
self three hours or more, if necessary.

2. *Do contour and gesture drawings of one fig-
ure from each row of the Muybridge photos on the
next page (Figure 9–11). Review Chapter 4 on these
techniques. Also, if possible get a book of Eadweard
Muybridge's photos of the human body from your li-
brary and do more. If you have children, do them as
they sleep, read, or watch TV. Use 2B pencil, char-
coal, or felt tip pen on rough newsprint at least
14"×17" in size. Repeat a drawing whenever you
wish to have a more satisfactory result. Allow your-
self three to four hours.*

3. *Take ten or more close-up photos of each of
several children of different ages, including at least
one infant. Do contour and gesture drawings from
the photos as well as at least one modeled drawing.
(Again, refer to Chapter 4.) Use pencil. Do several on
one page from one photo, as in Figure 9–12. Thus you
see how tiny variations in a feature, proportion, or
value emphasis affect the results.*

4. *Select three master portrait drawings of chil-*
dren. *Copy and enlarge them each in a medium that is
as close to that originally used as possible. Then do
each in a different medium. Use appropriate paper
that is at least 11"×14". In addition to getting "mas-
ter" lessons from doing both copies, you will appreci-
ate more fully how media influence results.*

Inexperience is overcome only by experi-
ence. Yet the quality of that experience is en-
hanced by critical analysis from professional art-
ists. Classes are naturally very useful for this
purpose. As mentioned in Chapter 7, if you are
working alone or with a small, self-gathered
group, you should arrange periodic critiques
from a teacher/portraitist who does fine work
and has good teaching credentials.

Be alert to images of children that interest
you due to expressions, attitude, action, use of
media, or any other reasons. If they are in news-
papers, magazines, or other throw-away
sources, cut them out and collect them in a
folder or box. You thus have an additional
source of images to draw from.

Figure 9-11.
"Girl crawling on floor" from *The Human Figure in Motion* by
Eadweard Muybridge, 1955.
Permission Dover Publications, Inc., New York.

Figure 9-12.
Student drawings from a photograph of Amy Splitt.
Courtesy Chansonette Wedemeyer and Amy Splitt.

REFERENCES

Physical Growth

1. WHIPPLE, DOROTHY V., M.D. *Dynamics of Development: Euthenic Pediatrics.* New York: McGraw-Hill Book Company, 1966.

2. SINCLAIR, DAVID. *Human Growth After Birth*, 3rd Ed. Oxford: Oxford University Press, 1978.

Behavior

1. ILG, FRANCES L., M.D. AND LOUISE BATES, Ph.D. *Child Behavior.* New York: Harper & Row Publishers, Inc., 1981.

2. FRAIBERG, SELMA. *The Magic Years.* New York: Scribner and Sons, 1968.

Figure 9-13.
EASTMAN JOHNSON (American, 1825-1906).
Sheet of Studies (Charcoal and pencil).
Courtesy Museum of Fine Arts, Boston: Gift of Maxim Karolik.

120

Figure 9-14.
MARY CASSATT (American, 1845-1926).
Portrait of a Child (Pencil).
The Wadsworth Atheneum, Hartford.

Eastman Johnson

Figure 9-15.
EASTMAN JOHNSON (American, 1825-1906).
Child in Bed (Charcoal).
Museum of Art, Rhode Island School of Design, Providence; Gift of the Museum Associates. Photo courtesy Childs Gallery, Boston.

122

Figure 9-16.
PETER PAUL RUBENS (Flemish, 1577-1640).
Head of a Little Girl (Black and red chalk, heightened with white,
contours reworked by the artist in pan and brown ink).
Cabinet ds Dessins, Musée de Louvre.

123

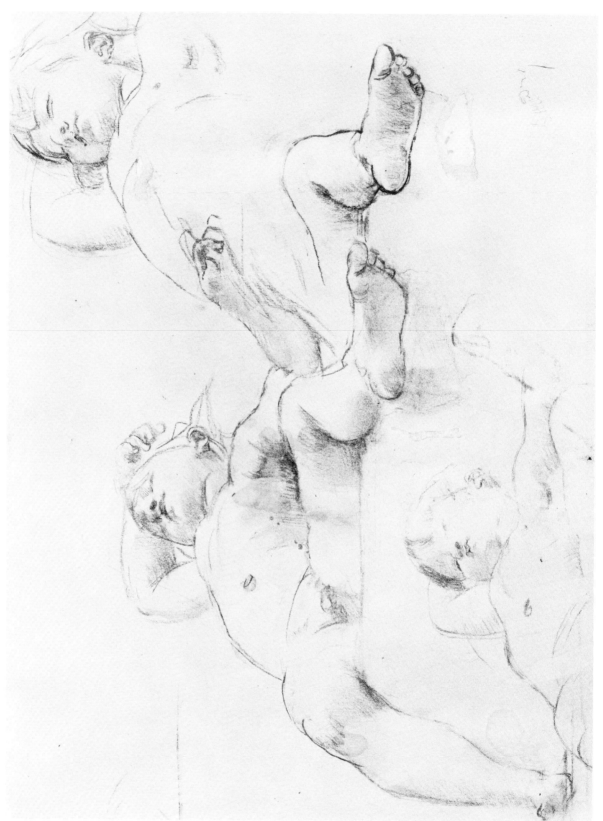

Figure 9-17.
PAUL JACQUES AIME BAUDRY (French, 1828–1886).
Three Studies of a Sleeping Child (Black chalk).
Courtesy of the Fogg Art Museum, Harvard University, Cambridge; Bequest of Grenville L. Winthrop.

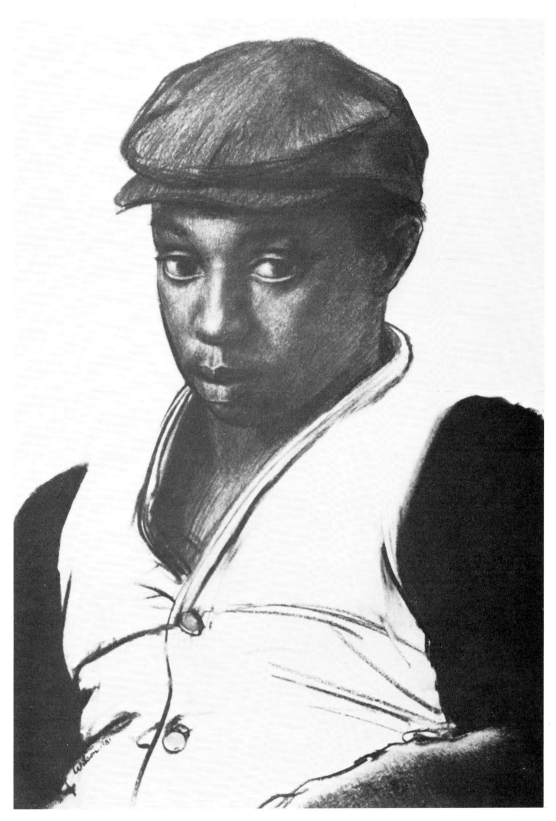

Figure 9-18.
JOHN WILSON (American, 1922-).
Ritchey (Charcoal).
Permission of the Artist.

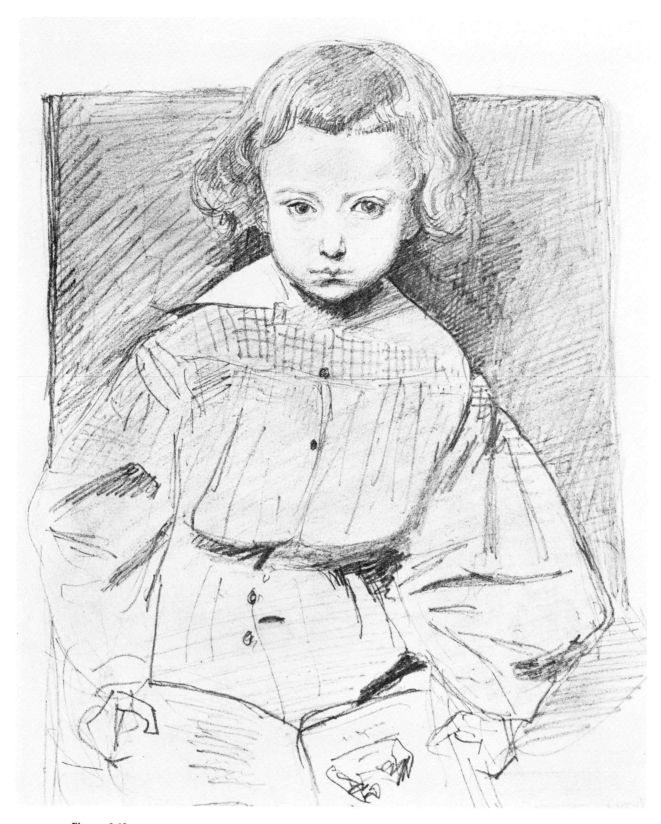

Figure 9-19.
JEAN BAPTISTE CAMILLE COROT (French, 1796-1875).
Henry Leroy as a Child (Graphite).
Courtesy of the Fogg Art Museum, Harvard University, Cambridge; Bequest of Meta and Paul J. Sachs.

Figure 9-20.
GIOVANNI BATTISTA TIEPOLO (Italian, 1696-1770).
Head of a Page (Pen and bistre wash over black chalk).
Cincinnati Art Museum; Bequest of Mary Hanna.

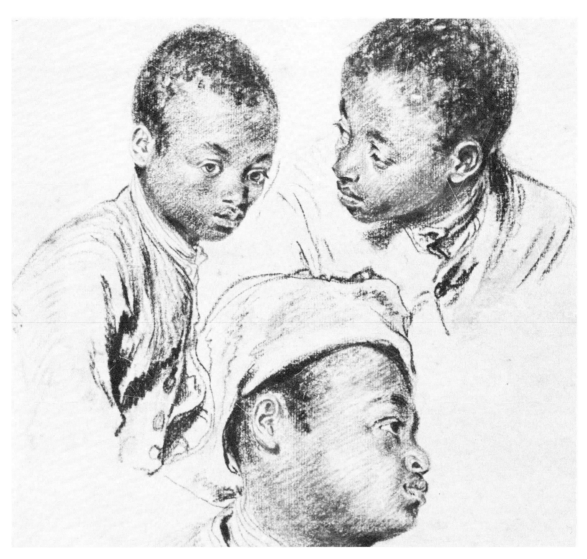

Figure 9-21.
ANTOINE WATTEAU (French, 1684-1721).
Three Studies of the Head of a Young Negro (Sanguine of two shades, black
chalk with touches of white and gray wash).
Cabinet des Dessins, Musée de Louvre.

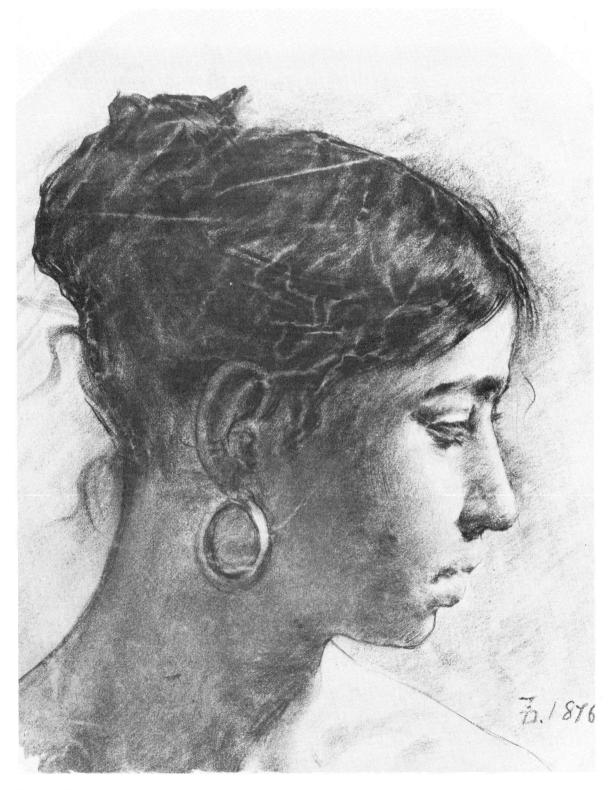

Figure 9-22.
FRANK DUVENECK (American, 1848-1919).
Head of a Girl, Right Profile View (Black chalk).
Cincinnati Art Museum.

Figure 9-23.
ROBYN WESSNER (American, 1949-).
Self-Portrait (Photo-drawing).
Courtesy Private Collector.

130

CHAPTER TEN

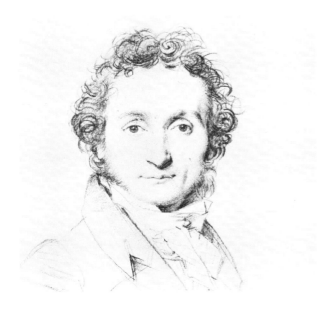

Adults and elders

While portrait drawings of children are appealing beyond measure, portraits of adults and elders are *far* more numerous. Why haven't artists focused more on artless, beguiling young faces? The most significant historical reason is that most motives for portraiture were all adult concerns. Children do not typically wish to insure their immortality, extend their power, memorialize their greatness, establish genealogy, or provide love tokens.

Today, the usefulness of portrait work in an artist's self-learning and discovery certainly extends to drawing children, but the practical obstacles persist. Child models are hard to find, and they don't sit still!

Beyond these past and present considerations, the relative rarity of child portraits stems also from an overriding aesthetic consideration. Between the ages of 20 and 90 or so, the human face becomes a fascinating map of the journey from artlessness to art*ful*ness. Life experience and physical change gradually form its character. Smooth baby and teen faces evolve into longer, lined, more compelling adult and elder faces. In Figure 10–1, you see clearly this compelling quality, which holds the attention of an adult audience longer than the unmarked faces of childhood. The evolution of the face—the surface change that takes place after 20—is the substance of this chapter. (Underlying anatomy is covered in Chapter 5.)

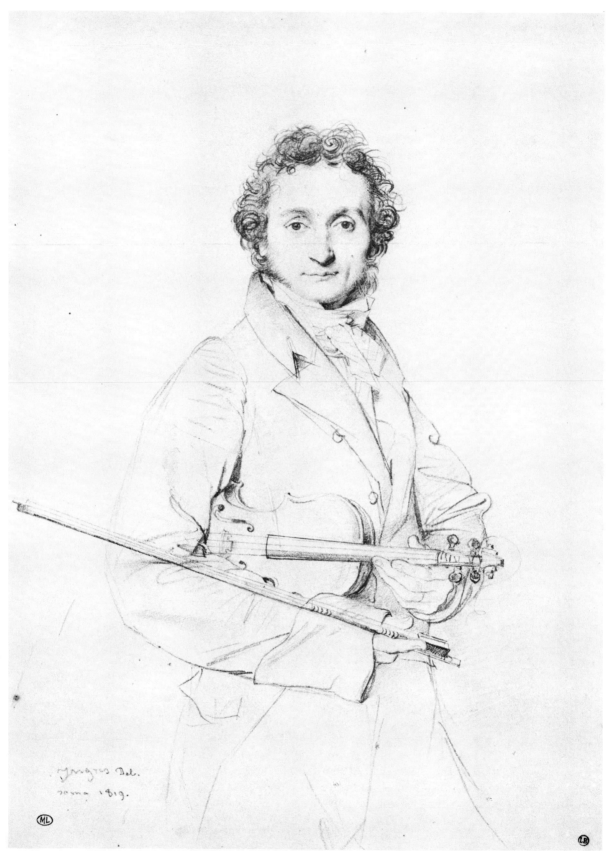

Figure 10-1.
JEAN-AUGUSTE DOMINIQUE INGRES (French, 1780-1867).
Portrait of Nicolo Paganini (Lead pencil).
Cabinet des Dessins, Musée de Louvre.

132

PHYSICAL CHANGES

Occurring at about the same age in all people, the end of physical growth is a clear marker that enables us to say childhood is over. But when does an adult become an elder. In ten years? In 20 years? The process is long and complex, and its manifestations occur over a period of many years. One aspect of a person's physical or psychic makeup becomes "old" at a different time than another. The process is also continuous. For that reason, it is more useful to consider the process as a whole than to divide adults from elders by an arbitrary marker, such as retirement age.

Many people anguish over visible signs of age and treat them like shameful secrets. Women cover their necks, dye their hair, and fight off wrinkles. Men, increasingly, do the same. We seem to worship youth. Yet, nothing in an attractive baby or teenager is intrinsically more beautiful than in an attractive octogenarian. The difference lies in our attitudes. For youth, we narrow our focus to the promise of achievement ahead. As a person grows old, we reverse that focus and concentrate on decline and the pathologies of aging. I prefer a consistently wider view that also sees the awkwardness and pain of being young and values the potential experience and grace of being 80. From this perspective, let's discuss the changes of aging that are important to portraiture. I will be as honest as I can, meaning to cause no discomfort for any reader. Instead, I hope to generate the satisfaction of discovery and understanding.

Muscle Structure

As you follow the life of Helen Keller's face in Figure 10–2, first marvel at the understanding and human sensitivity radiated by this woman who could neither see nor hear. Then look at the shape changes of parts of the face as it matures.

For all of us, muscles provide the give and take of body movement. They stretch and contract in cleverly engineered arrangements. They are exceedingly elastic. However, as they age, they gradually lose their ability to snap back into position and become progressively stretched and stiff. Add to this process the downward pull of gravity and you can account

for a part of the change that you observe. In addition, an overlay of loosening skin follows the lead of, and accentuates, sagging muscles by draping around them.

You can observe the early stages of this process in the photo taken of Helen Keller at age 45. She has a slightly fuller brow line as a beginning accommodation to the muscle and flesh that "slide" down and rest there. At the side of her eye, the line has changed for the same reason, as has the jaw, neck line, and length of the chin.

Ears and noses also seem to droop. While some of the change may have to do with muscle relaxation, it is also true that ears and noses continue to grow after the age of twenty. Ears add about a quarter of an inch to their length, and the lobes grow fatter. Noses not only grow about a half-inch in length, making the slope downward from the nostrils greater, they also become about a half-inch wider. And, because the muscles from the chin to the lower neck sag after about 45, the neck gradually increases in circumference.

During the years from 20 to 70, muscles not only become less flexible, but their mass diminishes.

Skin

Skin, the word we use for the tough, waterproof, flexible covering of the human body, is its largest "organ," comprising a fifth of the body mass. This "organ" has multiple roles that are specific and important. It keeps body fluids in and harmful agents out. It maintains body heat and acts as a cooling device. It guards against infection. It restores and replaces itself. It embodies our sense of touch. It tells us of pain, pressure, heat, cold, and things touching the skin, all converted by the brain into warning, understanding, enjoyment.

As the surface of the body, skin is its most visible indicator of age. It relates to our culture's standard of beauty, and its nearness to or distance from that standard bears on our self-concept.

In the adult, adolescent skin changes stabilize, and gradually signs of aging appear. *When* they appear depends to a great extent on how much melanin (brown pigmentation) the skin has to protect it from sun damage. Very fair

(c)

(b)

(a)

Figure 10-2.
Helen Keller: (a) about age 18, (b) about age 45, (c) age 73.
Wide World Photos, Inc., New York.

adults who freckle and burn in the sun begin to develop lines and wrinkles in or around their 40s. For light-skinned people who never burn, signs of aging begin much later. With black or brown skin, changes aren't visible until the 70s or so. Muscles sag, but the skin over them is smooth and unlined much farther into life.

From birth to death, the skin changes in other ways. It contains progressively less water and oil. It loses flexibility and elasticity. The outer layer loses some cells permanently, making it thinner and flatter and therefore more transparent. Together, changes in skin and muscle structure result in fragile, loose, wrinkled, dry skin. The process accelerates for women after menopause so that some women in their 50s look older than men of the same age.

With age, skin is damaged more easily and heals more slowly. It is prone to new growths, such as flat or raised dark patches.

Changes in the skin are irreversible, but largely preventable by avoiding the sun. Compare the back of a 50-year-old woman's neck, always covered by hair, with that of a 50-year-old man who has been outdoors a great deal. Hers is smooth. His is deeply creased.

Some lines in skin that later become creases result from frequent folding in smiles and frowns. They go diagonally from the sides of the mouth up to the nostrils, fan out at the corners of the eyes, go across the forehead and up between the eyes. They can begin to appear as early as the late 20s.

From the mid-30s to mid-40s, skin begins to loosen. This loosening, combined with reduced elasticity and sagging muscles, causes little folds that start at the top of each ear and drape downwards after 45 or so. The combination also causes pouches under the eyes and sagging chin lines. In the late 40s, vertical lines begin to appear around the lips (Figure 10–3).

Eyes

For most people, the early 40s are the years when the lens of each eye loses the elasticity that allows it to focus on material at close range. This change is invisible, but the manifestation is a very visible pair of glasses, which may greatly alter appearance.

Also in the 40s, the pouching of flesh below the eye causes the lower edge of the eye to

Figure 10-3.
"Diagram" of lines and muscle sag that develop in the face between the ages of about 30 and 60.

move down slightly. At the same time, eyelids begin to droop slightly from above. Together, the changes cause the shape of the eye to change slightly over the years, making eyes look as if they are a little lower on the face.

Hands and Arms

In middle age, hands and arms begin to look different because the skin becomes thinner, allowing tendons and veins more prominence. In addition, fold lines at the wrist, around knuckles, and on the palms of hands are deeper. Forearm flesh sags a little, more noticeable in arms where muscles have been well developed.

Visibility of Bone Structure

As skin and muscle mass lessen and sag, bone structure is easier to see, especially in thin faces and especially on the upper surfaces of bones, such as the skull, cheekbones, and nose bones.

In Andrew Wyeth's portrait of Beckie King, the skull beneath flesh and the bones in the arms are clearly revealed (Figure 10–4). In this tender, explicit portrait, nearly all the signs of aging discussed so far are evident.

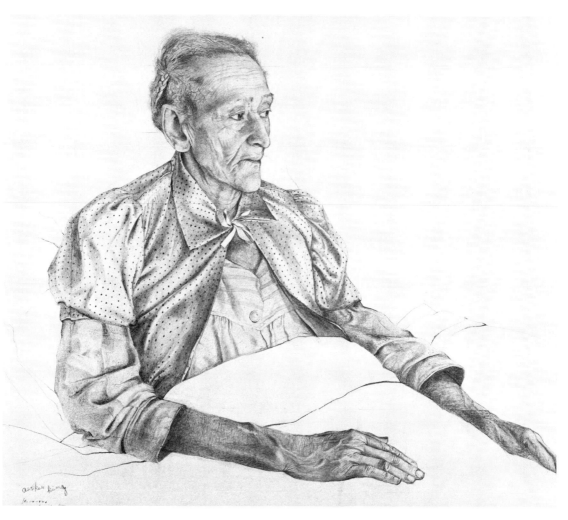

Figure 10-4.
ANDREW WYETH (American, 1917-).
Beckie King (Pencil).
Dallas Museum of Fine Arts; Gift of Everett L. DeGolyer.

136

Figure 10-5.
Henry Fonda at ages 41 and 60.
Wide World Photos, Inc., New York.

Hair

Technically, hairs (along with finger and toe nails) are part of the skin because they grow from it. These "appendages" are built from dead cells pushed from follicles that exist over most of the body. The type, amount, and distribution of the hair depend largely on hormones and heredity. Some hair grows long—to the waist or below—while other hair remains short. Some hair is fine, other hair is coarse. Some is tightly curled, some wavy, some straight. Some people suffer extensive, permanent hair loss; others, relatively little. Hair may be red, brown, black, or blonde; and eventually it all turns white when no more melanin is produced by the follicles. Whatever the particular characteristics of hair, people take a great deal of pride in it.

The abundant, shiny, nonwhite hair of youth is the standard of beauty. Over time, hair slowly deviates from that standard. White hairs begin to appear for most people in the late 30s. Hair is less oily and therefore duller usually by the age of 50. And hair thins even in women after 40, and, by 80 or 90, it may appear wispy (also seen in Wyeth's portrait of Beckie King).

However slight the thinning may be in men's hair, the hairline recedes somewhat, giving middle-aged and older men added length in their faces, specifically in their foreheads. In Figure 10–5, photos of the actor, Henry Fonda, at ages 41 and 60 show a steadily lengthening forehead (as well as chin) giving the face a longer, leaner look. Many people add weight as they grow older, and facial elongation is therefore not as apparent.

After hair begins to recede on the forehead, the next pattern of hair loss for men is the

137

"monk's spot" or bald circle on the back of the head. It gets larger until it meets the receding forehead, leaving the top of the head bare. With age, men have new hair growth in the ears and nostrils, and eyebrow hairs grow longer, making eyebrows bushier.

Over the years, for all men and women, some hair is lost completely, and each remaining hair becomes about 20-percent thinner. By age 70, it approaches baby fineness, and the appearance of hair loss is accentuated.

You may be certain that a man with little hair would like to have more. That is why the scalp preparation, hair implant, and toupee industries have thrived. To a lesser extent, this desire for youthful looks applies to graying hair—think of the enormous hair coloring business. Sensitivity to these matters is important for a portraitist, although gray hair cannot be changed to black, nor can a bald head be made hirsute.

Figure 10-6.
Overlay comparison of the proportions of Henry Fonda's face at ages 41 and 60.

Overall Facial Proportions

At the risk of overgeneralizing, let's summarize the overall changes that take place from age 20 onward:

1. Noses broaden and lengthen, ears lengthen, and lobes become fatter because growth continues after 20.

2. The overall face "oval" is longer because muscles and skin stretch and sag. This change is greater in men because the hairline recedes. In Figure 10–6, the photo from 10–5a of Henry Fonda at age 41 is overlaid with an outline of his head at 60 (10–5b). It dramatically demonstrates the proportional differences that have emerged.

3. Eyebrows and eyes appear to be a bit lower because both muscle and flesh shift. If in later years this is combined with toothlessness, which raises the chin, the proportions approach those of childhood, though the differences in every other respect make age clear.

4. Necks appear to be shorter sometime between 50 and 70 because chins sag and because the neck thrusts forward a bit to accommodate increased curvature at the top of the spine.

5. Finally, shoulders become narrower, more so in men because the change results from muscle shrinkage and men have more muscle to shrink. The narrowing amounts to about an inch in men and a little less in women. It may appear to be greater due to rounded or sloping shoulders.

Results of Stress

While the role of this book is not to take a long look at the difficult experiences of life, they affect us all. We experience the major life changes, the deep worries and grievances, the physical and psychological disturbances, and the abuse, self-inflicted or otherwise. They are entwined with the rest of what we are, and they affect the way we look. For example:

- Fatigue can make a person look older. Lines deepen, and the whole body seems to drag.
- A poor diet can lead to a variety of physical problems, the most commonly seen in America being obesity.
- Heavy drinking eventually affects the appearance of the face. Skin becomes coarser, blotchy, and roseate.
- Constant worry can cause tense facial expressions and premature lines between the eyes.

- Disease or intense grief generate a variety of visible physical symptoms—the flush of fever, paleness, rashes, weight loss, and the like. In Figure 10–7, John Graham has drawn a woman who is striking because of her "pop" eyes, often a symptom of thyroid imbalance. Looking again at Wyeth's *Beckie King*, we see the results of an unidentified illness—the strength to move that mighty body is not there.
- Mental illness can also cause physical response in the realm of body behavior or "gesture," in the disturbed expression on the face, or in an unkempt appearance (Figure 8–11).

Few portraits have any of these pathologies as a primary focus, but their manifestations can provide interesting visual stimuli, as with the Graham in Figure 10–7.

Unlike growth or muscle change, these "trouble" changes cannot be neatly measured or meaningfully described. They happen at different times to different people, and their effect varies. From the standpoint of what is objectively recorded in a drawing, of achieving "correct" likeness, intimate personal information is not a prerequisite. *But* from the standpoint of expressing what can be seen only with the heart, your understanding of appearance or behavior—sometimes at great variance with age norms—can give greater meaning to your work.

Unlike other physical changes, "trouble" changes can often be reversed. More sleep, better diet, or the sweetness of success can "turn back the clock" and make a person look younger, stronger, more vibrant.

DRAWING ADULTS AND ELDERS

The chief difference between drawing adults or elders and drawing children is that you are working with mature people. Doing an adult's portrait is to some extent a partnership because each person has an important job, and each has control over his or her degree of participation. In addition, each has respect for the other, as well as an understanding of the job to be done.

Whatever your level of interaction with adult and elder models, respect for your subject enhances the portrait-making process. If you enjoy working with people, talking and lis-

tening to them, using models is a good mode for you.

Amateur Models

If friends or family members pose for you as a favor, consideration of their convenience and comfort is important. Their understanding of what you are doing and why you need their help can make them feel participatory and comfortable rather than imposed upon or awkward. Since they are volunteers, they decide how much and when they can pose. You decide all other issues pertaining to the work: size, shape, medium, setting, costume, and where it will hang.

Professional Models

Professional models understand that their job is to provide you with a good visual stimulus, and they will tell you when they can pose and their fees. What is expected is clear on both sides. Beyond that, all the choices are yours. Finding out a little about the model makes the process more personal and interesting.

Subjects of Commissioned Works

A quite different situation arises when you are working with an adult or elder you don't know who commissions a portrait. Though this book is not meant to teach you how to make a living doing portraits on commission, the following information helps if you *are* invited to work for a fee.

If the person is well known, a valuable preliminary step is to do some background reading. This prepares you for a preliminary meeting to become acquainted and to discuss the portrait. (If the subject's schedule precludes this meeting, much of the first sitting should be devoted to covering the same ground.) In this discussion, many of the decisions that would be yours if you were working with a volunteer or paid model have to be negotiated with the subject: size, shape, medium, setting, costume, where it will hang, and, of course, the fee.

The last two decisions need further comment. Where a work will hang in part determines its size, composition, and the distribution

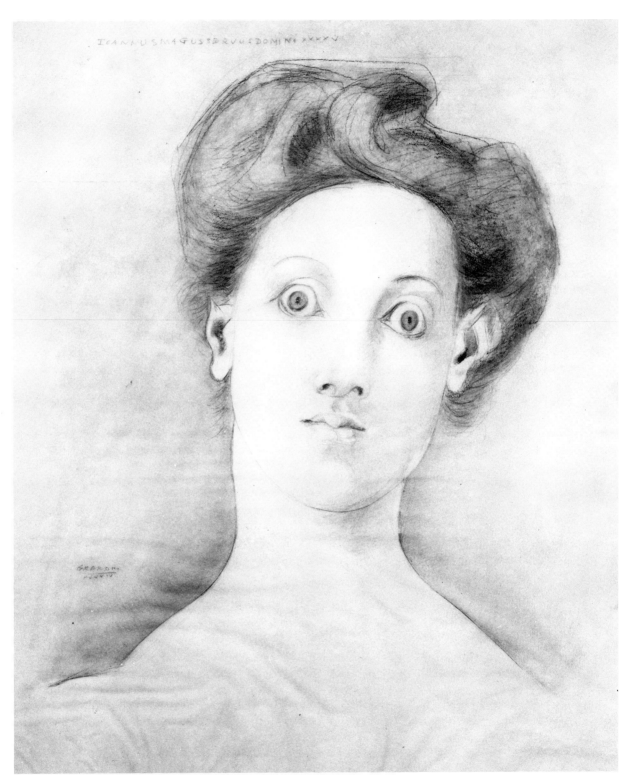

Figure 10-7.
JOHN GRAHAM (American, 1881-1961)
Celia, 1944-45 (Pencil, 23″ × 18⅞″).
Collection, The Museum of Modern Art, New York, gift in honor of Myron
Orlofsky. The Joan and Lester Avnet Collection.

140

of value and color. If the work is institutionally commissioned by a bank, university, or church, for example, it may well hang high and be viewed at some distance in a dimly lit space. If so, it requires a degree of visual assertiveness that might otherwise be overbearing. Institutional commissions, however, are usually paintings. A drawing is more likely to be personally commissioned. It will then probably hang in a home where light is ample and the viewer is close. Subtleties will be seen more easily.

The fee may not be negotiable. If it is, however, the basis of the fee should be understandable to a nonartist, such as size or color. You may wish to make distinctions among jobs or have one flat fee. The point is really that, whatever your fee structure, it should be understandable and understood.

Another purpose of this first visit/sitting together is to put the subject at ease. Having a portrait done is probably a new experience for the subject, and it can be intimidating. A neophyte wonders what the artist will be like, what the "right" behavior might be, whether the artist will see right through to the core and reveal too much? The subject of a commissioned portrait needs tactful and pleasant reassurance as part of the introduction to the whole process.

In addition, the subject probably has to be taught to pose. You need to watch to see how long a pose can be before unnatural stiffness or fidgeting begins? How can the face be kept alert and alive? (Music or conversation might help.) How can eyes be kept still? Most models choose an object or a spot in the room to focus on so that their eyes don't wander. These tips on posing are useful with other nonprofessionals as well.

Always remember that photos you take of the subject are honorable "assistants." Use them in whatever way they can help.

Finally, as a portrait maker, your first obligation is to produce a telling work. When you accept a commission, you are taking a job. An unwritten but mutually understood part of the commitment is that the work you do will please the customer, who presumably has seen other work of yours and likes your style. In addition, you agree on size, shape, and medium, and the customer looks at preliminary sketches. The finished drawing should be free of significant surprises and very acceptable. However, even with all preliminaries carefully carried out, commissioned portraits are sometimes rejected.

The problem lies in the subject's expectations—a mental image of the finished work that is invisible to you. There may be an unexpressed desire for glamour, dignity, sweetness, strength, or something else, some quality that to your eye does not exist. In such a case the product varies from the secret hopes of the subject and is a disappointment.

If the wish for transformation *is* expressed by the subject, and if it is not compatible with your style and vision, then your choices are to either decline the commission or let yourself be diverted from the truth as you see it. The latter choice is risky business. Your artistic integrity is all that preserves your unique vision.

Looking and Seeing

Seeing the shapes of your subject matter in a focused way (Chapter 3) affects all your work, and its importance in adult portraits has to do not only with resemblance but with getting the shapes of a particular age right. Look again at Figure 10–5 in terms of shape change. If the forehead is shorter, Henry Fonda looks younger. If the ears are longer, Fonda looks older. If the hair shape is tall and full, he looks younger. When it becomes a narrow band across the top, he looks older.

Look again at the series of photos of Helen Keller in Figure 10–2. Even without overlays or measuring, you can see the changes in the slant of the neckline, the length of the upper lip, the shape of the nose, the configuration of the jaw, and the form of the ear. You can see the "set" of her head on her shoulders and how it shifts. At age 80, you can even note a slight hairline recession and consequent lengthening of the forehead.

It is also interesting to observe another involvement—that of value. As Keller's hair greys, it provides less contrast with her light skin, and the head mass becomes more unified. This is not always a function of age because a Black person with black hair that turns grey with age gradually develops more contrast in the head form. A blonde with light skin shows little contrast change as hair whitens.

If you continue to look at these photos intently, you make additional discoveries about the relationships of lines, value changes, and the shapes they make, which it turn build the forms of the head.

How do you bring all this information on

the aging process together and apply it? How do you decide what to include and what to leave out? The following Practicals help. As a transition to them, look at Albrecht Durer's drawing of his mother in Figure 10–8. From all the surface signs of aging that he was looking at, he picked and chose. We see creases in her forehead and a deep nose-to-mouth line, but no lines at the outer corner of her eye and no lines or wrinkles on her cheeks. With value change, he suggests but does not fully describe the shifting planes of elder flesh that has lost its firmness.

His mother was a thin woman. Durer became very involved in the look and explicit rendering of her neck and collar bone, which does not add to the power of the drawing. In fact, the collar bone is distracting because it seems to reside outside the body. Even the masters go astray, but what matters is that the impact of the work isn't diminished by the imperfections.

The lesson here is that there is no need to draw *everything*. You can include less or more to suit your taste, but you must sort through the possibilities and choose those that best convey your feeling about the subject. Durer has shown a resolute woman. With solid contour lines, dark accents, and restrained use of modeling, he has depicted a firmly structured face with strong features, a fixed gaze, and a stubborn set to the mouth. He has chosen the visual routes he liked to arrive at the emphasis he wanted.

Practicals for Drawing Adults and Elders

MATERIALS. *Your choice.*

1. At the end of this chapter is a portfolio of drawings, images created by master artists of this and past centuries. Study them. Choose the three that you like best, and "read" them visually. Then draw each, doing your best to imitate the style, technique, and use of the medium or media. Be constantly aware of shapes and how they come together to build the drawing.

2. Draw each of the three master drawings again. This time, follow your own impulses. Change media if you like. Alter techniques. Omit passages. Or add to the work. Revise the composition.

When you are done, compare the three versions of each work—the original and your two. Think about the contrasts, what you like, and what you don't like.

Do your versions make the people look different? Older? Younger? Thinner? Fatter? More or less feminine or masculine? More or less three-dimensional? Why?

What effect does a difference in medium have? If possible, discuss these drawings with a teacher or an experienced artist who does portraits.

3. Now, prepare for a drawing from a subject.

a. Find someone who enjoys volunteering for you. Talk it over. Find convenient times. Think about the size and shape of the work. Consider costume and setting. Study works in this book for ideas.

Think about media. Be prepared to take photos. Do preliminary studies. Bear in mind at every turn that this is a learning process, an opportunity to bring all the ideas in this book to bear on what you are doing. You are bound to make errors and to try out ideas that aren't comfortable for you. The result may not meet your expectations, but more important is what you have discovered and learned as you do the piece.

b. Perhaps doing a second study from the same person at this point is a good way to consolidate your gains and to try ideas you may have set aside the first time.

4. Now apply all you know to another self-portrait. Give it a good deal of preliminary thought. Consult the master drawings in this book again. Realize that, in drawing yourself, you have the greatest possible freedom to express yourself, to experiment, even to fail. Take advantage of the situation. Use yourself.

Plan the drawing, but consider changes that suggest themselves. Know where you are going, but be open to new possibilities. When you are done, compare this drawing to the first you did of yourself for pencil practical 3 in Chapter 2. Analyze your progress. Identify both strengths and weaknesses. If possible, discuss the two drawings with an experienced artist/teacher.

REFERENCES

Body Changes

1. TIERNEY, JOHN. "The Aging Body," *Esquire.* New York: Esquire Publishing, Inc., May 1982.

2. PARRISH, JOHN A., M. D., et al. *Between You and Me.* Boston-Toronto: Little, Brown & Company, 1978.

Life Changes

1. SCARF, MAGGIE. *Unfinished Business: Pressure Points in the Lives of Women.* New York: Doubleday & Company, Inc., 1980.

2. SHEEHY, GAIL. *Passages.* New York: Bantam Books, Inc., 1977.

Figure 10-8.
ALBRECHT DURER (German, 1471-1528).
Portrait of the Artist's Mother (Black chalk).
Staatliche Museum, West Berlin.

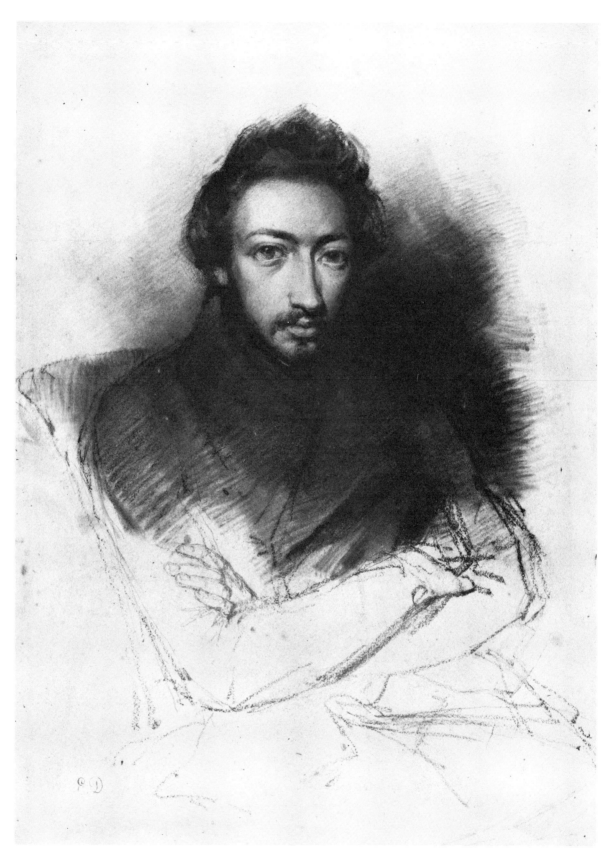

Figure 10-9.
EUGENE DELACROIX (French, 1798-1863).
Portrait of Frederic Villot (Black chalk with some graphite and charcoal or black crayon accent).
Courtesy of the Fogg Art Museum, Harvard University, Cambridge; Gift of Meta and Paul J. Sachs.

144

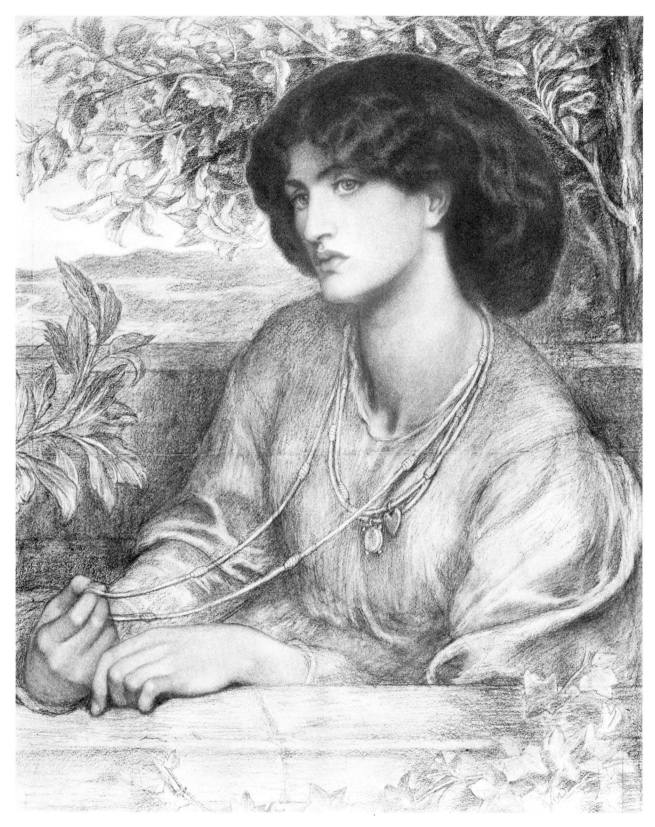

Figure 10-10.
DANTE GABRIEL ROSSETTI (British, 1828-1882).
Aurea Catena (The Lady of the Golden Chain) (Pencil and colored chalk).
Courtesy of the Fogg Art Museum, Harvard University, Cambridge; Bequest of Grenville L. Winthrop.

145

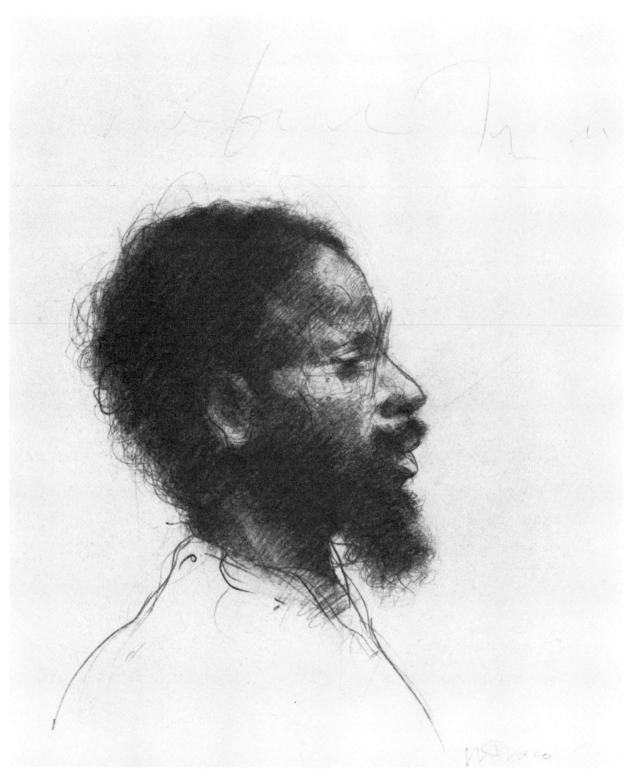

Figure 10-11.
THERESA MONACO (American, 1939-).
Untitled (Pencil).
Courtesy of Marion Kilson.

146

Figure 10-12.
HENRI MATISSE (French, 1869-1954).
Untitled (Lithograph).
Collection of Author.

Figure 10-13.
DAVID LEVINE (American, 1926-).
A. A. Shikler (Charcoal).
Courtesy of Mr. and Mrs. Aaron Shikler.

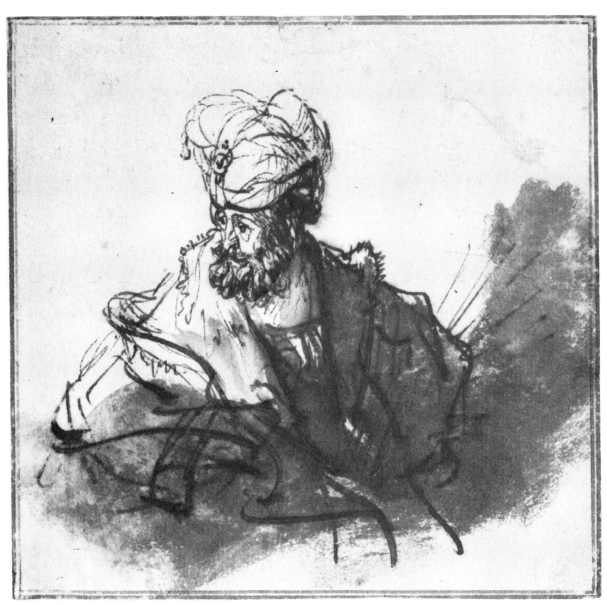

Figure 10-14.
REMBRANDT VAN RIJN (Dutch, 1606-1669).
Bearded Oriental in a Turban, Half Length (Pen and wash).
Staatliche Museum, West Berlin.

Figure 10-15.
PAUL GEORGES (American, 1923-).
Self-Portrait, 1964 (Wash, pencil, and brush and brown ink, 14″ × 10¾″).
Collection, The Museum of Modern Art, New York. Gift of Mr. and Mrs. E. Powis Jones.

150

Figure 10-16.
WINOLD REISS (American, 1886-1953).
Mary McLeod Bethune (Pastel).
National Portrait Gallery, Washington, D.C.

151

Figure 10-17.
FRANZ KLINE (American, 1910-1962).
David Orr's Mother (Pencil).
Courtesy Mr. and Mrs. I. David Orr.

152

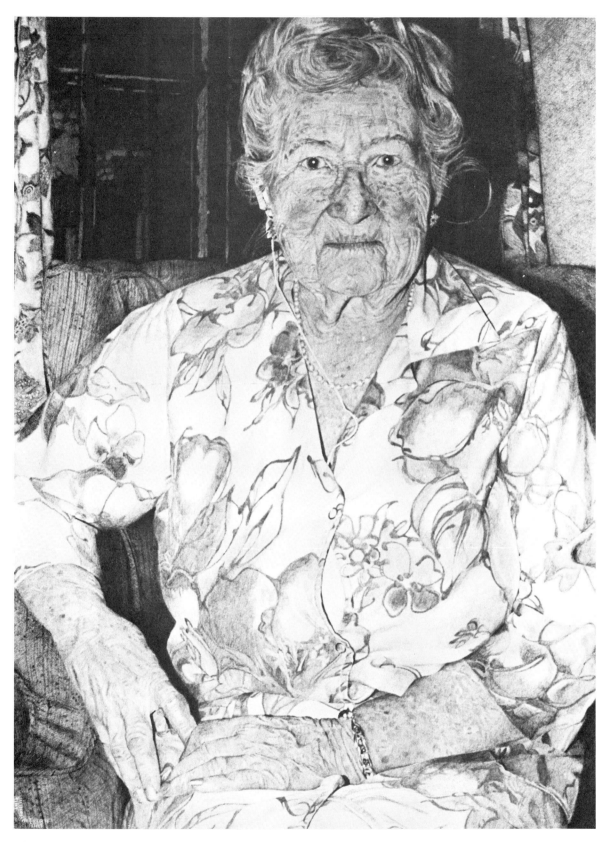

Figure 10-18.
JERI METZ (American, 1947-).
Selma at 92 (Pencil).
Courtesy Jane Haslem Gallery, Washington, D.C.

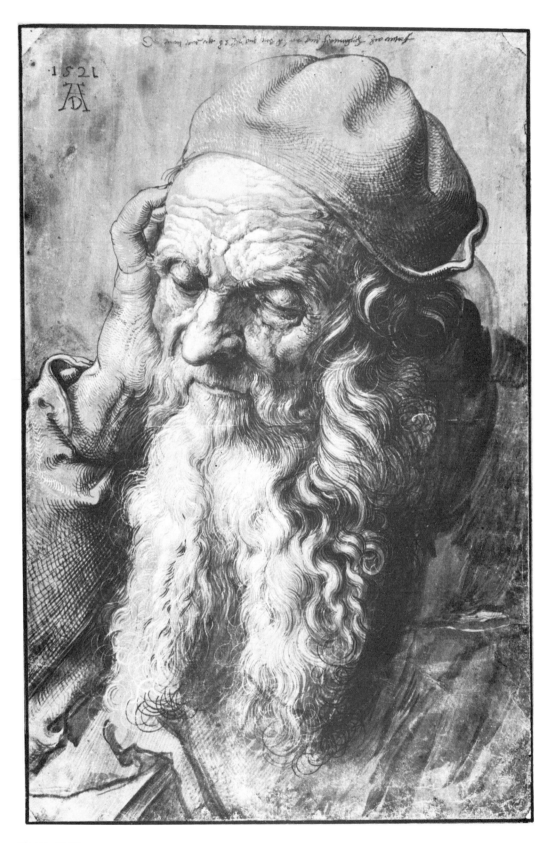

Figure 10-19.

ALBRECHT DURER (German, 1471-1528).
Ninety-three-year-old Man (Brush, India ink, and white body
color).
Albertina Graphics Collection, Vienna.

154

CHAPTER ELEVEN

Portrait caricature

In *The Synonym Finder*, under "caricature," J. I. Rodale lists "cartoon . . . parody . . . spoof . . . farce . . . burlesque . . . takeoff . . . satire . . . lampoon." Though none is an exact equivalent, taken together, they clearly suggest the thrusts of caricature. In the same entry, Rodale lists "portrait," "sketch," and "drawing," suggesting respectively likeness, spontaneity, and intimacy. These qualities are found alike in good caricature and more conventional portrait drawing.

Portait caricature is not the embodiment of general ideas, as Michelangelo's *Head of a Satyr* was (Figure 1–7). The caricaturist is in pursuit of the essence of a person, just as the portrait is. Yet caricaturing *is* different in its purpose, and this difference transforms a conventional portrait into a portrait caricature.

Conventional portraiture honors individuals, revealing them with compassion and subtlety. In the finest examples, it is not important for the viewer to recognize the subject, for the universal human qualities transcend the individual.

In sharp contrast, caricature exists to make a point. It is an instrument of propaganda and opinion, using exaggeration and humor to expose individual folly and wickedness. To per-

155

Figure 11-1.
RANAN LURIE (American, 1932-).
Untitled political cartoon (Ink).
Courtesy The Times, London, England.

© Lurie, in *Life*

suade with one drawing (or even with a comic strip series of three or four), the artist must take advantage of every bit of available impact. The subject must be *very* well known to the target audience. To guarantee recognition, the artist exaggerates the subject's features, mannerisms, or activities—always with humor, for that is a strong element of viewer attraction.

To caricature a subject successfully, an artist needs up-to-the-minute knowledge and understanding of the person's character and activities. The discussion later of David Levine's work shows you how fundamental background information is to good portrait caricature. Without background information, any caricature would have to be superficial. Thus, caricatures done of strangers by sidewalk artists are capable of no more than superficiality. The artists, however skillful, can use exaggeration only of what they see, not of personality, beliefs, or activities. They can exaggerate heavy eyebrows but not a political stand, such as believing in lower taxes. They can draw humor from big ears, but not from personal habits or idiosyncracies.

In Ranan Lurie's masterful caricature parade of men and women who were world political leaders in 1974 how many can you identify now (Figure 11–1)? As the years pass, it becomes more difficult. For satire to make its point, subjects must be known and known *now*.

The message Lurie originally delivered depended on special knowledge. Caricature is at the mercy of time far more than other art forms. It has an inherent "one shot" nature and usually does not endure. The impact of Lurie's message has diminished over time and judgment of the work depends increasingly on the same elements by which we judge conventional portraiture: skillful drawing, visual intrigue, and communicating universal human experience.

The number of caricaturists, portrait or editorial, whose work has transcended current events, has stood the test of time, and has earned them niches in the history of art is small, but their work is fascinating. William Hogarth (British, 1697–1764) and Honoré Daumier (French, 1808–1879) are examples. (A Daumier drawing is included in the portfolio at the end of this chapter.) Their work is more powerful when the viewer knows about the social or political situation portrayed, but it is judged great now on aesthetic merit alone.

Caricature is a valid, compelling avenue of portraiture. It is of interest to many talented artists either as a primary or secondary focus or as a diversion and means of relaxation.

The balance of this chapter is devoted to looking at and analyzing the work of three artists who have made it a major focus, to a portfolio of works by others, and to Practicals.

A LOOK AT WORKS BY THREE MASTERS

David Levine, Friendly Satirist

David Levine, at the forefront of portrait caricature in the second half of the twentieth century, is also a sensitive painter of people and landscapes. Daniel P. Moynihan, in his introduction to *Artists, Authors, and Others: Drawings by David Levine,* describes Levine as the "first genuine artist to attain vast influence as a caricaturist— once simultaneously on the cover [sic] of *Time* and *Newsweek*!" In his foreword to the same catalog, Abram Lerner elaborates:

There is universal agreement that Levine is unique in his genre . . .the amiable iconoclast whose pen good-naturedly spoofs our pretentions and cuts us down to human size. Levine is at his best in revealing personalities rather than the events which shape them. His

portraits are witty and perceptive observations whose veracity neither the camera nor the looking glass can match.

To express his perceptual genius, Levine has developed a style most recognizable by the large heads and small, progressively dimishing bodies of most of his subjects (Figure 11–6). This approach has roots in the work of Benjamin Ribaud (French, 1811–1847) who produced more "finished" drawings, which actually balance on a fine line between caricature and conventional portraiture (Figure 11–2). Levine's style also stems from that of Andre Gill (French, 1840–1885), whose work resembles Levine's and Sir Max Beerbohm (English, 1872–1956), whose figures were more grotesque, though done in a simpler drawing style (Figure 11–3).

The source of the large-head/small-body device is unclear. It may derive from the proportions of dwarfs and what they once represented in society—amusing freaks endowed with special talents. Given that caricatures are usually of the famous, the most gifted and unusual people among us—talented "freaks"—dwarf proportions not only suggest their unusual role, but also reassure us in our normalcy. On a less speculative level, the device is fascinating. We are drawn to and sometimes excited by the unusual. And it is a means of presenting the face, the mirror of character, with far more visual emphasis than normal proportions would allow.

The other consistent stylistic dimension of Levine's work has even longer roots. It is the classical cross-hatching technique (Figures 1–7, 2–5, and 6–1), which is used in the Bogart drawing in Figure 11–4 and the Chaplin drawing in 11–6.

When he undertook the Bogart drawing, Levine surely knew of the contradictions that Humphrey DeForest Bogart embodied. Born into gentility, bred to go to Yale, and expected to become a physician, he was instead asked to leave prep school, became the prototype tough guy of film, and was a socially difficult person. On the one hand, he was a Puritan, gentle at heart and afraid to say so, who rejected pomp, conspicuous wealth, gossip, and boasting. On the other hand, he was known as a barfly, a moody drunk, raucous and guilty of much verbal effrontery. But, for the world at large, he had, as Alistair Cooke phrased it in *Six Men,* "the simple, inexplicable characteristic of natu-

Figure 11-2.
BENJAMIN RIBAUD (French, 1811-1847).
Portrait of Grandville (Lithograph).
Courtesy of the Boston Public Library, Print Department.

158

Figure 11-3.
MAX BEERBOHM (English, 1872-1956).
Mr. Swinburne, June 1899 (Pencil and watercolor).
Reproduced with permission of Mrs. Eva Reichmann, Copyright ©Mrs. Eva Reichmann.

Figure 11-4.
DAVID LEVINE (American, 1926-).
Humphrey Bogart (Pen and ink).
Reprinted with permission from The New York Review of Books.
Copyright ©1972 The New York Review.

160

ral stars; you cannot take your eyes off them. (No one in the history of the movies has made smoking a cigarette a more deadly and fascinating thing to watch—and deadly, alas, in the end to him.)"

Levine has communicated Bogart's presence, at once repellent and fascinating, working the Puritan/tough-guy contrast into his caricature effectively. Compare the drawing with the photo in Figure 11–5. He has done this considerable job by exaggerating the hurt look of the eyes and by diminishing the strong chin to show the vulnerability of this morally conservative man. Then he has strengthened two lines of

defense, the heavy, black, doubting eyebrows and the slight smirk, aimed at the falseness of the world. In addition, Levine has used the diminutive body to evoke the past, familiar to long-time fans, by dressing it conservatively and giving it the familiar gun and cigarette. The caricature is an emotionally unified statement. There is nothing heroic in either the tough guy or the Puritan. Bogart was the first antihero hero.

The next Levine work, the study of Charlie Chaplin, is actually a caricature of a caricature—*The Tramp* (Figure 11–6). Chaplin survived a childhood that Dickens might have created. He

Figure 11-5.
Humphrey Bogart.
Wide World Photos, Inc., New York.

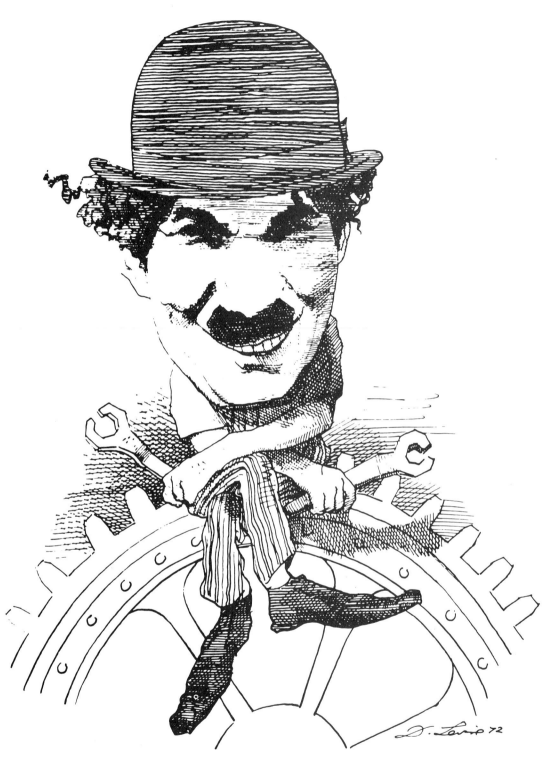

Figure 11-6.
DAVID LEVINE (American, 1926-).
Charles Chaplin (Pen and ink).
Reprinted with permission from The New York Review of Books.
Copyright ©1972 The New York Review.

162

knew humiliation and the injustice of grinding poverty from his earliest days. Yet his mother, despite poverty and precarious mental health, always made him feel unique and distinguished. Of course, Chaplin *became* unique and distinguished. He survived childhood and went on to create the most widely known "caricature" on earth, the Little Tramp, the grown-up child who exposed the tradition of the gentleman on behalf of the dispossessed (Figure 11–7).

Chaplin's account of the "birth" of the Little Tramp is a rare view of the artist's creative process at work. The following is condensed from his autobiography. It was 1914. He was acting in one-reel comedies for Mack Sennett.

"We need some gags here," Sennett said, then turned to me. "Put on a comedy make-up, anything will do." On the way to the wardrobe, I thought I would dress in baggy pants, big shoes, a cane and a derby hat. I wanted everything a contradiction: the pants baggy, the coat tight, the hat small and the shoes large . . .I had no idea of the character. But the moment I was dressed, the clothes and the make-up made me feel the person he was. I began to know

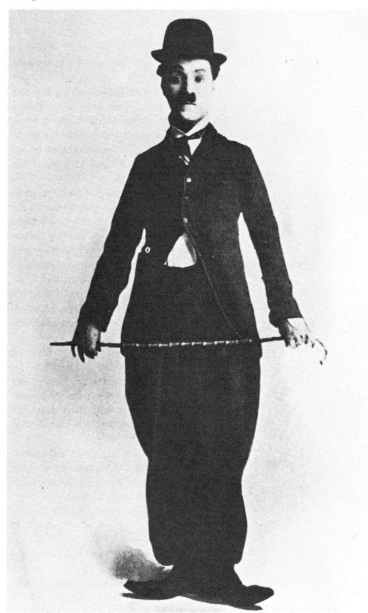

Figure 11-7.
The Tramp.
Reproduced with permission of The Bodley Head Ltd., London, from *My Autobiography* by Charles Chaplin.

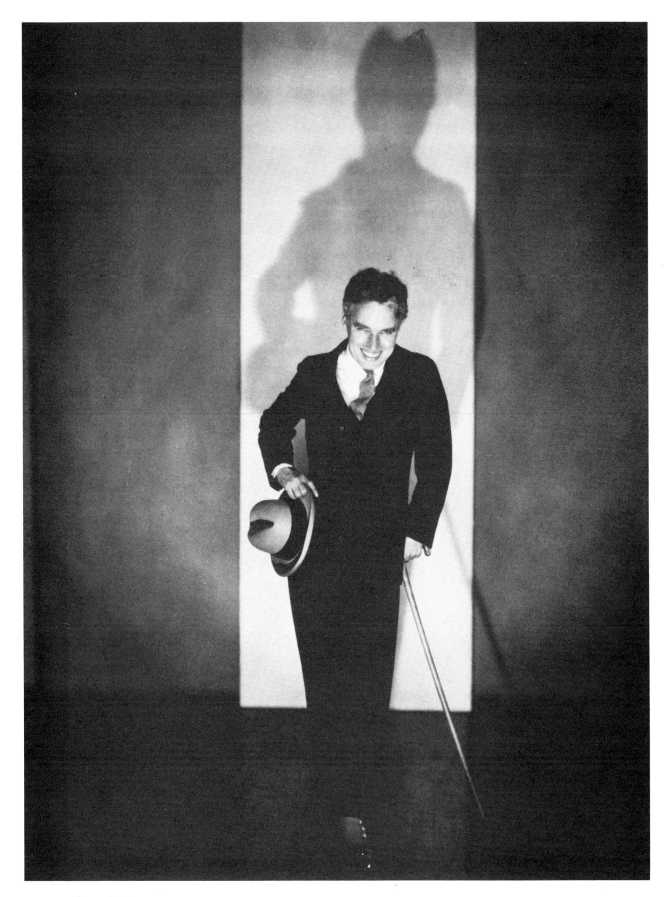

Figure 11-8.
EDWARD STEICHEN (American, 1879-1973).
Charles Chaplin, 1925 (Gelatin silver print, 16⁹⁄₁₆″ × 13⁵⁄₁₆″).
Collection, The Museum of Modern Art, New York. Gift of the photographer. Reprinted with
the permission of Joanna T. Steichen.

him, and by the time I walked onto the stage he was fully born . . .I began to explain the character: "you know this fellow is many sided, a tramp, a gentleman, a poet, a dreamer, a lonely fellow, always hopeful of romance and and adventure. He would have you believe he is a scientist, a musician, a duke, a polo player. However, he is not above picking up cigarette butts or robbing a baby of its candy . . ."All right," said he, "get on the set and see what you can do there." . . .I entered and stumbled over the foot of a lady. I turned and raised my hat apologetically, then turned and stumbled over a cuspidor, then turned and raised my hat to the cuspidor. Behind the camera, they began to laugh.

In his caricature, Levine captures the child-adult by means of the figure's location and gesture, sitting atop the machinery, gleeful with success. The famous sophisticate is also revealed in the "on-top" position and in the cunning eyes and knowing smile. By presenting both, Levine has managed to expose the Tramp, giving us a caricature of a caricature.

Yet he has gone even further. He has also captured what we see in Steichen's photoportrait of Chaplin, who, without makeup and dressed like a bank president, evokes the Tramp by the tilt of his head and the way he holds his cane and hat (Figure 11–8). The "real" Chaplin was sensuous and handsome beyond what could be imagined beneath the Tramp's crescent brows and comic moustache. Just as Steichen brilliantly captures a touch of the Tramp in an image of Chaplin, so Levine gives us a glimpse of the sensuous good looks in an image of the Tramp. A virtuoso performance.

ALBERT HIRSCHFELD, PUBLICIST OF BROADWAY

In Al Hirschfeld's work, simplification equals exaggeration, for it more clearly allows us to see what is essential. His style is immediately recognizable: the ultraclean, extravagant pen-and-ink lines, combined with bold areas of solid black that give each drawing extraordinary energy. Content is really secondary to his unrelenting insistence on outstanding design and meticulous technique.

For 50 years or more, Hirschfeld has been professionally linked to the legitimate theatre in New York City. His work appears weekly in the *New York Times* and occasionally in other mass media publications. In the introduction to Hirschfeld's book of his own work, John Russell writes that

Al Hirschfeld is the most observant of men, but he has the gift of human charity. The entertainments that he goes to see are failures, more often than not. For the people who appear in them, they mean an exposure that is most probably brief and quite possibly calamitous. There is no player, no matter how distinguished, who has not foundered more than once in some misbegotten venture . . . a vindictive ax-man could do them mortal damage if he recorded their failings, day in and day out, for half a century.

Hirschfeld has chosen not to be that axman. He is kind to his subjects, and the only evidence of personal theatrical preference in his drawings is the sense of extravaganza. He loves lavish production and expresses that love even when drawing a solo entertainer, such as Duke Ellington (Figure 11–9). Compare Hirschfeld's drawing to the photo of Ellington in Figure 11–10. The face is scarcely exaggerated, certainly not spoofed or satirized. It is with the hands that Hirschfeld is profuse and fanciful, exceeding the bounds of reason. He tells us thereby of great talent. And Hirschfeld didn't even draw the piano. We *know* it is there. He is an artist who draws nothing unless it is needed, however extravagant his bounding line and high contrasts might be.

As Russell points out, Hirschfeld does not deal in the exposure of folly and wickedness, and so he fails to wholly fit the definition of caricature given in the beginning of this chapter. His approach differs from Levine's. Yet he *is* primarily a propagandist, enticing us to see live performers by means of his own joy and energy. His work is not so much the essence of the person as it is the "presence" that the person takes on in the particular entertainment at hand. Beyond that, the study of Ellington holds my interest because the design and the role of the hands is so brilliantly done. As a "grace note" to his own performance, Hirschfeld provides a game—not one that relates to the subject, but one that reveals a little of him as a person. When his daughter, Nina, was born, he began to "hide" her name in each drawing, usually more than once, sometimes several times. The game is to "find the Nina's."

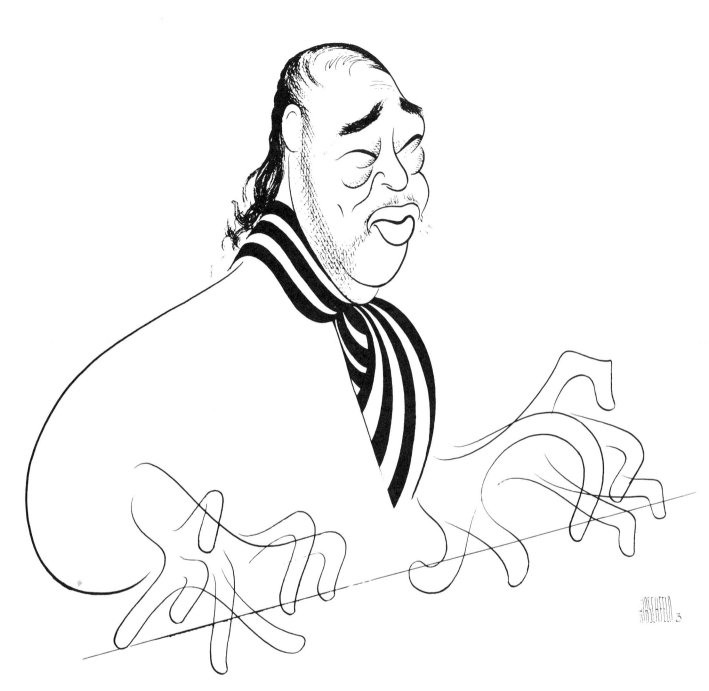

Figure 11-9.
AL HIRSCHFELD (American, 1903-).
Duke Ellington (Ink).
Courtesy of the Artist.

Figure 11-10.
Duke Ellington.
Wide World Photos, Inc., New York.

JULES FEIFFER, EDITORIAL SATIRIST

Having looked at portrait caricaturists in Levine and Hirschfeld, the work of Feiffer provides an opportunity to see the part that portrait caricature plays in editorial cartoons.

In Figure 11–11, you see that Feiffer's format is very different from Levine's and Hirschfeld's. He uses a comic strip, story-telling approach, as dependent on words as it is on image. In this example, Feiffer uses three presidential caricatures: John F. Kennedy, Lyndon Johnson, and Richard Nixon. They are essential to his message and to the devastating twist in the last frame that is Feiffer's hallmark.

Obviously, political and social satirists must be able to handle caricature. Leaders of the world often have a role in their work. Yet Feiffer, like most other caricaturists, find some faces and characters they are obliged to use easier to make instantly recognizable through exaggeration than others. In this example, Nixon's pear-shaped head and small, suspicious eyes tell the story. With Johnson, the nose and downward slant of the cheeks yield quick recognition. However, Kennedy is more difficult. Kennedy was a handsome, youngish man with regular features and a ready, perfect smile. Had he been 20 years older, the caricature might have been easier. Instead, Feiffer and others relied more on resemblance than on exaggeration.

In this example of Feiffer's work, you can observe the difference between caricature and cartoon. The boy as he grows is a cartoon figure, an expression of a general type, rather than the exaggeration of a particular individual as the presidential images are.

Other examples of editorial caricature are included in the portfolio section at the end of this chapter.

Practicals for Caricature
Marshal all your mastery of drawing materials and techniques, as well as your sensitivity to people. You now have an opportunity to focus on the dimension that exaggeration and wit can add to portraiture—to "see" in another way. This experience adds to your ability to capture the essence in any kind of portrait you do.

MATERIALS. *White bond and pen, with ink, charcoal, Conté, or pencil.*

1. Select a 20th century caricature from the portfolio that follows this chapter. Find a photograph of the person so you can analyze what the artist has done to transform the face into a caricature. Then develop your own caricature from the photo as follows:

a. Make a gesture drawing from the photo. Reinforce it with some contour and modeling. Work on it until you feel familiar with the features and their placement just as they appear in the photo.

b. In another drawing, distill this face to the simplest possible statement that is still a likeness. Study the Beerbohm drawing again in Figure 11–5 to get a sense of just how reduced a drawing can be and still present an individual.

c. Then, using this "distilled" drawing as a springboard, make a series of sketches experimenting with changes in the face that might lend themselves to witty exaggeration. Consider each feature and its potential for expressiveness. What happens if the eyes are magnified? Made smaller? What about eyebrows? Do they have expressive potential that would help reveal the essence of the subject by being bushier? More arched? Less noticeable? How about the subject's ears? Are the subject's earrings, if any, a statement of personality? What can be done with them?

Continue your questioning, working your way in this analytical fashion through all aspects of the face, hair, and adornments.

Bear in mind that there are many ways to express the same person and still trigger instant recognition. Look at the two responses to Picasso's death shown in Figures 11–18 and 11–19. In Figure 11–18, Picasso is drawn in one of his most widely known styles, the style in which he drew himself in Figure 7–7. In Figure 11–19, another artist represents Picasso indirectly by applying the same well-known style to two other recognizable people, former president Nixon and his wife. Both works portray Picasso, though very differently. Be patient with yourself as you search for your personal insights and style of expression.

d. Now consider the medium you would be most comfortable with. Pen with ink is the traditional medium of the caricaturist because it reproduces nicely. But black crayon, charcoal, conté, or even soft pencil are possibilities. Anything is a possibility that yields high contrast, preferably without the middle tones that are more difficult and expensive to reproduce.

Continue working in a relaxed, experimental

Figure 11-11.
JULES FEIFFER (American, 1929–).
Cartoon from *Feiffer on Nixon: The Cartoon
Presidency,* 1975.
Permission of the Artist.

way for as long as you like, trying various approaches to a caricature of the whole face.

2. Work through the preceding Practical again; only this time begin with a photo of a friend, or a member of your family. Study available photos thoughtfully and choose one that you think has good possibilities for exaggeration and humor. Follow the procedure described in 1. above.

3. Use the same process again, this time with a self-portrait that evolves into a self-caricature. Work from photos if you think doing so will be helpful.

4. Whenever you can, make quick caricatures of people you know. Those in Figure 11–12 were done by one member of a group traveling together for a long enough time to become well-acquainted. In each of the four sketches, appearances were first simplified and then exaggerated. The results are perceptive, comic likenesses of the sort you will find yourself doing, though your personal style will doubtless be different.

5. Look at other work by portrait caricaturists discussed in this chapter, as well as those included in the portfolio that follows. Get books on them from the library. Look at the caricatures in any major newspapers the library may carry. By photocopying, collect examples you like and keep them for future reference. This kind of activity steadily increases your sensitivity to portrait caricatures.

Above all, KEEP DRAWING.

Figure 11-12.
Courtesy Daniel S. Pettee.

Figure 11-13.

HONORE DAUMIER (French, 1808-1879).
Le Bon Argument (Pen, graphite, carbon ink wash and black, red,
and white inks over graphite).
Courtesy of the Fogg Art Museum, Harvard University, Cambridge; Bequest of Grenville L.
Winthrop.

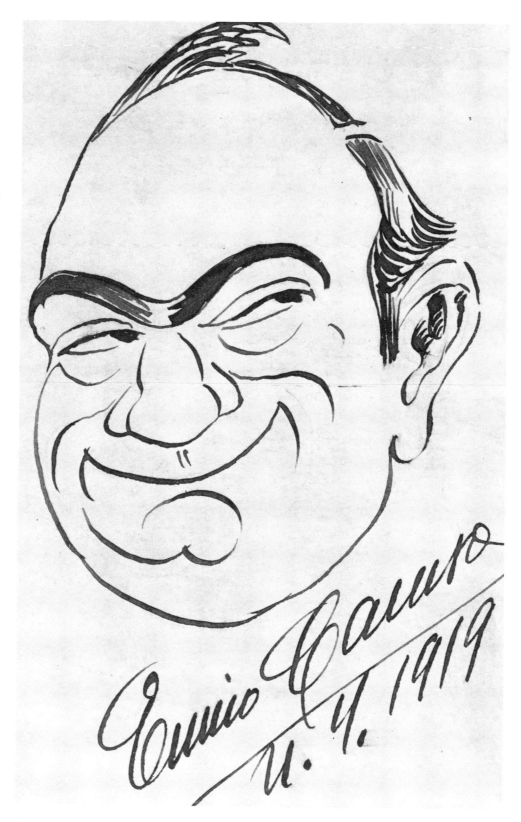

Figure 11-14.
ENRICO CARUSO (American, 1873-1921).
Enrico Caruso (Ink).
National Portrait Gallery, Washington, D.C.

172

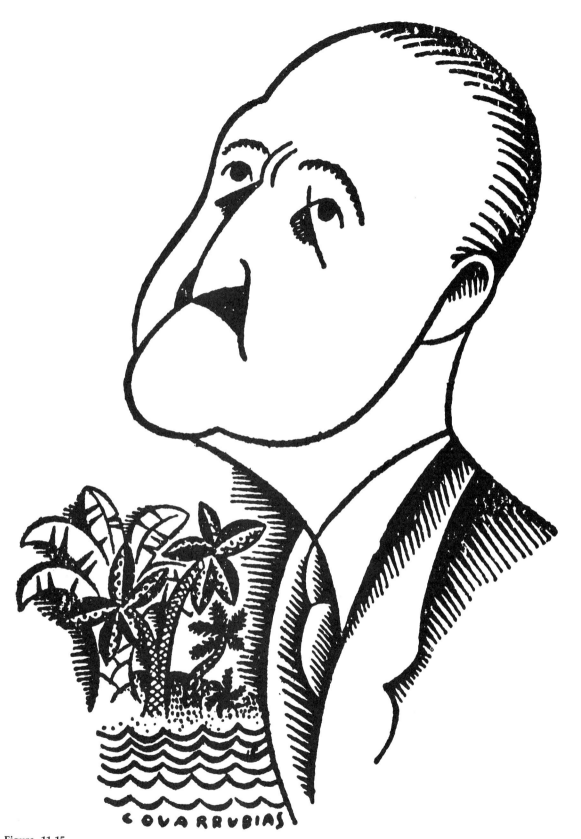

Figure 11-15.
MIGUEL COVARRUBIAS (Mexican, 1904-1957).
Somerset Maugham (Ink).
From *The Prince of Wales and other Famous Americans* by
Miguel Covarrubias. Copyright ©1925 by Alfred A. Knopf,
Inc. and renewed 1953 by Miguel Covarrubias. Reprinted by
permission of the publisher.

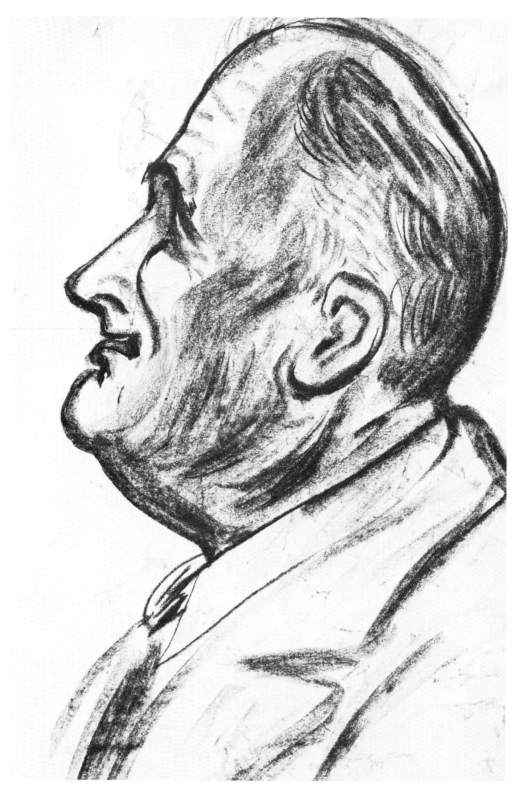

Figure 11-16.
PEGGY BACON (American, 1895-).
Franklin D. Roosevelt (Charcoal).
Courtesy Kraushaar Galleries, New York.

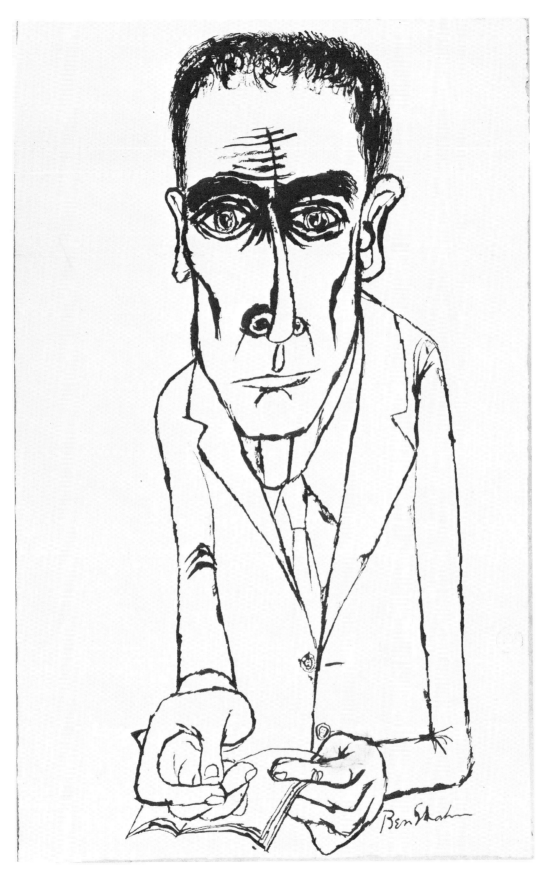

Figure 11-17.
BEN SHAHN (American, 1898-1969).
Dr. J. Robert Oppenheimer, 1954 (Brush and ink, 19½″ × 12¼″).
Collection, The Museum of Modern Art, New York; Purchase.

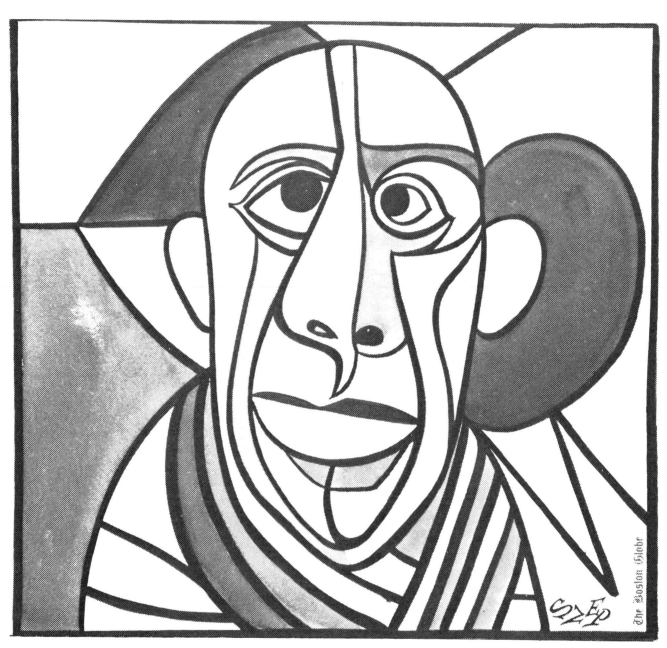

Figure 11-18.
PAUL SZEP (American, 1941-).
Tribute to Picasso (Ink).
Reprinted courtesy of The Boston Globe.

'I WAS ALWAYS THANKFUL HE WASN'T A POLITICAL CARTOONIST!'

PAT OLIPHANT/*Washington Star*

Figure 11-19.
PAT OLIPHANT (American,)
I was always thankful he wasn't a political cartoonist (Ink).
Permission of the Los Angeles Times Syndicate.

Figure 11-20.
SVEN SONSTEBY (Norwegian, 1933-).
Untitled political cartoon, Shah of Iran/Ayotolleh Khomeni (Pencil).
Na Magazine, Norway; ©Sven Sonsteby.

Index

The names of artists whose work is included are in CAPITALS.

The titles of works, the pages on which they appear, and their figure numbers are all in *italic*. (For example, "*A. A. Shikler* (Levine, David), *148, 10–13*" means that the work entitled *A. A. Shikler* is to be found on page 148, in Figure 10–13.)